# SUNDERBANS

# SUNDERBANS
## The Mystic Mangrove

Biswajit Roy Chowdhury ◆ Pradeep Vyas

NIYOGI
BOOKS

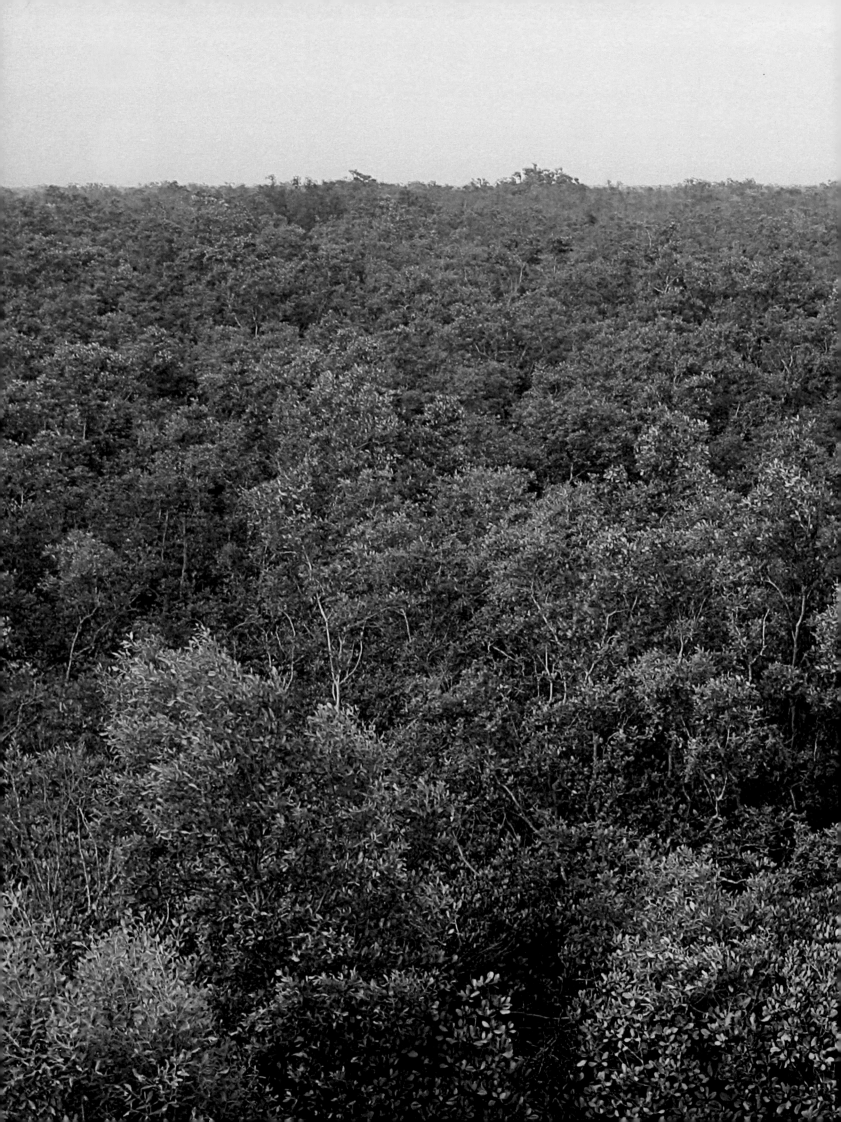

*For all who love*
*the wonder of wilderness*

Published by

## NIYOGI
## BOOKS

D-78, Okhla Industrial Area, Phase-I
New Delhi - 110 020, India
Tel.: 91-11-26816301, 26813350/51/52
Fax: 91-11-26810483, 91-11-26813830
e-mail: niyogibooks@gmail.com
website: www.niyogibooks.com

Text & Photographs: Biswajit Roy Chowdhury & Pradeep Vyas

Design: Anouk Chatterjee & Sushovan Ghose

ISBN: 81-89738-13-5

© Niyogi Books

Year of publication: 2007
2nd impression: 2009

Printed at: Niyogi Offset Pvt. Ltd., New Delhi, India

# Contents

Foreword 9

Prelude 10

The Desperate Delta 13

The Mangal 25

The Vibrant Mudflats 37

The Stunning Sea Face 67

Bound by Faith 77

Survival in the Sunderbans 85

Dedicated to the Cause 97

Tourist Haven 108

Factfile 109

Sunderbans Map 110

Useful Addresses 112

Checklist 113

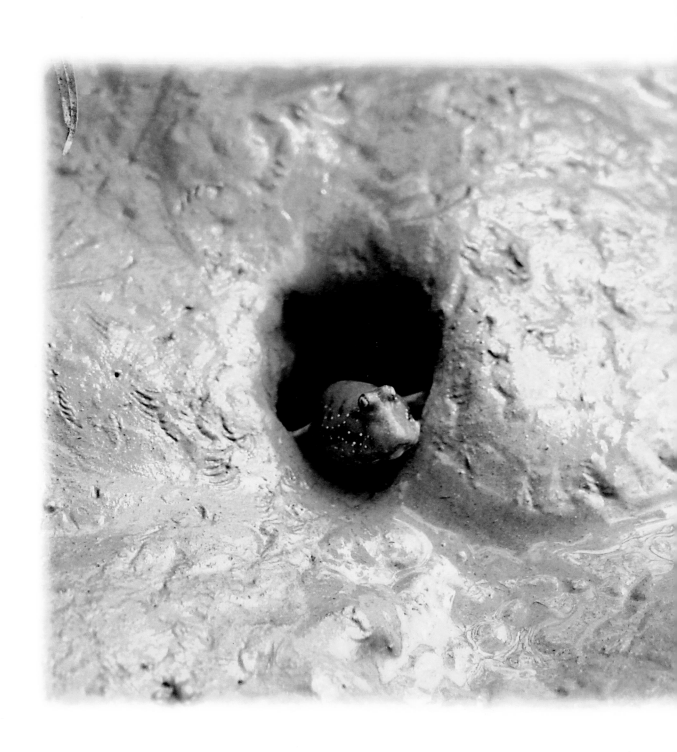

# Foreword

The Sunderbans—the world's largest mangrove expanse—has a unique eco-system. Two high tides and two low tides each day make this terrain very difficult to negotiate, both for Man and Animal. Here the tiger strives hard to catch its prey while the deer is equally vigilant to defend itself from the predator. In such typical natural conditions, all animals have learnt to adapt to the environment. They are accustomed to drinking saline water; they are fine swimmers; they are constantly fighting the odds of nature.

The people of this region, however, have to struggle hard for their livelihood, and live under the ever-present threat of tiger attacks. Besides having to deal with riverbank erosion, they are regularly exposed to natural calamities like cyclones. However, these natural adversities have made the people of this region aware of the necessity to co-exist with nature.

The success of a good forest manager or an NGO working in this region depends largely on the ability to uphold the conservation of nature and wildlife, while improving the living standards of the people. In this regard, Pradeep Vyas, with his experience of over five years in the Sunderbans, and over 15 years in Wildlife Management has been able to strike the right balance. The tough Sunderbans Tiger Reserve administration with a human touch has enabled him to win the trust of the local community who, in turn, have proved to be an invaluable supporter of the conservation of this World Heritage Site. Biswajit Roy Chowdhury has been working in the villages of the Sunderbans and in the forests for the last 15 years. Writing *Sunderbans: The Mystic Mangrove* on the flora and fauna of the Sunderbans is a very noble task to have undertaken.

*Sunderbans: The Mystic Mangrove* will help us understand the essence of the Sunderbans and the necessity of preserving the mystic mangroves for all times to come.

**Tushar Kanjilal**
Secretary
Tagore Society for Rural Development
Rangebelia, Gosaba

# Prelude

Located at the southernmost fringe of Bangladesh and West Bengal, a state of eastern India, are the pristine deltas of the Sunderbans. The Sunderbans, since time immemorial, have been considered to be a topic of immense ecological significance by scholars and researchers, and even though a lot has been explored, the deltas still retain an uncanny aura of mysticism.

However, the most widely accepted view is that the Sunderbans were formed by the gradual deposition of alluvial silt at the union of the River Ganges and the River Brahmaputra as they cascaded down the mighty Himalayas to the Bay of Bengal.

The Sunderbans are spread over an area of 26,000 sq km, running across India and Bangladesh and are recognized worldwide as the largest deltaic region and home to the famous Royal Bengal Tigers. It ranks amongst the first nine Wildlife Reserves of India, and was brought under 'Project Tiger' in 1973. The immense biodiversity and ongoing geological processes led to further accolades as the Reserve was declared a World Heritage Site by UNESCO in 1987 and a Biosphere Reserve in 1989.

The Indian Sunderbans comprises 9,630 sq km of the total deltaic area, encompassing two major districts of southern West Bengal—the North and South 24 Parganas. An imaginary line known as the Dampier-Hodges Line after the two surveyors, William Dampier and Lt. M. Hodges, demarcates the forest area on the Indian side, which stretches over 4,263 sq km. The line extends in the north up to the River Hoogly and moves westwards. On the eastern side, it covers the Rivers Ichamati-Raimongol and serves as an excellent guide in establishing the extent of the Indian Sunderbans.

Osprey

The Sunderbans experience a long spell of monsoons from the end of May till the end of September. Summers are usually between March and end of May. During these months the Sunderbans become sultry and humid, and the waters turn turbulent. Occasional depressions in the Bay of Bengal during summer and the end of monsoons result in fierce cyclonic storms, which cause heavy destruction.

Numerous references to the Sunderbans have been found in ancient Hindu literature and epics, such as the Upanishads, the Ramayana and the Mahabharata. The Sunderbans are a treasure-trove for naturalists and scientists, a paradise for nature and wildlife photographers and a wonderland for tourists from all over the world.

Geographical evidence of the origin of the Sunderbans reveals that the entire bed is a result of alluvial deposition, as there is no trace of marine deposits deep below the ground level. The tidal swamps extend up to the Rajmahal Hills,

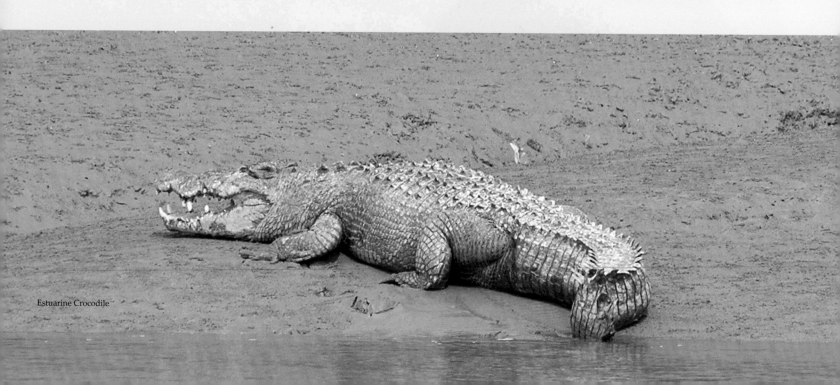

Estuarine Crocodile

situated in Jharkhand, a state in eastern India. These swamps were filled up about 35 million years ago by drainage from the folded mountains of the north. Older sediment started getting covered by the thick alluvium carried down by the rivers. This geological activity resulted in the formation of numerous tiny islands. The eminent geologist, R.D. Oldham, in his study of the region, stated that the entire area of which Sunderbans was a part, took shape owing to the constant deposition of debris carried down by the River Ganges and the River Brahmaputra and their many tributaries.

Research certifies that 200 million years ago, a series of tectonic activities caused the elevations and depressions of the gneissic hills in the Gondwana belt, and coupled with slow deposition of alluvium, spread over a hundred years from the Himalayas, were responsible for the formation of the lower Gangetic delta. The geography of the coastal area and the two flanks of the Sunderbans suggest that sometime in the past, the main flank of the water from the central and eastern Himalayas, after covering a point somewhere in the north of Bengal, started its journey towards the sea through a small channel. Consequently, the fierce velocity of water flooded the adjoining coastal areas, which led to the formation of a large shallow continental shelf in the Bay of Bengal. The deposition of alluvial strata in the continental shelf was accelerated due to the subsequent depression of gneissic hills, which allowed the enormous silt burden to be deposited in the region. The main channel coming down from the Himalayas divided itself into several small channels and took the present shape of innumerable creeks. These creeks are characterized by low depth in comparison to

Royal Bengal Tiger

their width, restricting their capacity to carry the water-load. Studies reveal that for a river to carry the burden of silt, a minimum of 12 cm slope in the riverbed is required. However, in most areas of southern Bengal, the slope of the riverbed is much less. When the River Ganges touches the plains of southern Bengal, after travelling 1800 km, the current tends to become slow allowing the silt to sediment. The islands thus formed continue to maintain an extremely suitable natural biosphere. However, the flatness of the land is a constant threat because even a nominal four-metre rise in the water level can wash out the entire landmass, including Kolkata in the blink of an eye.

Olive Ridley Turtle

According to geologist, J. Fergusson, the entire Bengal basin was a shallow marine land in the early Pleistocene age. During the later part of the Pleistocene age, the sea receded completely from this region. The bulk of alluvial deposits carried by the rivers covered the marine sediments. There are thus numerous theories regarding the origin of the place, some acceptable, others shunned. Nonetheless the few core and inherent characteristics which have the bewitching power to make anyone fall in love with the place and have been instrumental in making the Sunderbans unique, include its faunal treasure, the people and their culture, the complex riverine system, the eerie atmosphere of the mangrove forests and last but not least, the elusive Royal Bengal Tigers.

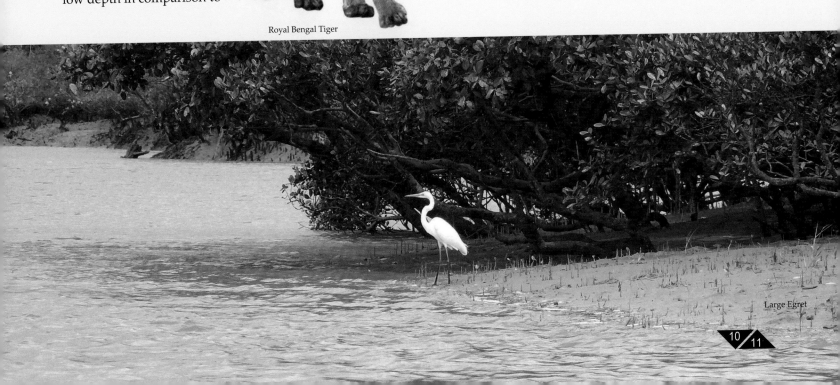

Large Egret

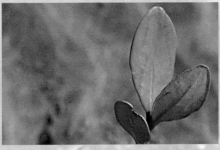

The
Desperate *Delta*

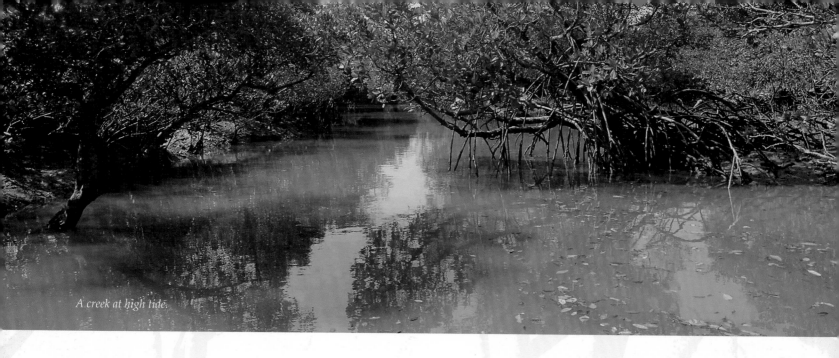

*A creek at high tide.*

The entire Bengal region may be considered a Gangetic delta. It has been formed by the deposition of silt carried down mainly from the Himalayas and partly from the Rajmahal Hills of Chhotanagpur plateau in Jharkhand. Innumerable creeks and channels criss-cross the deltas, which extend up to the sea face of the Bay of Bengal. It is a continuous process and will go on as long as the Ganga and the Himalayas exist. As the tributaries of the two mighty rivers, Ganga and Brahmaputra join the sea, the entire ecosystem experiences two high and low tides. Both these tides follow each other at an interval of six hours.

Some people are of the opinion that the forest derives its name from the *'Sundari'* trees found there. But surprisingly, *'Sundari'* is not a predominant tree of this forest. The other opinion is, however, more pertinent, which says that *'sunder'* in Hindi and Bengali means beautiful and *'bon'* means forest. Hence, it is called so.

Of the 102 islands, 54 are inhabited by humans, and the rest are forests. The Sunderbans is a mangrove forest, locally known as *'badabon'*. It is the only forest where one can witness tidal water dancing throughout the day.

*The level of water rises quite high during high tide. When the tidal water recedes, it leaves mud marks on the trees.*

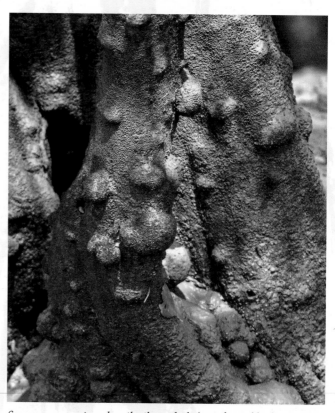

*Some mangrove trees breathe through their perforated barks instead of roots.*

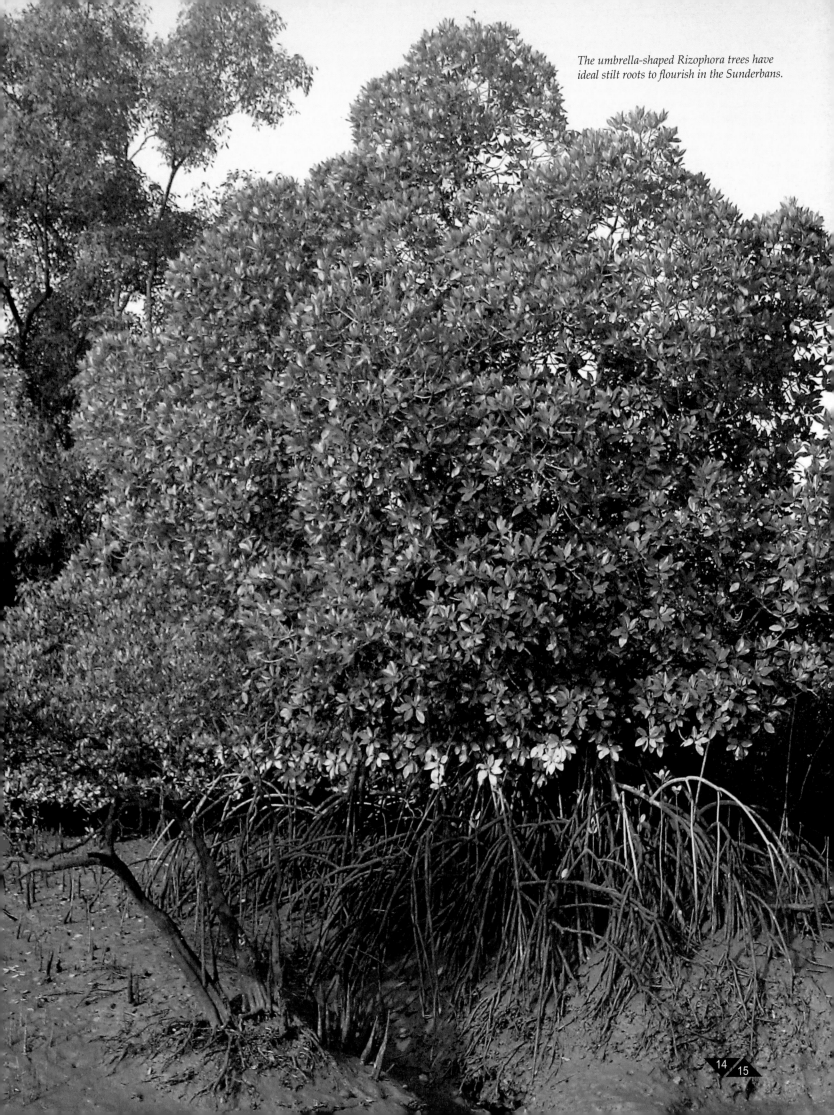

*The umbrella-shaped Rizophora trees have ideal stilt roots to flourish in the Sunderbans.*

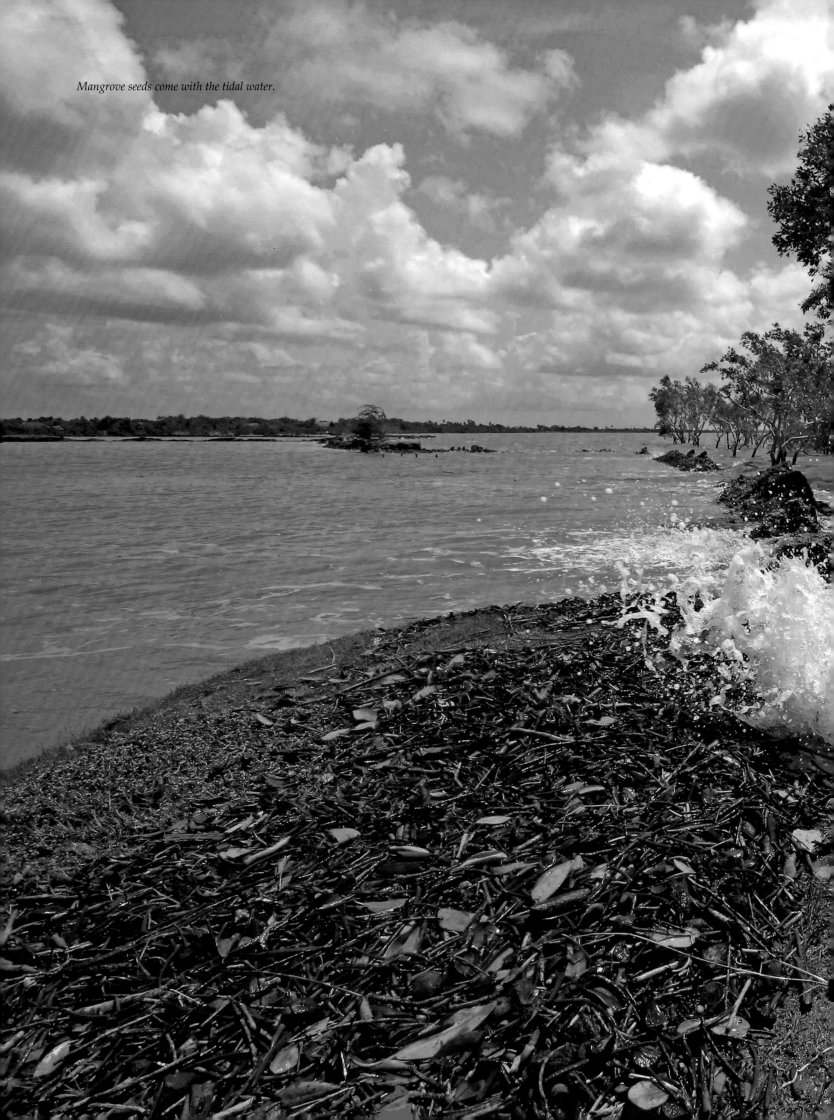

*Mangrove seeds come with the tidal water.*

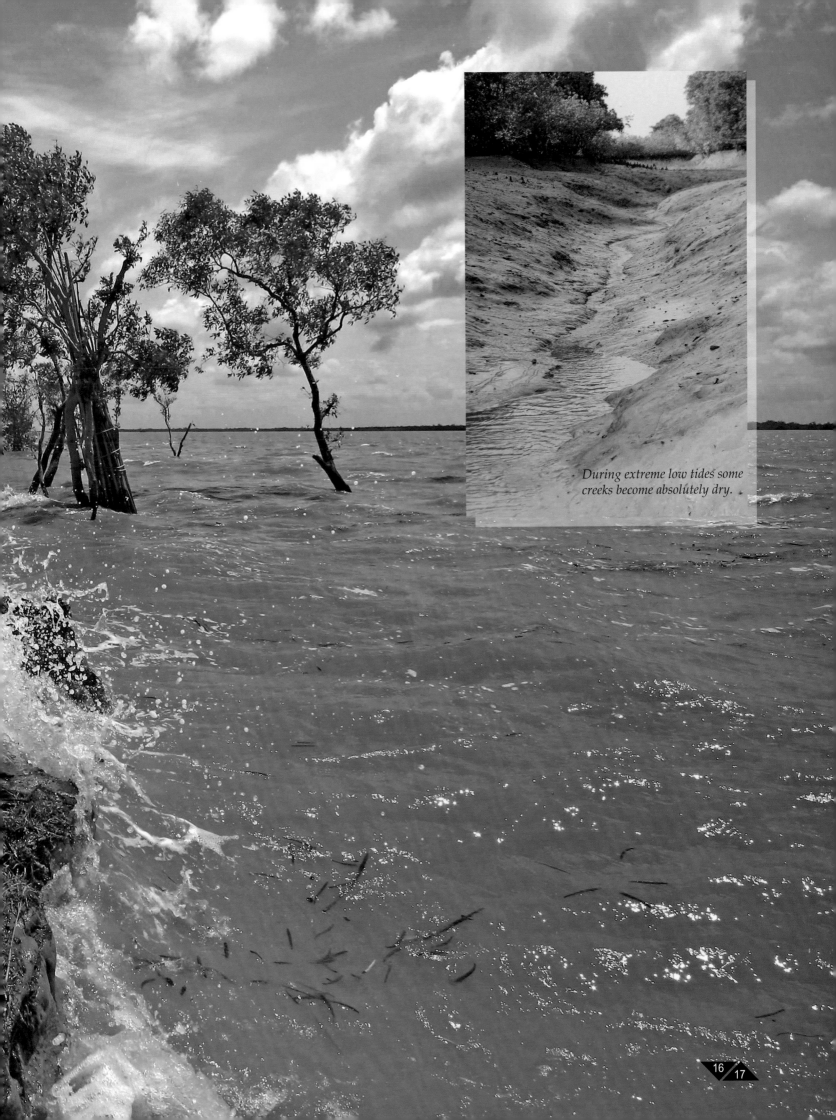

*During extreme low tides some creeks become absolutely dry.*

# 'Sunder' in Hindi and Bengali means beautiful and 'bon' means forest.

The forest is inaccessible due to the presence of pneumatophores, stilt roots and chest-deep alluvium. The Sunderbans consist of habitat and habitation. Its water, forest, soil, air—all have a distinct flavour and character unmatched by any other place on earth.

It is an experience of a lifetime to listen to *Bhatiali* (a Bengali folk tune), sung by fishermen on distant boats during a moon-flooded night. Shoals of fish play around in the tidal creeks and rivers. Hence, it is considered to be a paradise for fishermen.

Due to a rise in the level of the riverbeds and siltation in the upper streams of the Ganges, the rivers and tributaries that flow within the Indian Sunderbans carry more silt in water compared to the Bangladesh Sunderbans. As a result, more saline seawater enters the Indian Sunderbans, which has a threatening impact on the mangrove communities.

Some major rivers that traverse through the Sunderbans from west to east are Saptamukhani, Thakuran, Matla, Bidyadhari, Guasaba, Raimongol, Ichamati, Jhilla, Jamuna, Bhairab, Kapotaksha, Madhumati, Sibsa, Passar, Bhola and Meghna.

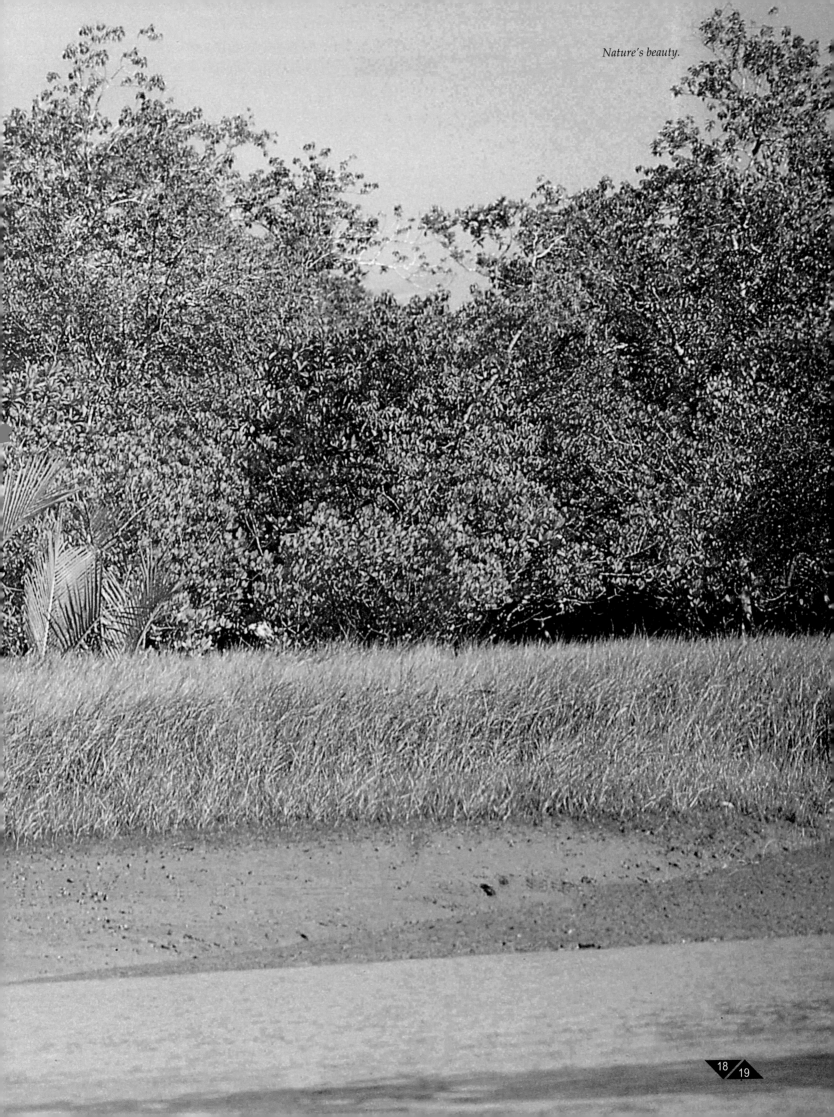

_Nature's beauty._

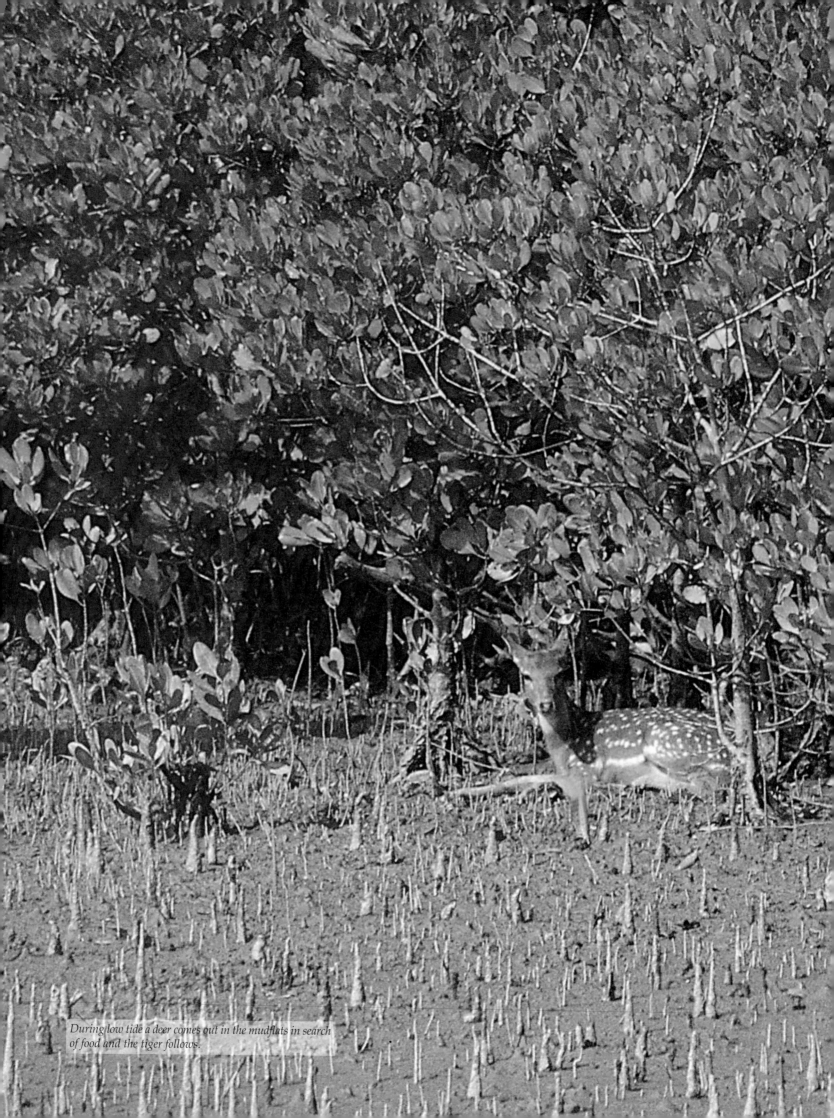

*During low tide a deer comes out in the mudflats in search of food and the tiger follows.*

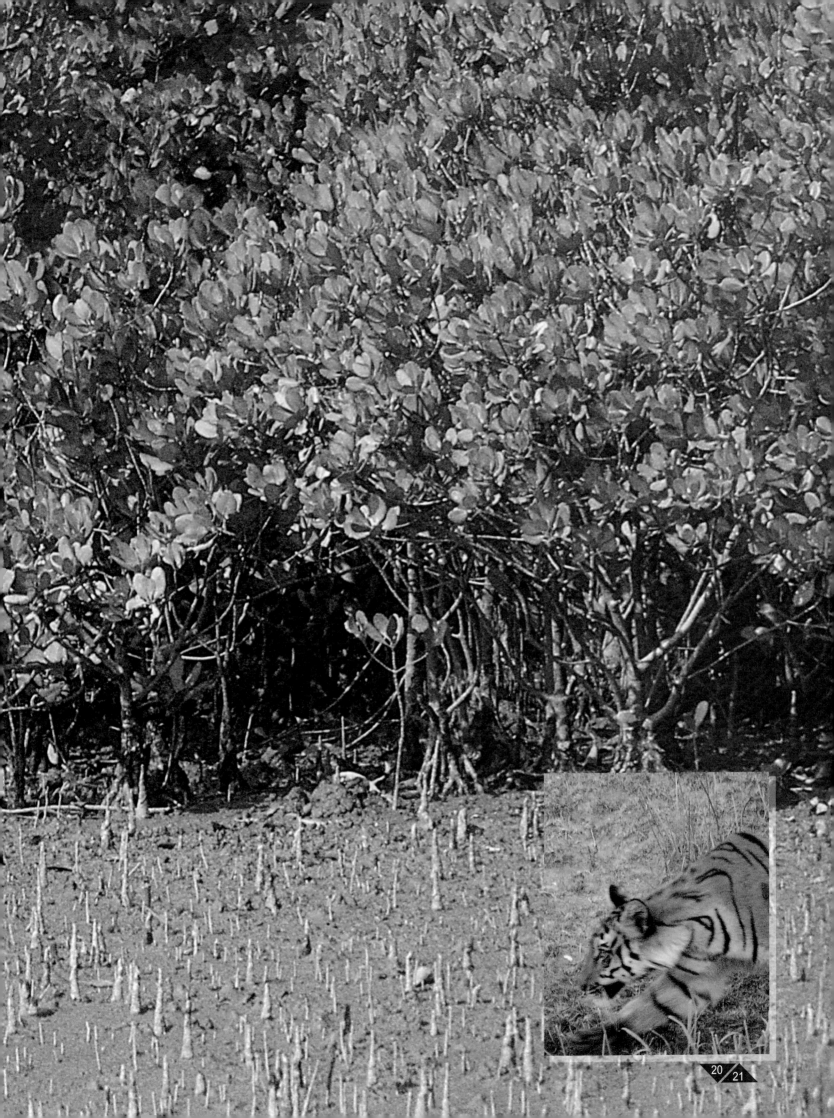

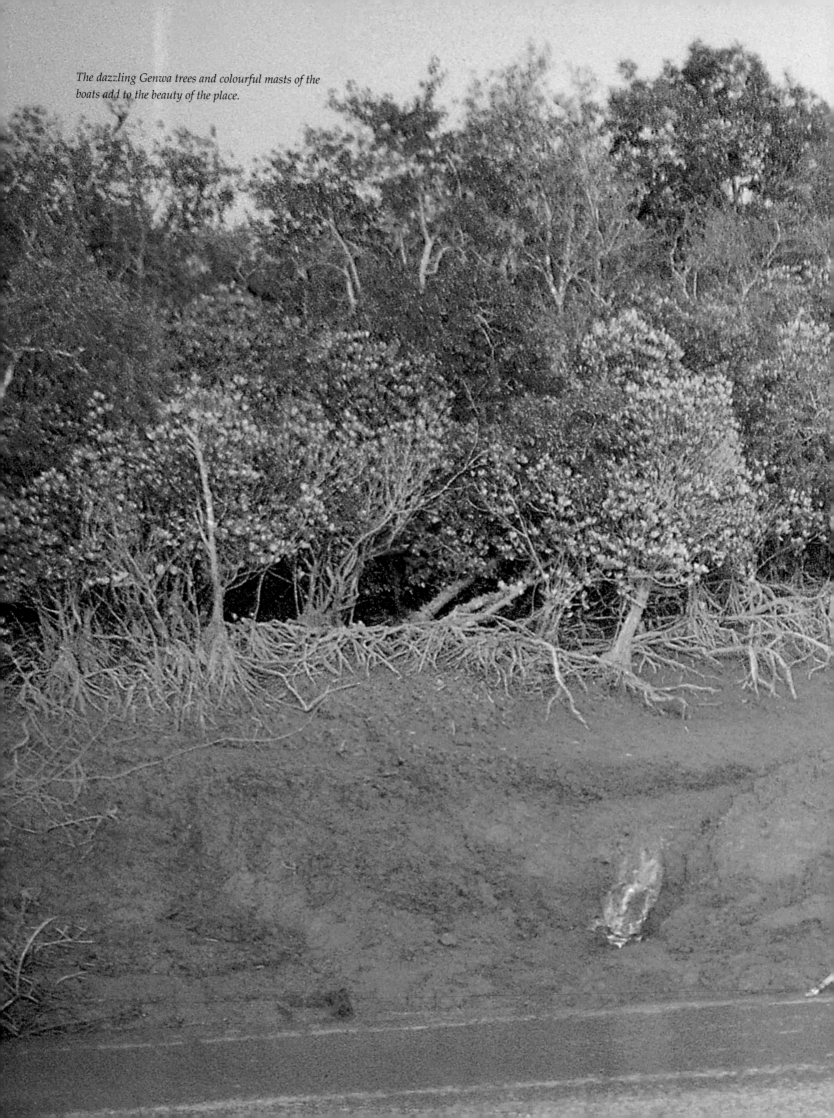

*The dazzling Genwa trees and colourful masts of the boats add to the beauty of the place.*

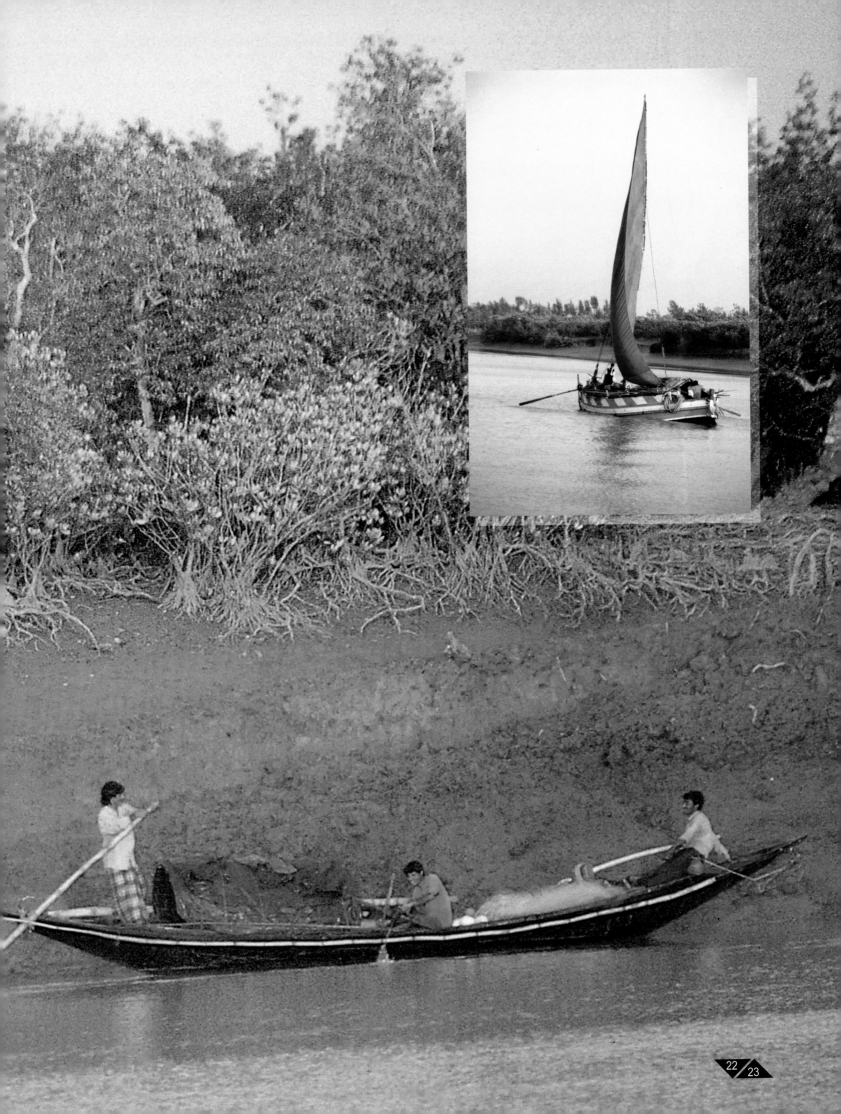

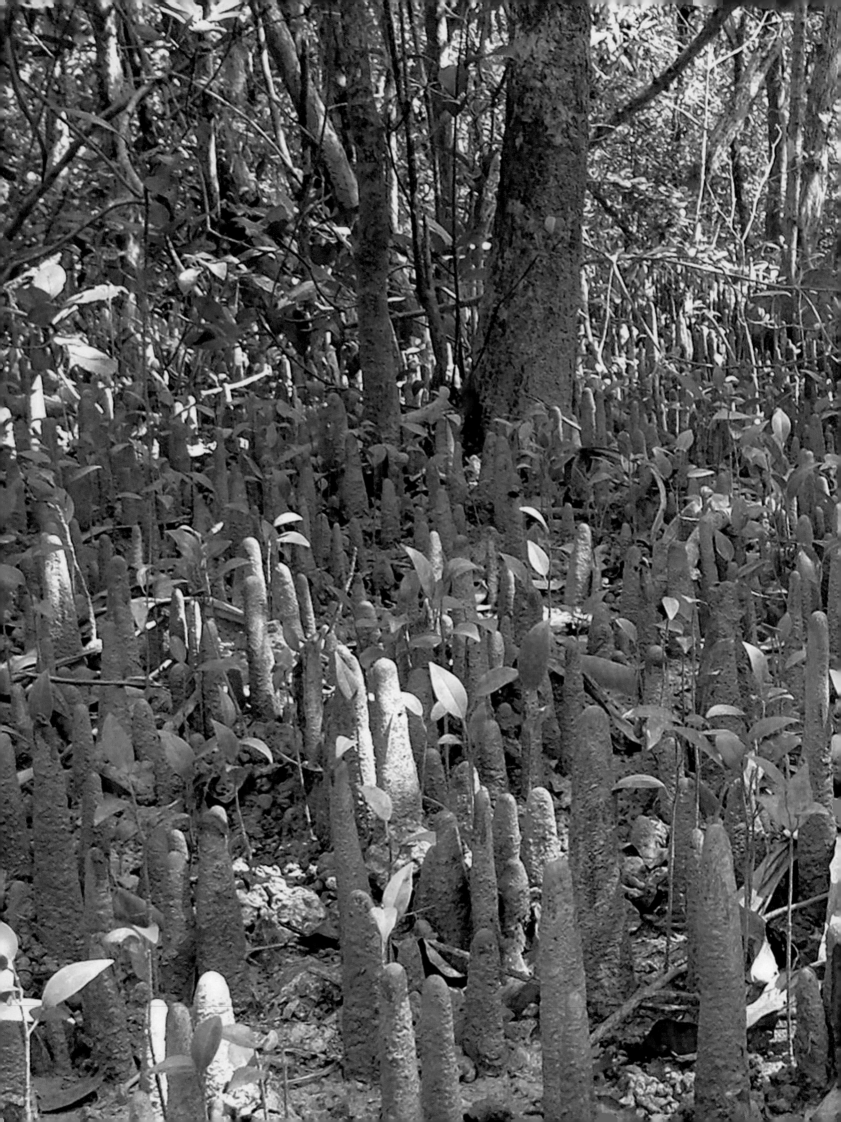

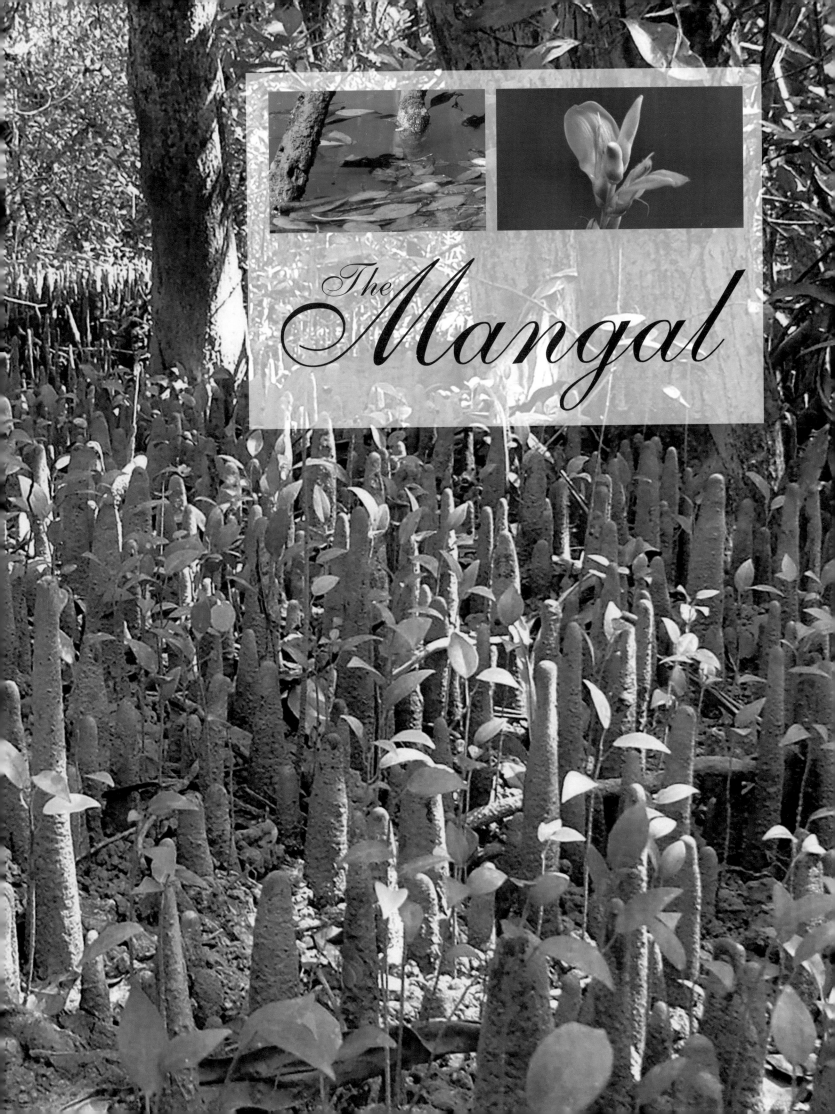

# The Mangal

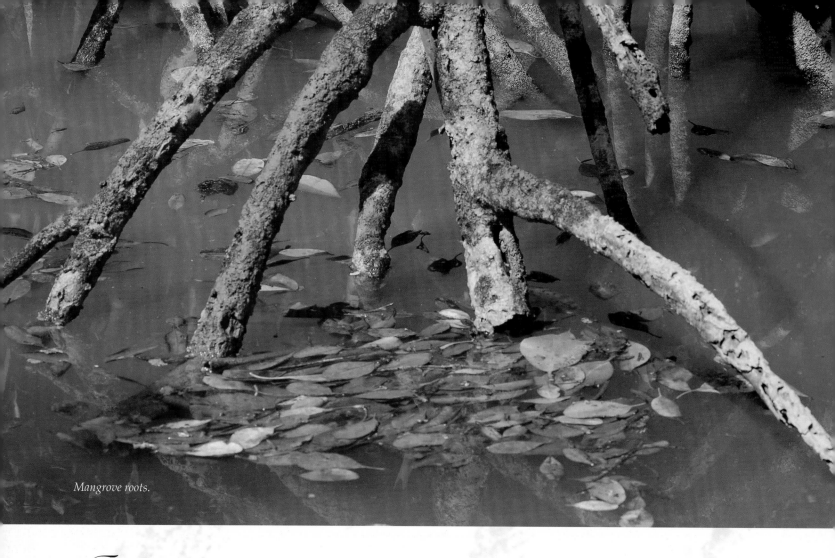

Mangrove roots.

The Sunderbans are the largest mangrove belt in the world. Mangroves may be simply referred to as a community of trees and shrubs, which grow in the particular inter-tidal ecosystem of the tropics. They may also be considered a self-maintaining coastal, inter-tidal estuarine component, which thrives due to constant interaction with the terrestrial and marine ecosystem. The word *'mangrove'* is a combination of the Portuguese word *'mangaue'* meaning individual mangrove tree or bush, and

The Keya is not a true mangrove.

the English word *'grove'*, meaning thicket or forest. The word *'mangal'* is also used sometimes to explain the term mangrove. Literally it means the community, and is used to signify the mangrove community as a whole.

In order to avoid confusion, William Macnae, an ecologist, in1968 stated that the term 'mangrove' would signify halophytic plant species, while the entire forest community including micro and macro-organisms will be considered as *'mangal'*. The *'mangal'* and its associated biotic factors constitute an ideal mangrove ecosystem.

Germination of seeds into seedlings while attached to the parental plant is known as viviparous germination. It is another important adaptation of the mangroves. Some of the seedlings can float on the water surface for more than a year in appropriate ecological conditions. These seedlings eventually get implanted in the suitable muddy substratum and grow into individual plants.

The inherent features of most of the mangrove species are glassy, leathery, dark, evergreen leaves with deeply embedded stomata and aqueous tissue, which help minimize transpiration. Root systems with numerous lenticels along with stilt roots and pneumatophores are few of the other characteristic features that distinguish these plants from those found in other climatic conditions.

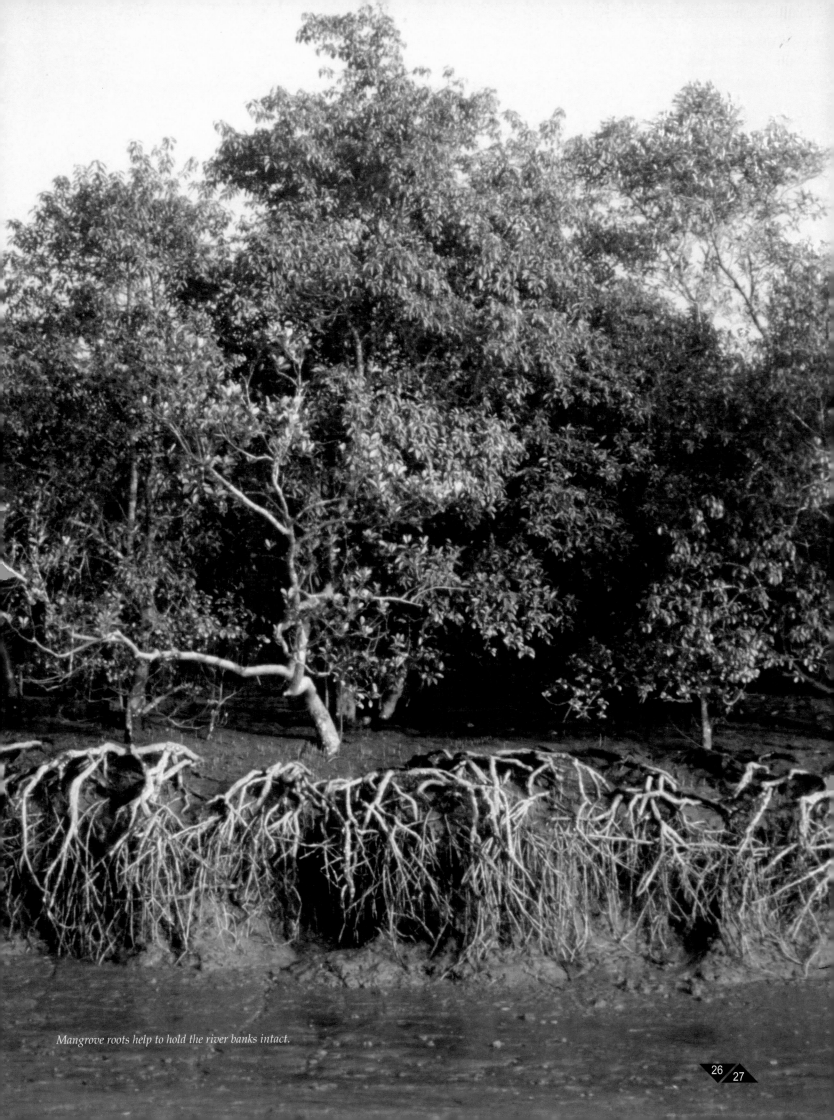

*Mangrove roots help to hold the river banks intact.*

# Mangrove forests tend to grow only in areas where sediments continually accumulate.

Salinity, sandy soil, lack of nutrients, weather hazards such as cyclones and floods are a few of the challenges faced by each and every species in the Sunderbans. However, the presence of these adverse conditions and the constant struggle for existence with the alien environment has a positive side to it too. Only those species that can tolerate these extreme biotic conditions and withstand the high salinity, tidal effects and periodic inundation, are able to survive and flourish.

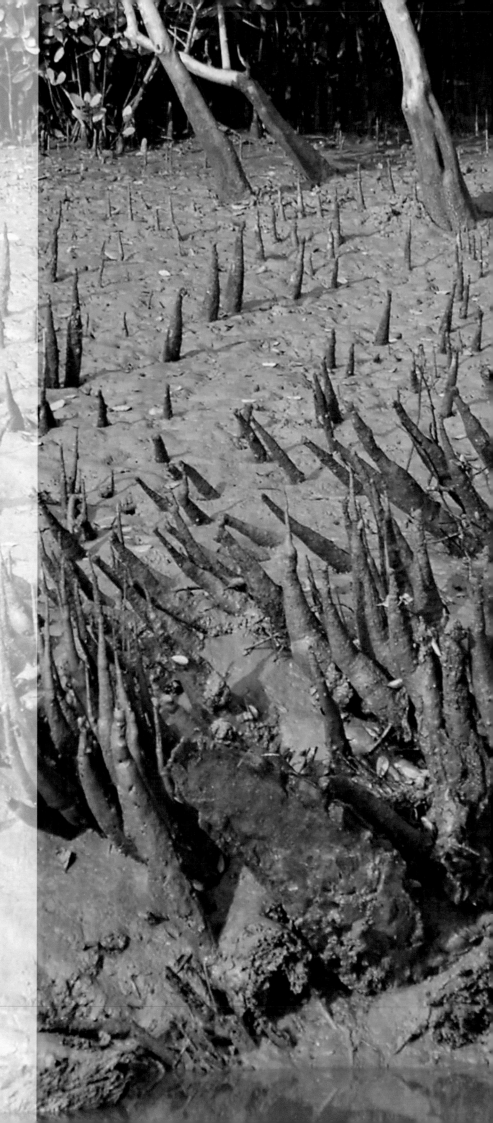

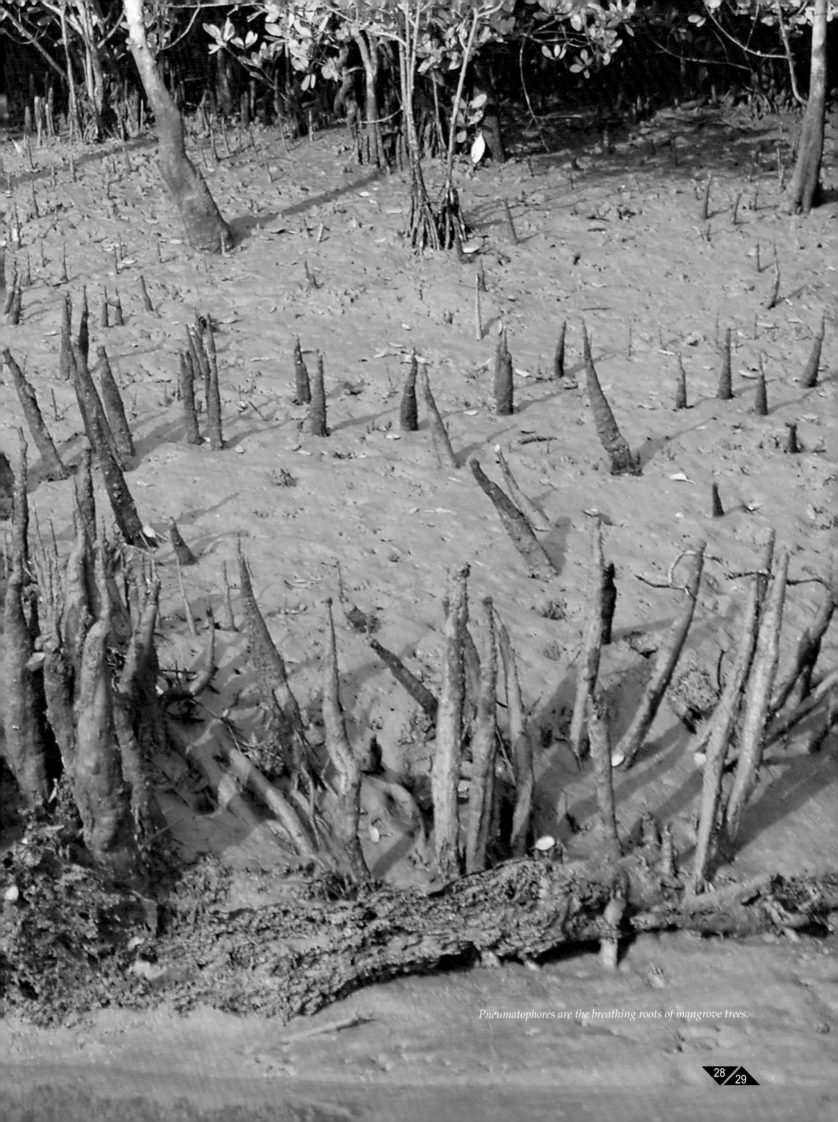

*Pneumatophores are the breathing roots of mangrove trees.*

## ROOTS

The mangroves share the shore with salt-marsh plants that have the ability to maintain a suitable water balance in spite of the salinity present in the seawater. Some of these plants excrete salt through their leaves. Tap roots are not of much use under such conditions, since the mud is poorly aerated. The upper layers under the surface of the mud contain no oxygen, only poisonous hydrogen sulphide. The trees are largely supported by prop roots or by flat root systems that spread out just under the surface of the mud. Trees like *Avicennia* and *Sonneratia* have evolved special aerial roots to ensure that the deeper roots receive their supply of oxygen. The roots of *Bruguiera* arch above the surface here and there, appearing almost like knees and also perform similar functions. The fine root hairs of the mangroves can absorb nutrients only from the uppermost, oxygenated layer of the mud. However, since mangrove forests tend to grow only in areas where sediments continually accumulate and the anaerobic zone steadily rises, the upward growth of roots has to keep pace with the progressive sedimentation. Aerial roots and knee roots are adaptations that have taken place to cope with these conditions.

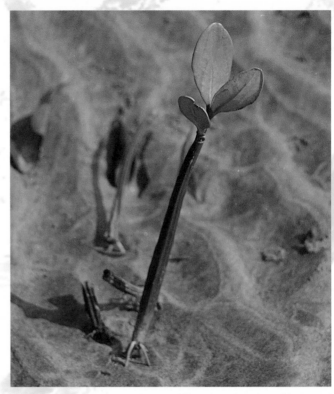

*Pointed fruits from the Kankra tree fall on the soft and muddy ground and stick out like spikes. This leads to germination. Sometimes these fruits get carried away by the river water and germinate on newer grounds even after a year.*

*Upward growing roots—a common sight in the Sunderbans.*

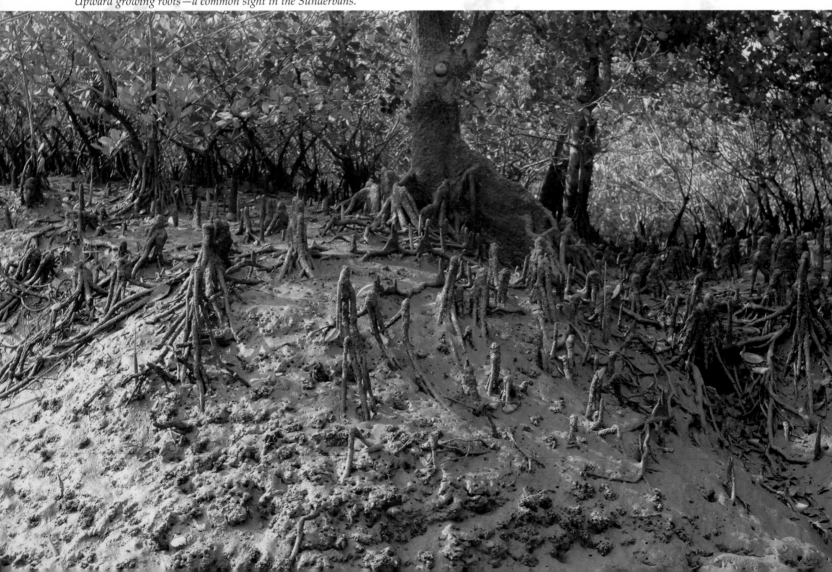

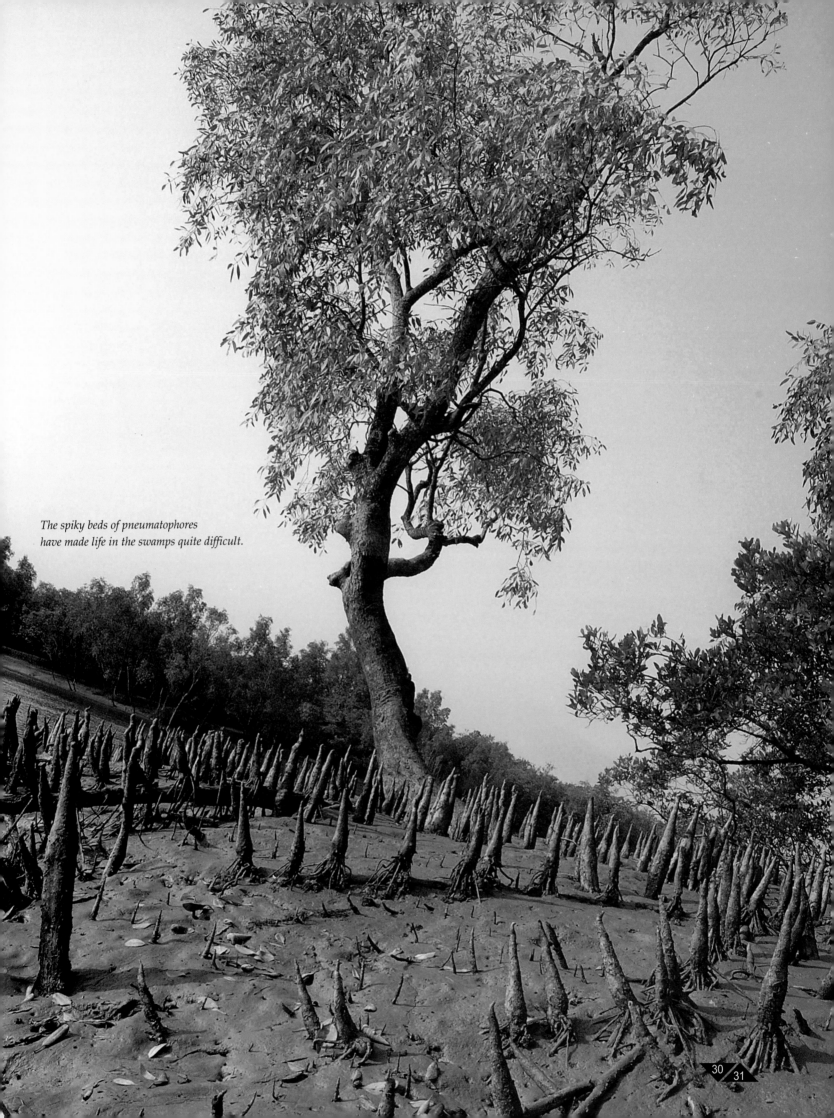

*The spiky beds of pneumatophores have made life in the swamps quite difficult.*

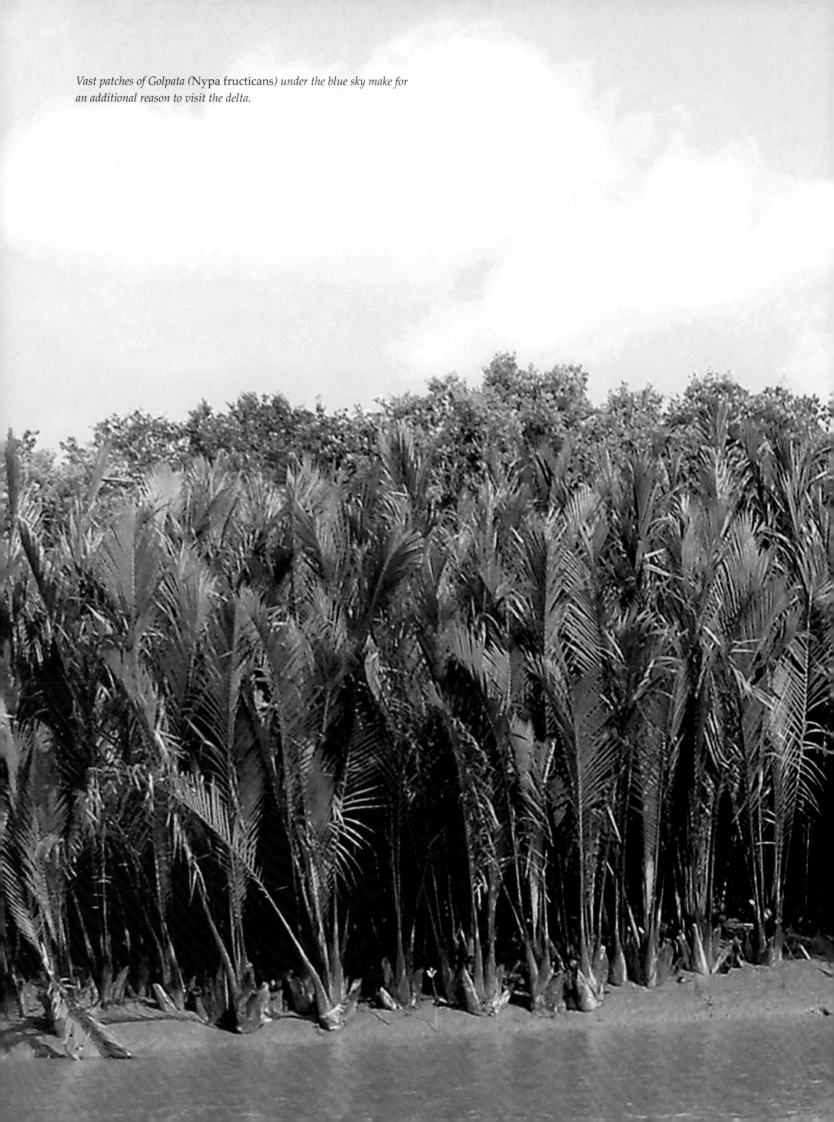

*Vast patches of Golpata (Nypa fructicans) under the blue sky make for an additional reason to visit the delta.*

1. *Sweet and sour fruits of the Keora are favourites of monkeys and deer.*

2. *'Sundari' in Bengali means pretty and the flowers of this tree corrobrorate this further. According to one theory, the Sunderbans have been named after the Sundari trees.*

3. *Ora is an unusual tree of this mangrove forest.*

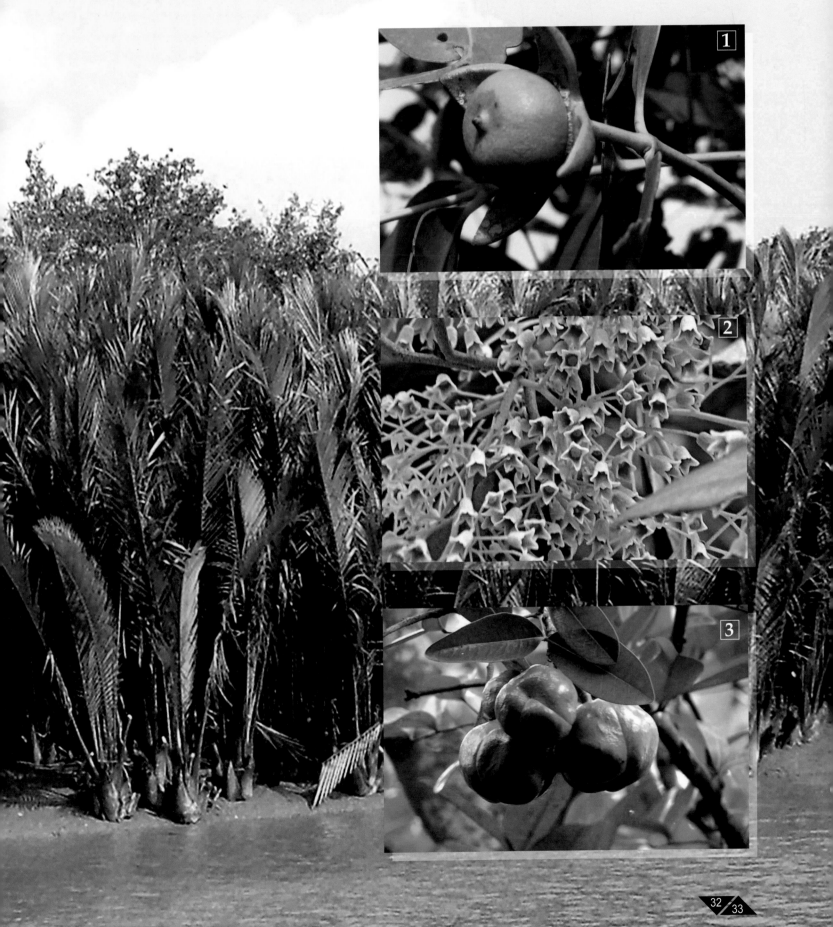

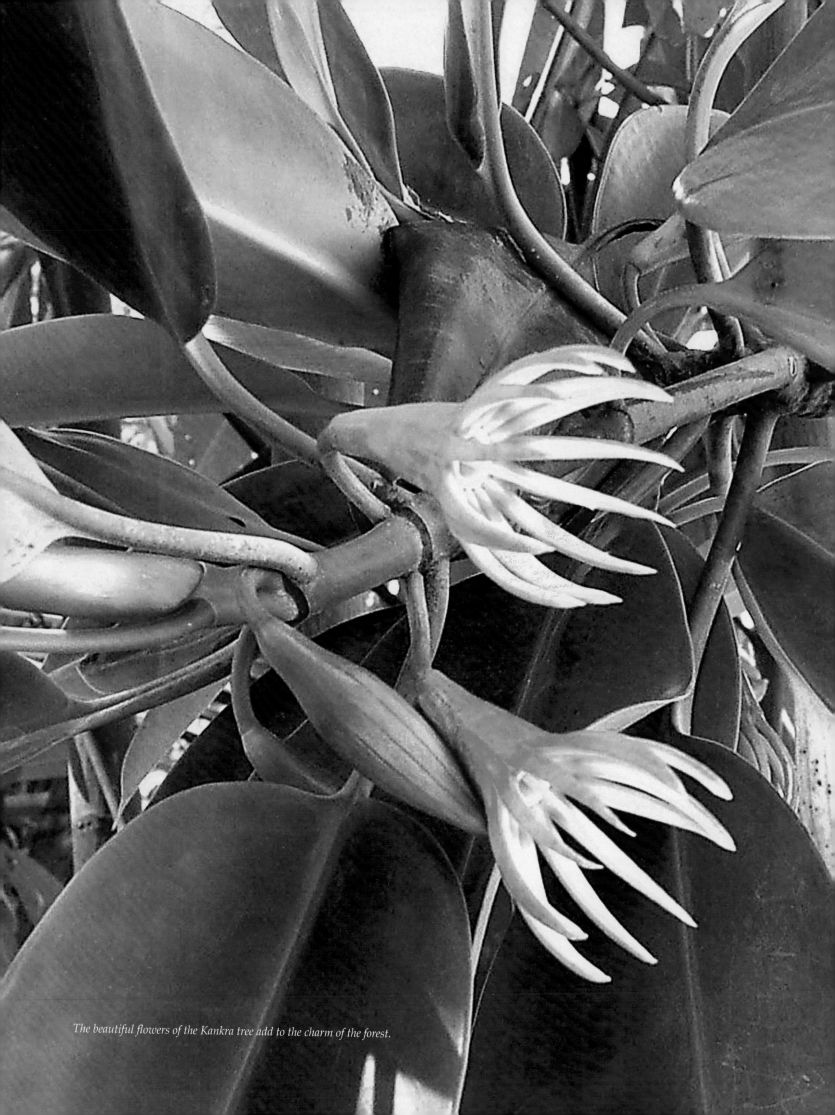

*The beautiful flowers of the Kankra tree add to the charm of the forest.*

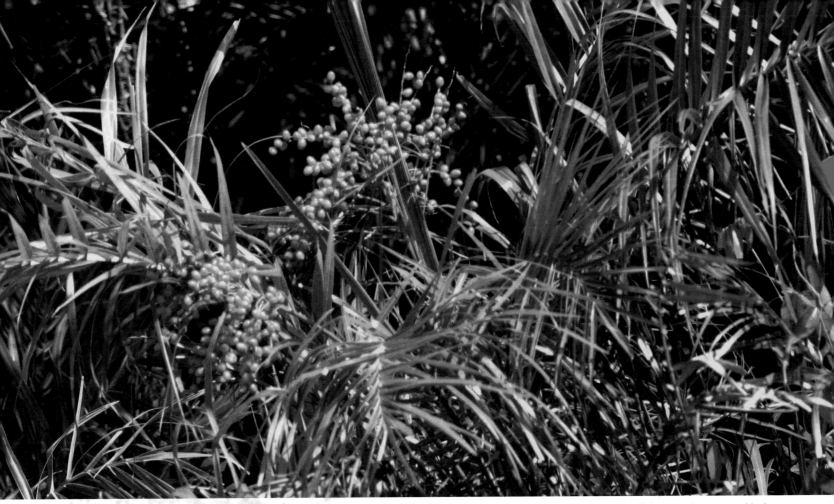

*Fruits of the Hental tree resemble dates.*

Ideal stilt root structures can be seen in Garjan (*Rhizophora*) trees. It has the greatest potential to hold the banks intact.

Passur (*Xylocarpus granatum*) has the tallest pneumatophores. Bain (*Avicennia*), Keora (*Sonneratia apetala*), and Kankra (*Bruguiera sp.*), all have pneumatophores of different sizes and shapes.

The Genwa (*Ecoecaria agallocha*) tree breathes through its bark and therefore has a perforated stem.

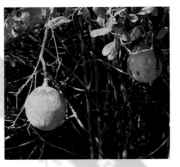

*The round-shaped fruit of the Dhundul contains three seeds inside. The fruit is not enjoyed by animals.*

## FRUITS AND FLOWERS

Mangrove trees of the Sunderbans bear fruits of different shapes and sizes throughout the year. Fruits of the Keora tree are small in size and are a favourite among monkeys and deer since they prefer a sweet and sour taste. On the other hand, the Dhundul fruit is round and big with three triangular seeds and is mostly avoided.

The period between end-February and mid-September is when most trees blossom with flowers and bear fruit. Honeybees fill their beehives with honey. During these months, the forest is a riot of colours with the multi-hued flowers and fruits.

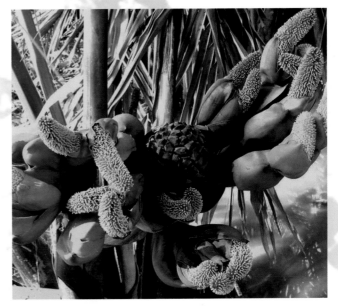

*Golpata flowers are huge and an extraordinary sight when in full bloom.*

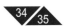

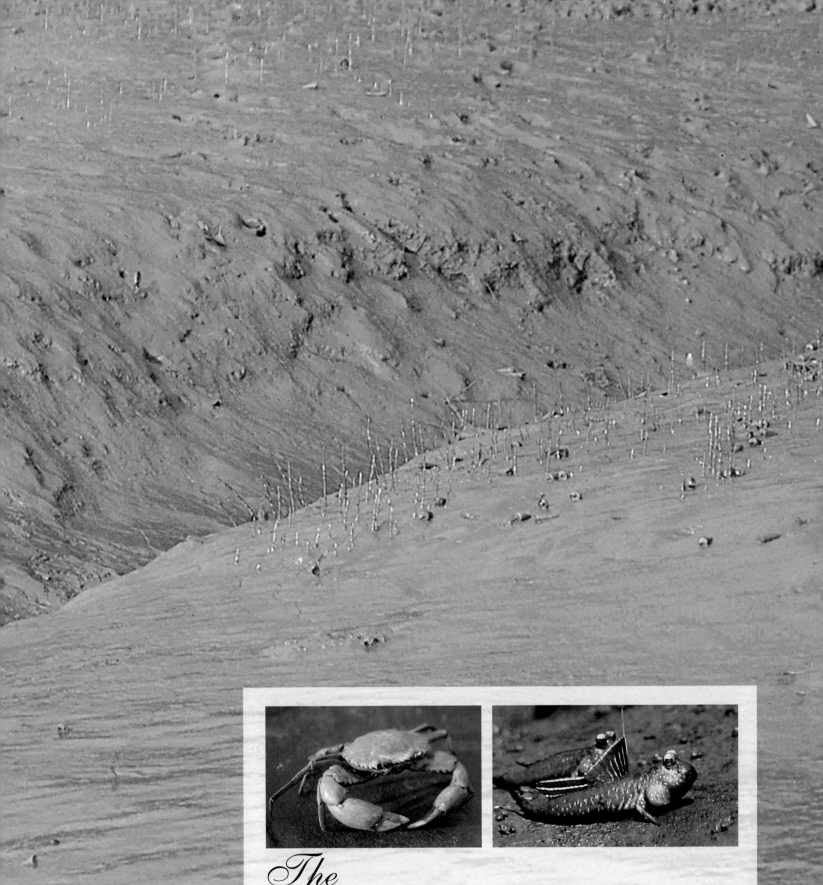

# The Vibrant Mudflats

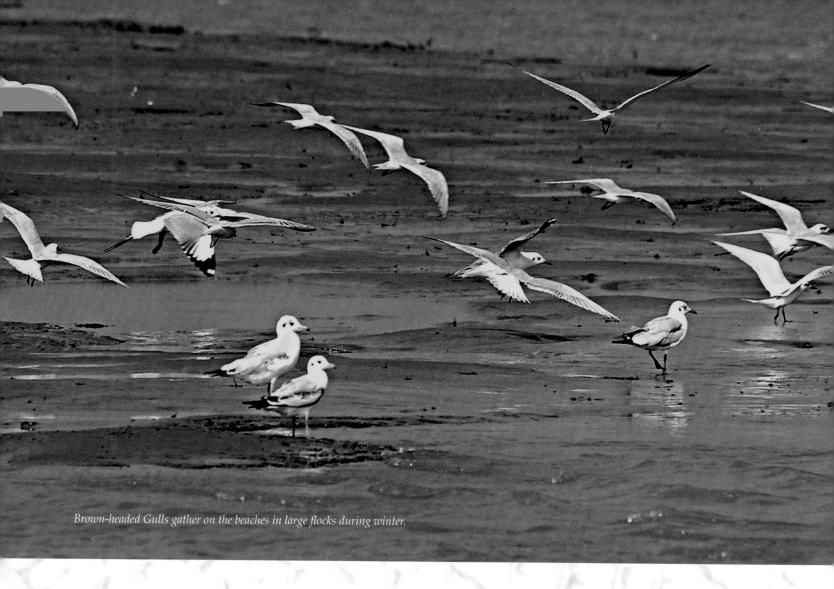

*Brown-headed Gulls gather on the beaches in large flocks during winter.*

When the tidal water recedes, a vast amount of alluvium is left behind. It gives rise to mudflats on the banks of rivers, creeks and channels. The mudflats are vibrant with life as most animals use it as a feasting ground.

Mud-crabs come out of their holes, Tree-crabs climb down the trees and the Swimming-crabs swim ashore to partake of a grand feeding session of the dead and live organisms that have been carried to the banks by the tidal waves.

Large, Median and Little Egrets, Pond, Grey and the rare Goliath Herons, Whimbrels and Curlews, Redshanks and Greenshanks, different gulls and terns, Godwits, Dunlins, Sandpipers, Snipes, Thick-knees and many other wading birds are seen engrossed in search of fishes and molluscs on the mudflats and in the river water.

The Mudskipper, though a type of fish, does not resemble one. During high tide, it hides itself inside the muddy burrows and only when the water level recedes and the mudflats are exposed, it comes out of its hole in search of food.

Organisms like bacteria, algae and fungi play a pivotal role in preparing a soft bed on the mudflats for other organisms to thrive.

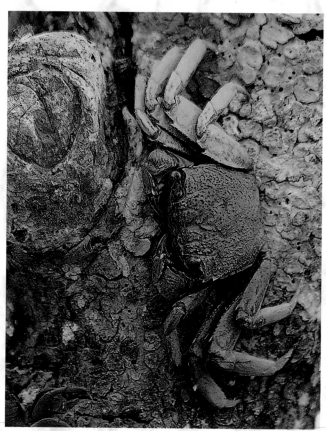

*During high tide, Tree-crabs crawl up the tree trunks and when the water recedes, they return to the mudflats.*

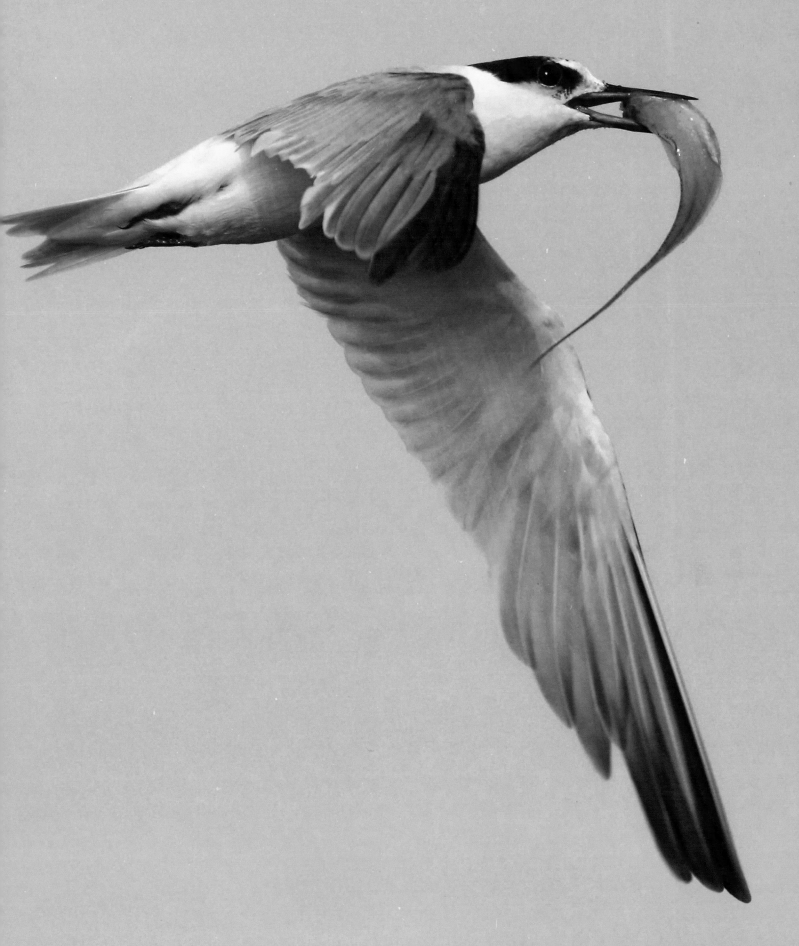

*Brown-headed Gull*

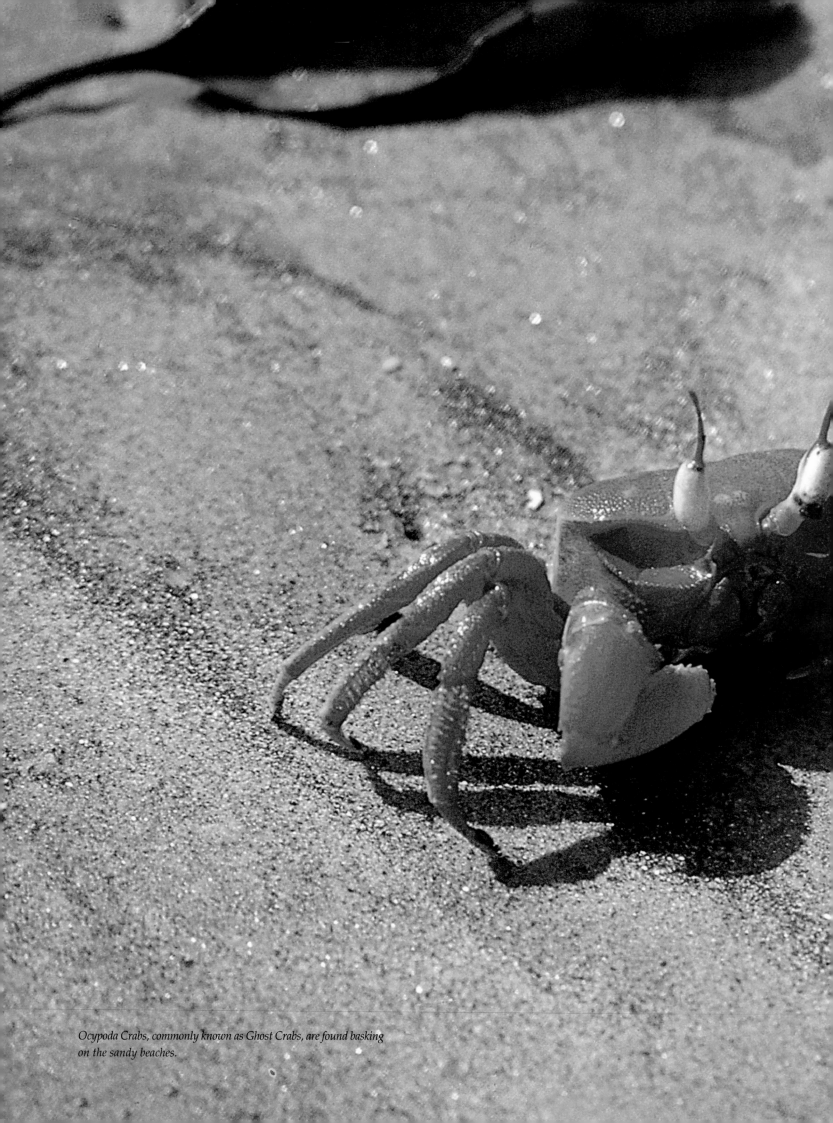

*Ocypoda Crabs, commonly known as Ghost Crabs, are found basking on the sandy beaches.*

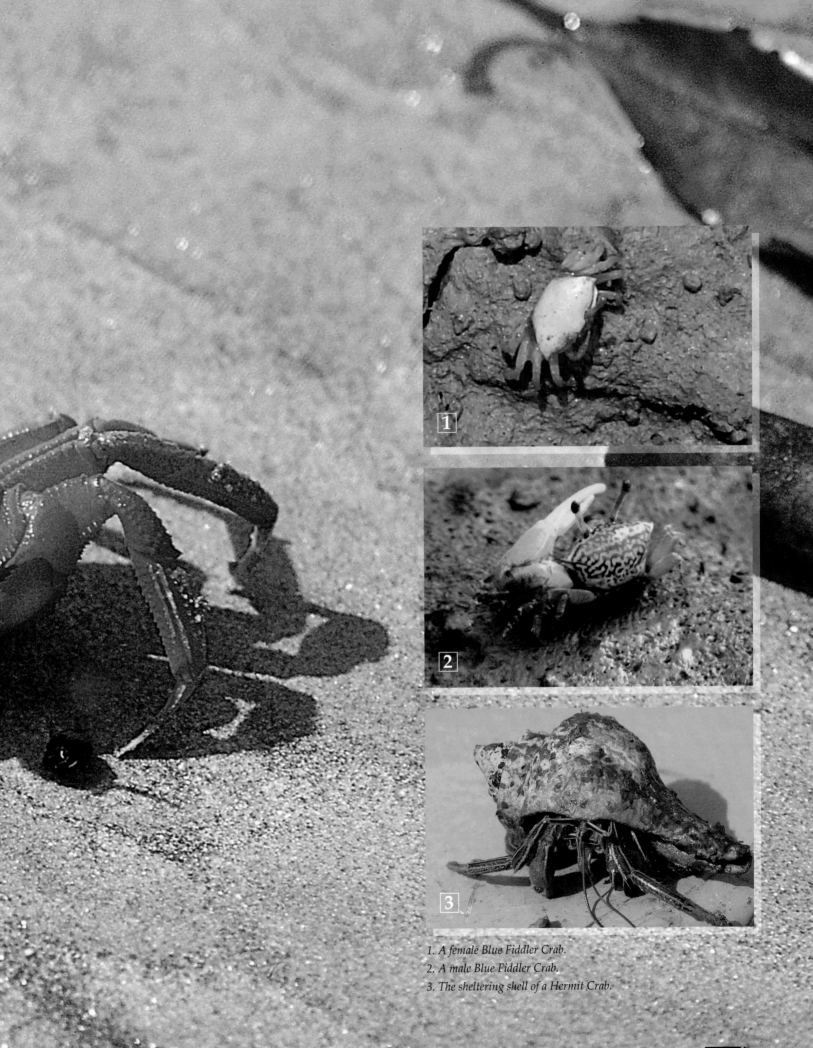

1. A female Blue Fiddler Crab.
2. A male Blue Fiddler Crab.
3. The sheltering shell of a Hermit Crab.

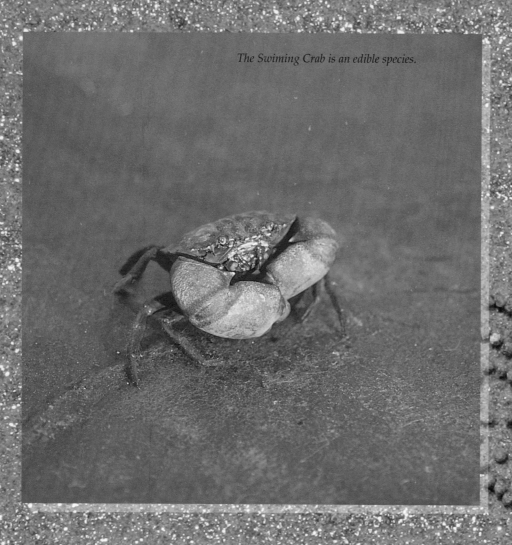

*The Swiming Crab is an edible species.*

*Each crab trail pattern is distinct from the other and plays a pivotal role in its study. The sandy beaches are an ideal study ground for crab researchers where the presence of numerous species of crabs can be gauged, based on the trail they leave on the shores.*

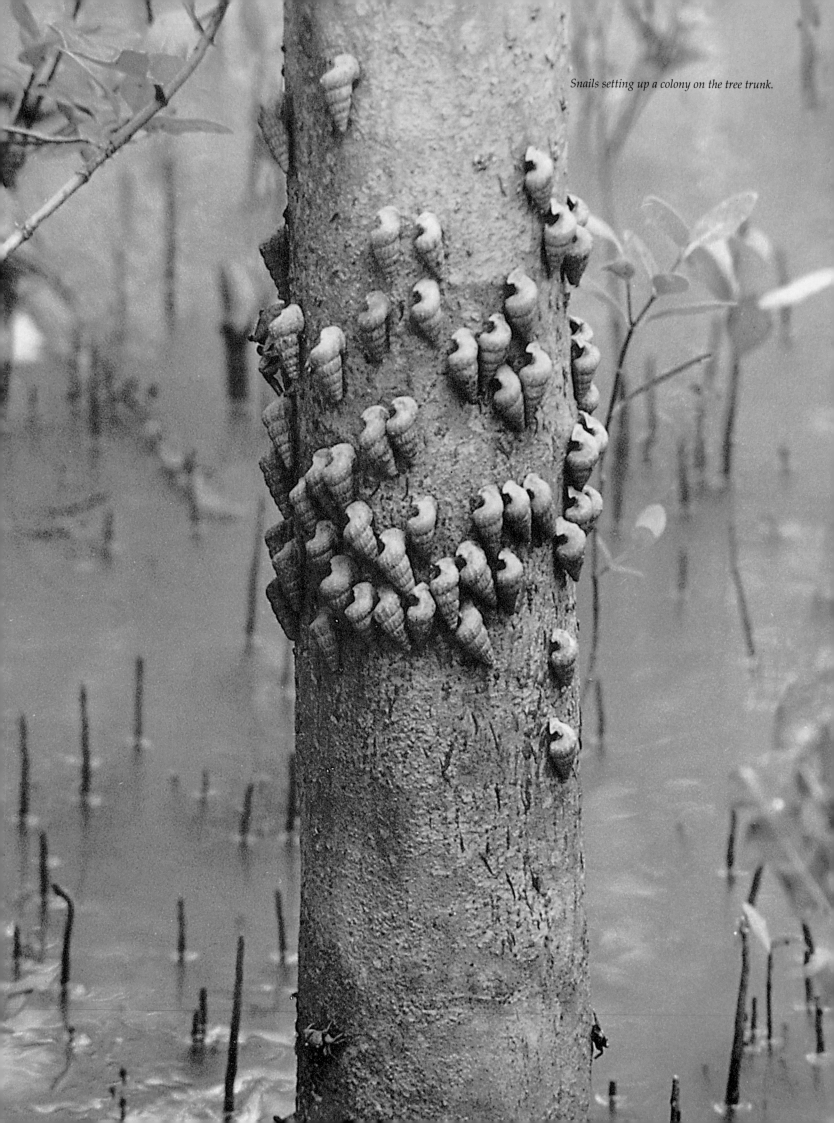

*Snails setting up a colony on the tree trunk.*

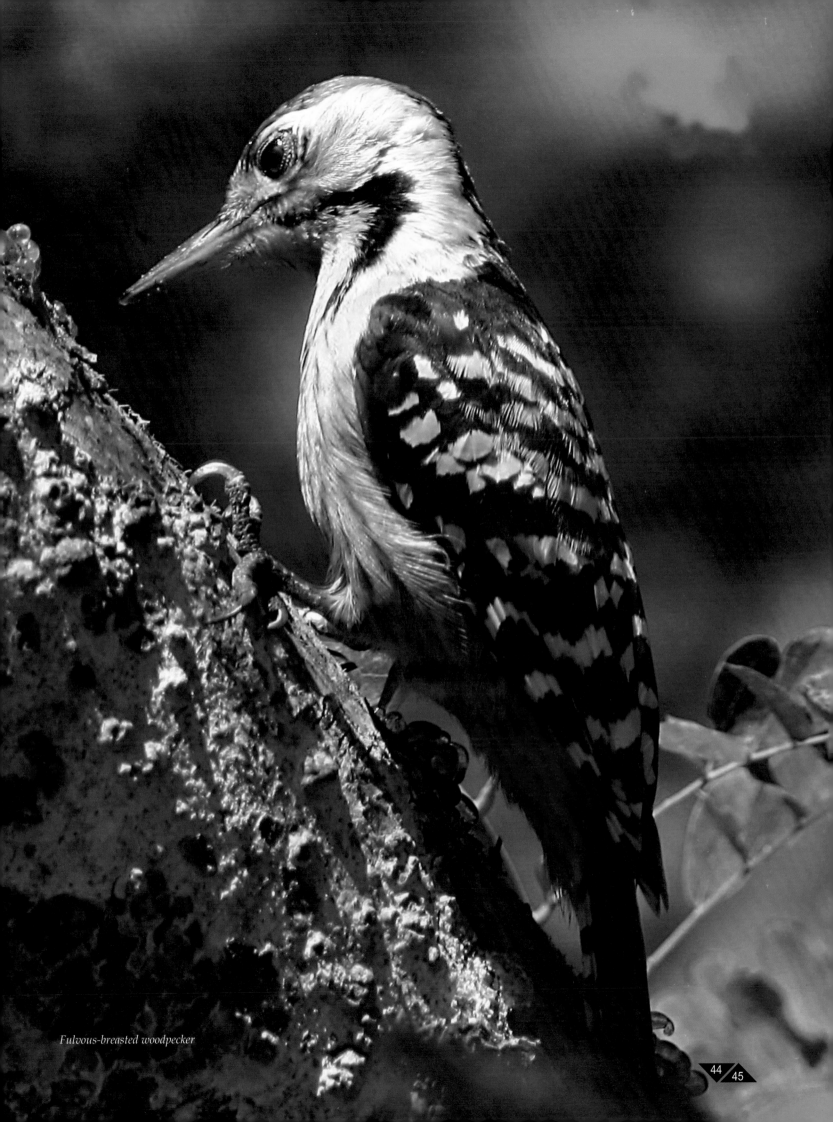

*Fulvous-breasted woodpecker*

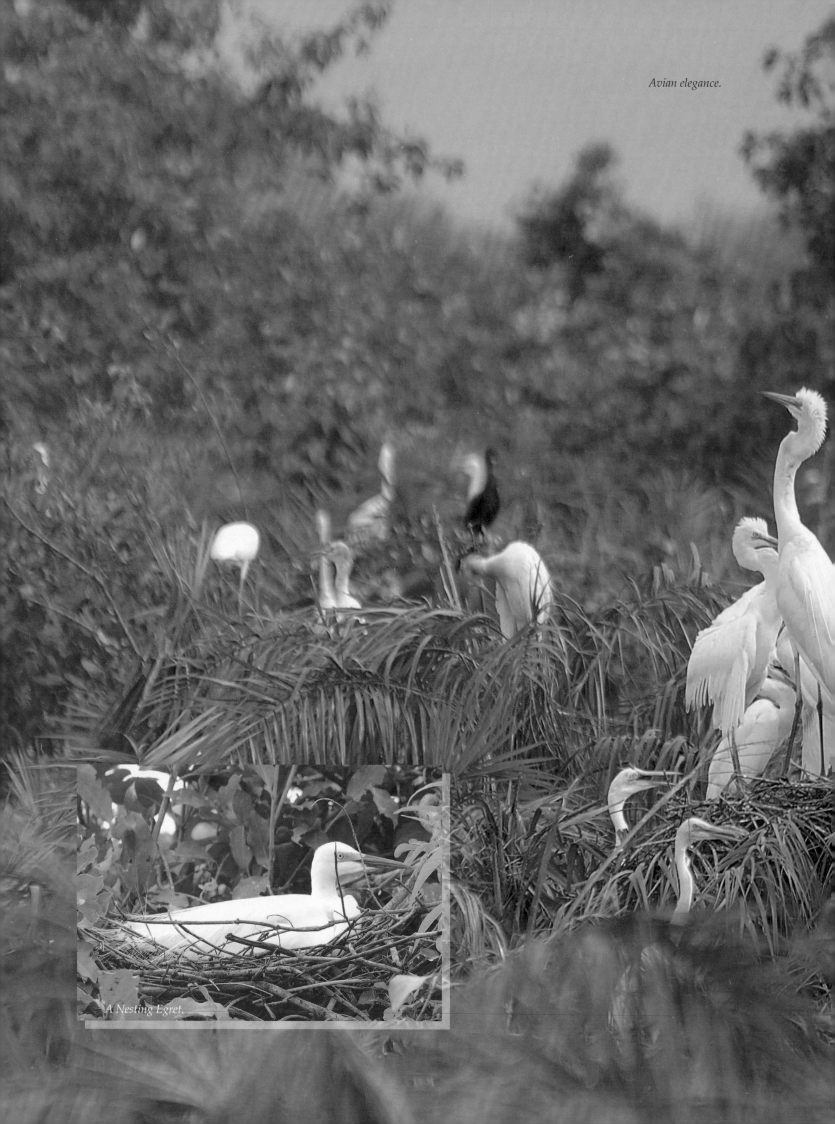

*Avian elegance.*

*A Nesting Egret.*

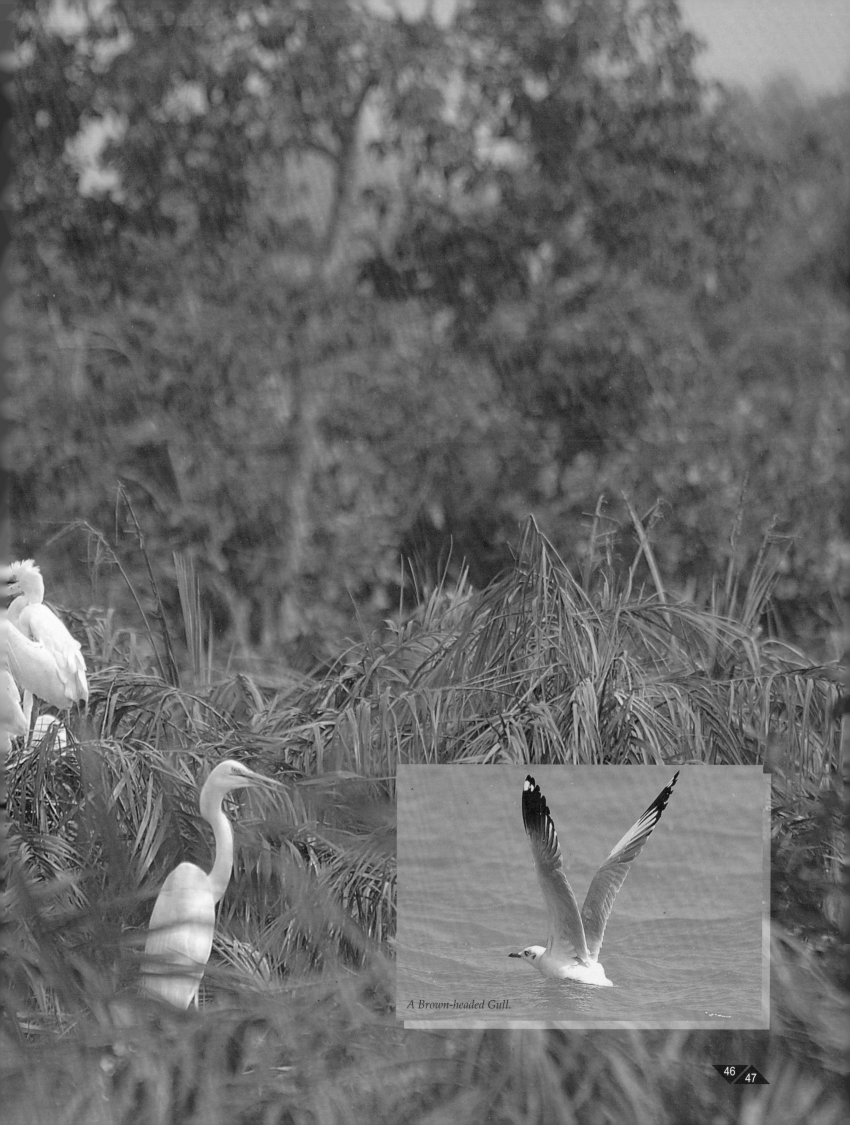

*A Brown-headed Gull.*

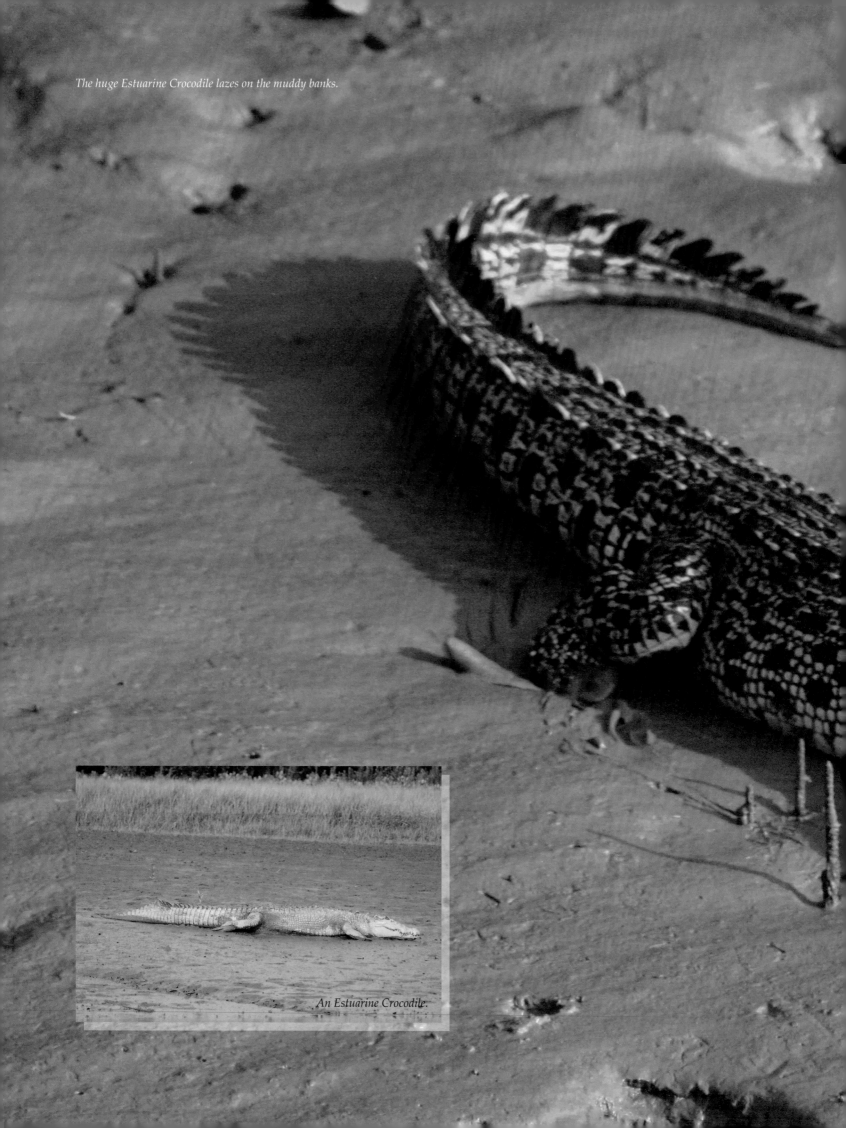

*The huge Estuarine Crocodile lazes on the muddy banks.*

*An Estuarine Crocodile.*

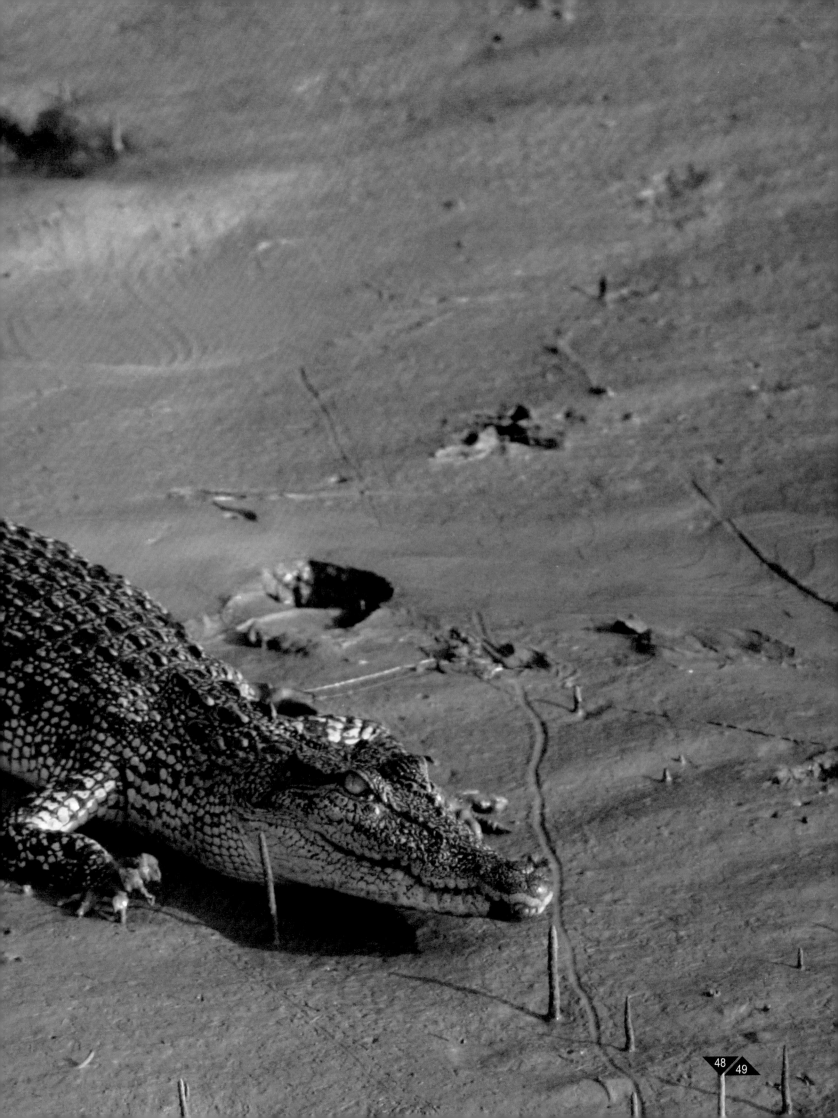

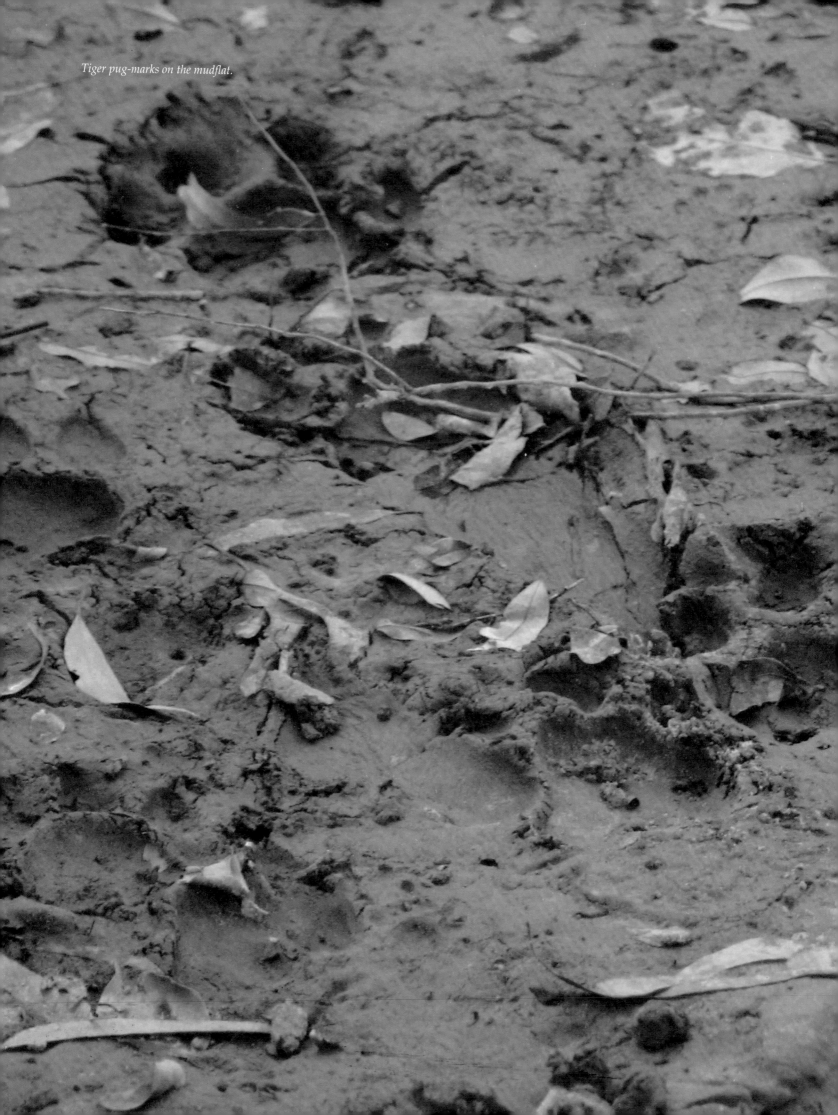

*Tiger pug-marks on the mudflat.*

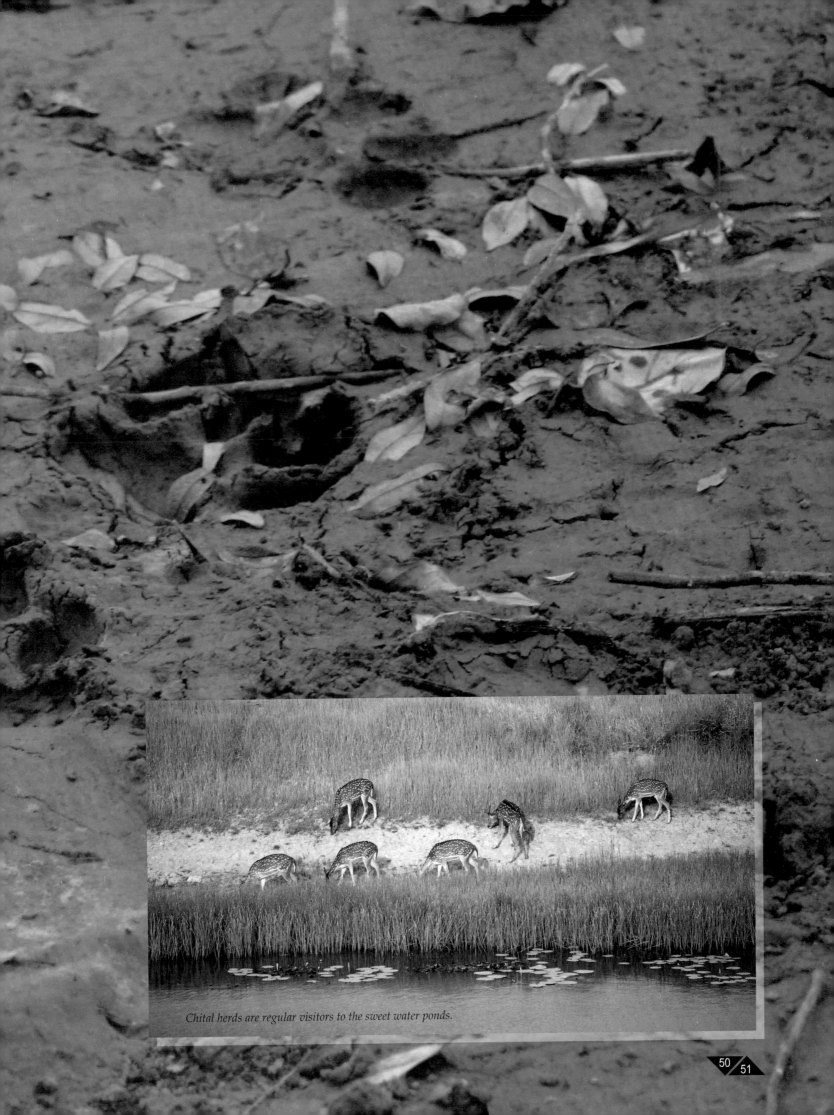

*Chital herds are regular visitors to the sweet water ponds.*

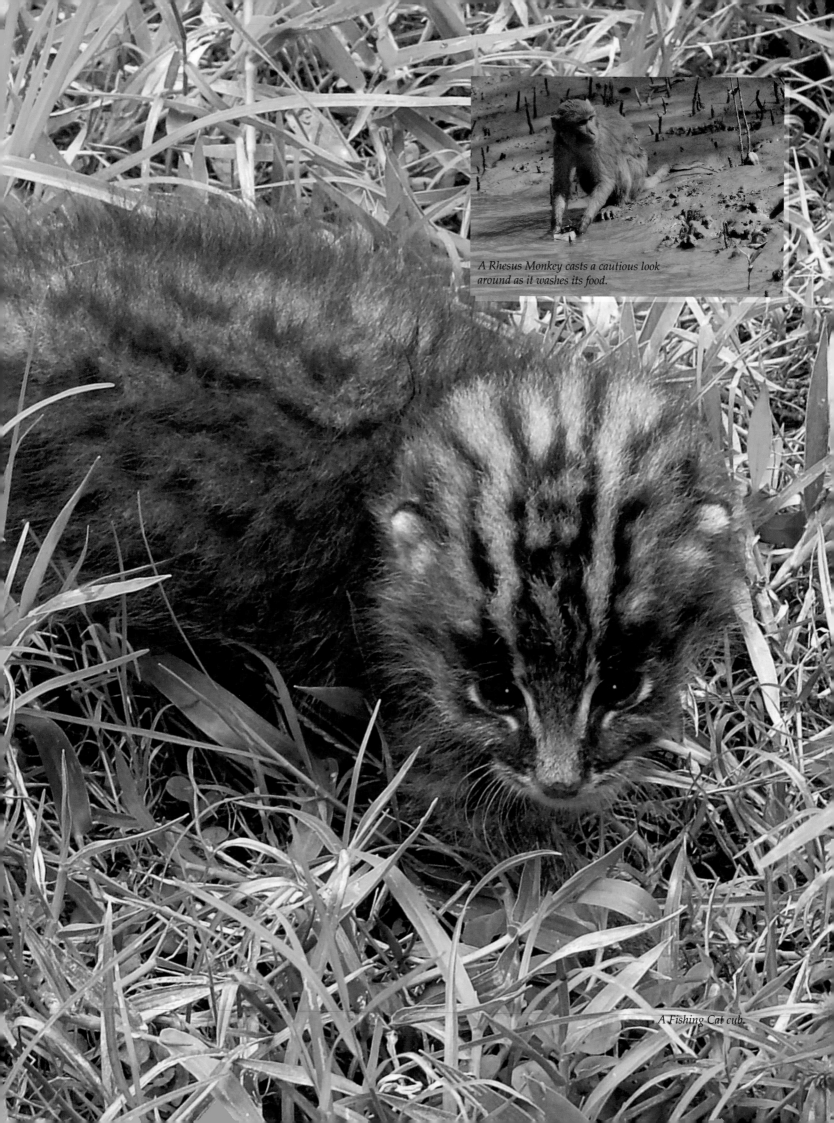

A Rhesus Monkey casts a cautious look around as it washes its food.

A Fishing Cat cub.

Other than the tiger, three other wild species roam the swamps of the Sunderbans. The biggest—the Fishing Cat mainly eats fish but is known to prey on jungle fowl and other animals. The Fishing Cat prefers to stay inside the forest unlike the Jungle Cat that often strays towards the villages bordering the forest causing constant worry to the inhabitants. Smaller in size than the Fishing Cat, it hunts domestic fowl and ducks. Of the three wild cat species, the Leopard Cat, is the smallest.

Jackass' are often seen lurking close to the villages in search of easy prey.

Palm Civets and Small Indian Civets have the same feeding habits as the Jungle Cat and keep close to the villages as well.

Tigers mostly prey on Wild Boars and Chitals that roam in large herds. There are many stories that suggest an amiable and close relationship between Chitals and monkeys in the Sunderbans. It is believed that monkeys often lower the branches of Keora trees to help Chitals feast on them, a shining example of harmony in the jungle.

Wild Boars move in big herds with their young females and a male team leader, and are constantly on the alert as the chances of being attacked by tigers are very high.

Rhesus Monkeys often hang around the tourist lodges and watchtowers in the hope of getting tidbits from the delighted onlookers.

*A Palm Civet drinking water from a pond in a village of the Sunderbans. Both the Palm and Small Indian Civets are found in the region. But usually civets are sighted in the fringe villages of forests and not inside mangrove swamps.*

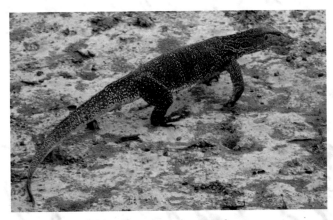

*A Water Monitor Lizard crossing a forest road.*

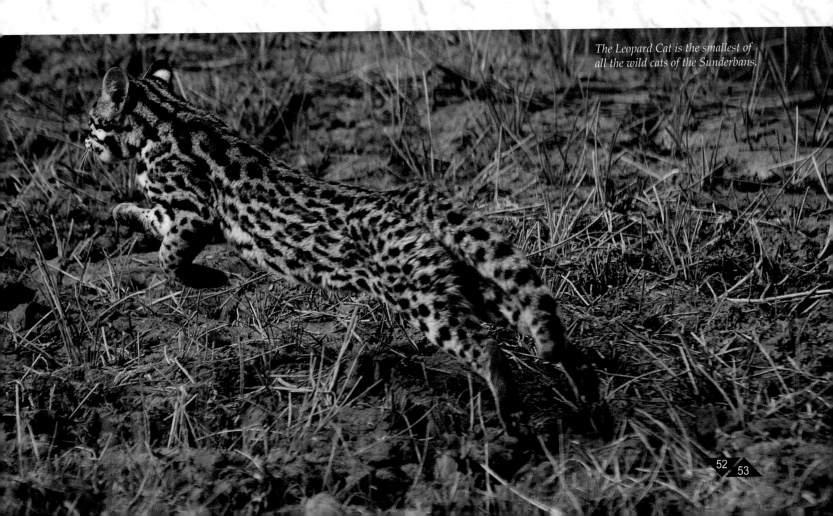

*The Leopard Cat is the smallest of all the wild cats of the Sunderbans.*

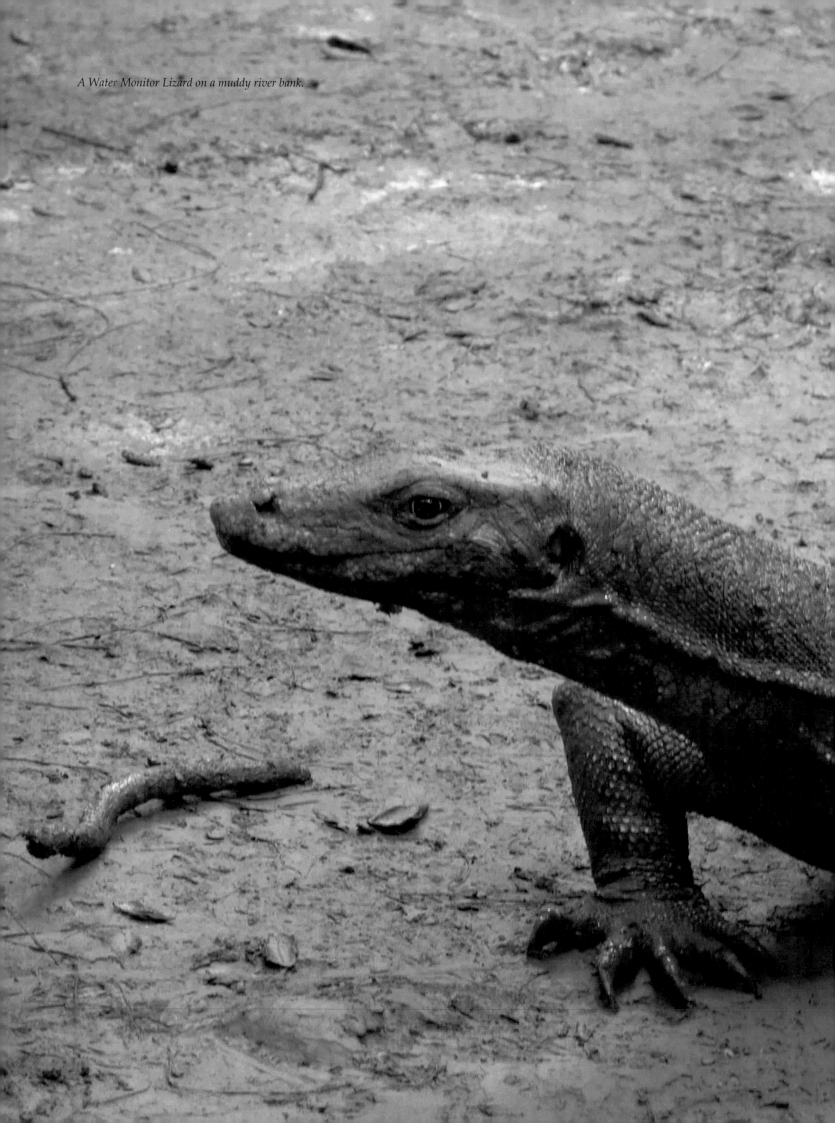

*A Water Monitor Lizard on a muddy river bank.*

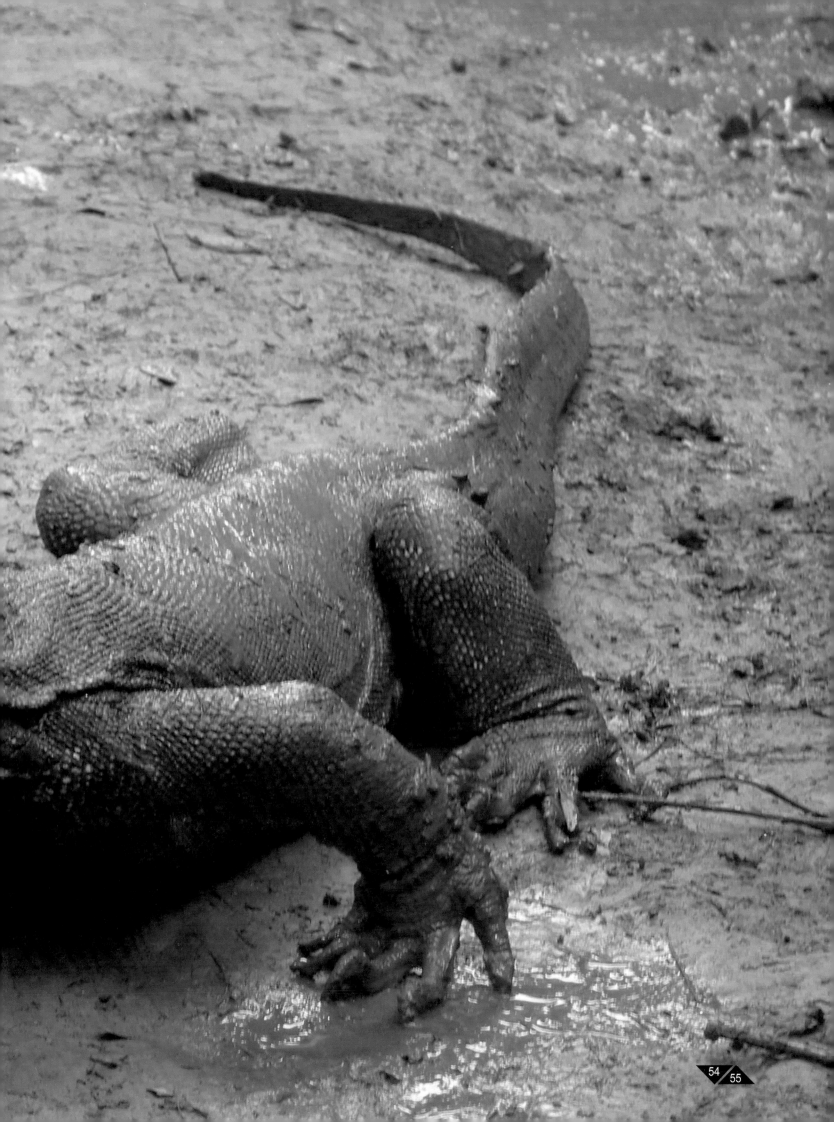

The Smooth-coated Otter is found in the swamps of the creeks and channels. It is a very shy animal and a lot of patience is required to capture the creature on film. In fact, very recently a new member of the otter family, the Small-clawed Otter, has been discovered in the Sunderbans Tiger Reserve in the forest near Kumarmari Island. There has been no earlier record of the presence of this species in the Sunderbans. The Small-clawed Otters are extremely playful by nature and less shy compared to the Smooth-coated ones.

Five-striped Palm Squirrels are commonly found here too.

With such a wide range of animals and birds, one can say with utmost certainty that the forest here never sleeps.

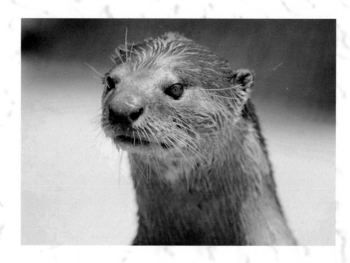

*The Smooth-coated Indian otter.*

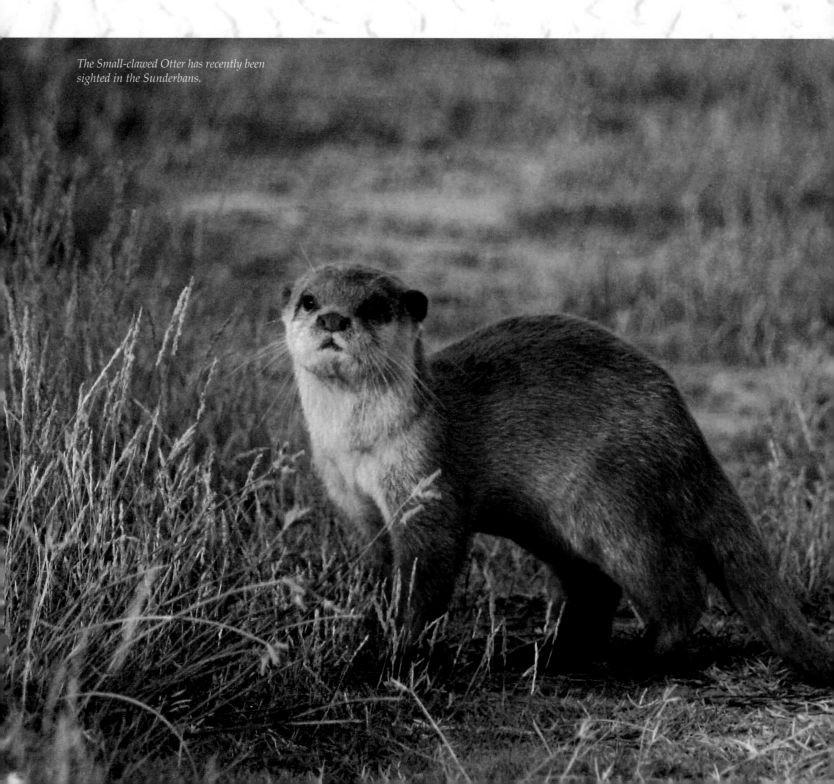

*The Small-clawed Otter has recently been sighted in the Sunderbans.*

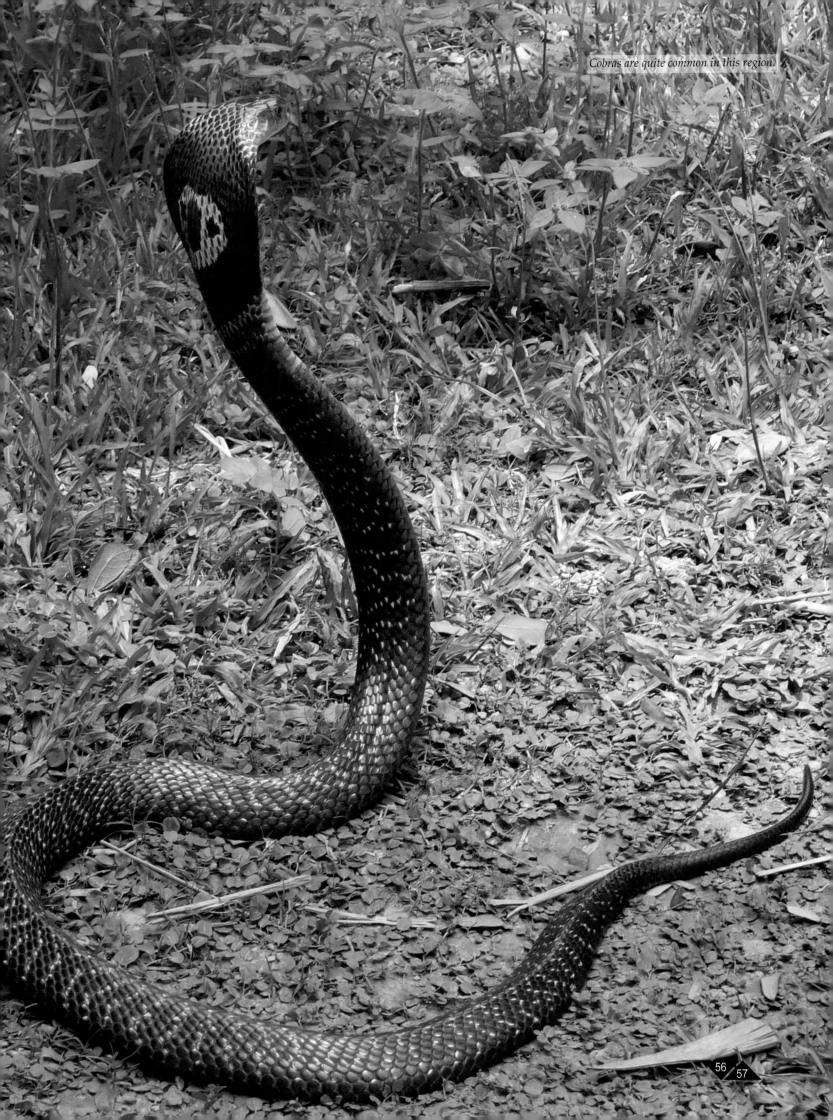

# The Sunderbans was brought under 'Project Tiger' in 1973.

There are many stories about the uncanny behaviour of the tigers of the Sunderbans. Some are true but most can be passed off as mere stories. There is a stigma of man-eater attached to the tigers of the Sunderbans. However, the situation has to be viewed in totality before reaching a conclusion. The hostile forest environment leaves the tigers with no choice but to devour whatever they chance upon, be it crabs, fish or human beings. Fishermen entering narrow creeks sometimes fall prey to hungry tigers.

However, the frequency of such incidents has reduced dramatically owing largely to awareness being imparted by non-government organizations and the forest department to the villagers of the Sunderbans.

The Sunderbans was brought under 'Project Tiger' in 1973. Yet due to the many odd conditions, it is a big challenge to the forest managers to tackle various problems, mainly man-animal conflict.

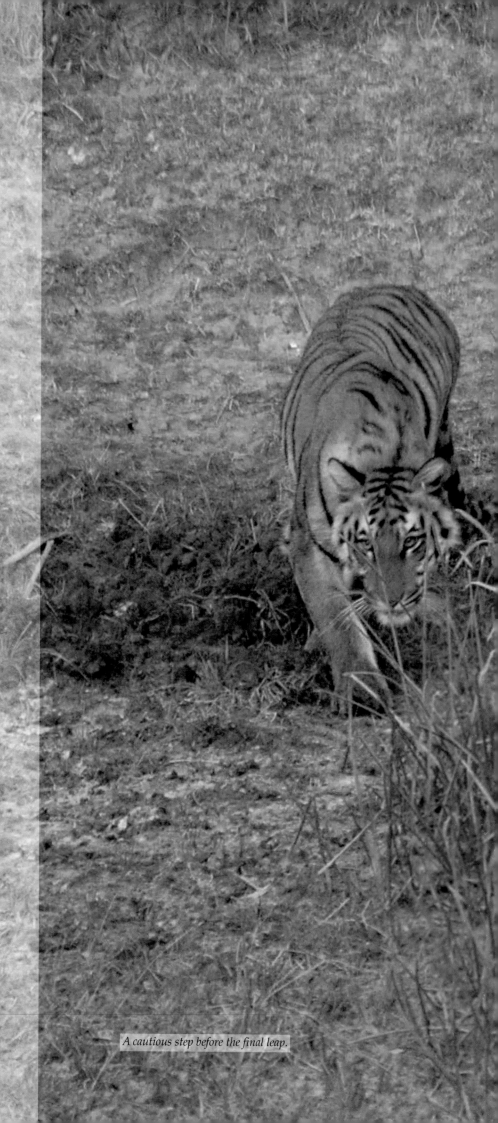

*A cautious step before the final leap.*

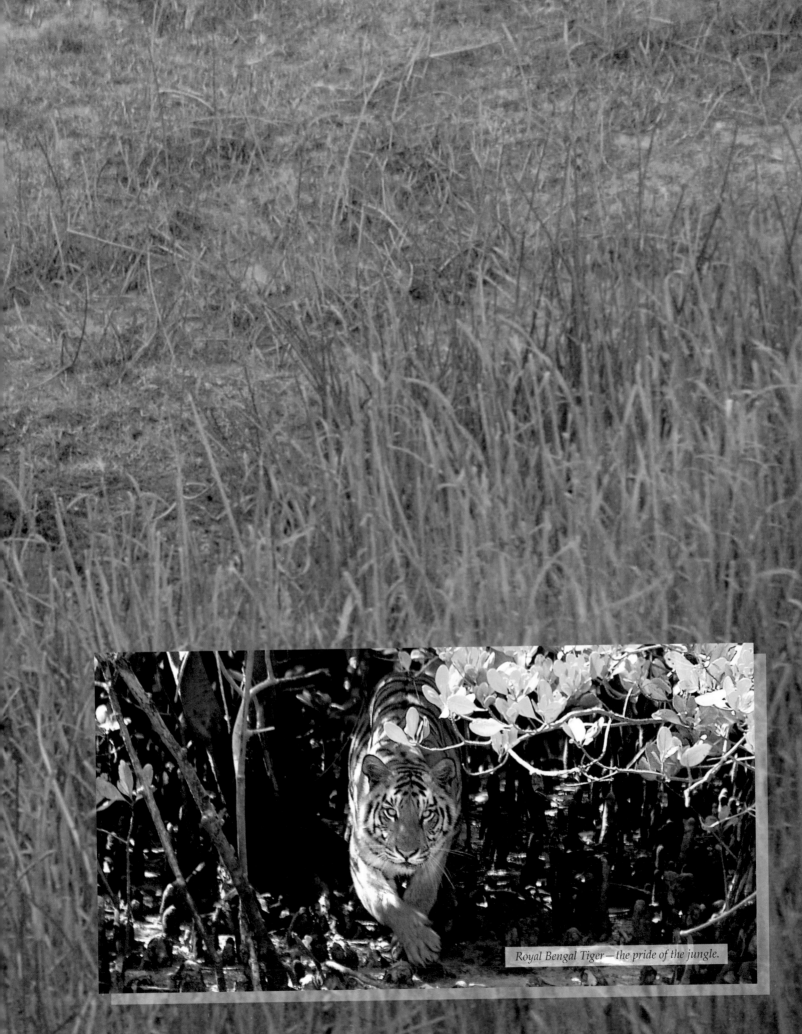

*Royal Bengal Tiger — the pride of the jungle.*

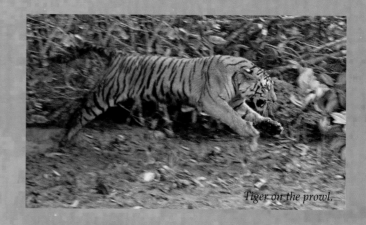

*Tiger on the prowl.*

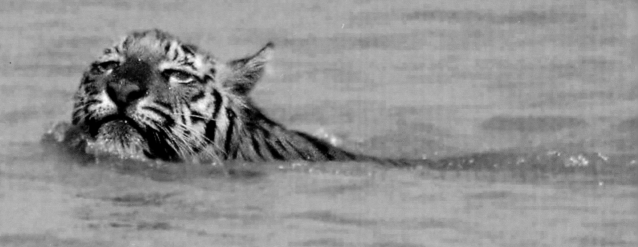

*Tigers can often be spotted crossing creeks and channels. But occasionally they have to cross vast rivers like the Raimongol or Bidya, primarily in search of prey.*

## AGILE SWIMMERS

To cope with the riverine and tidal conditions, all animals of the Sunderbans have adapted themselves to swimming. Tigers can be often seen crossing rivers as wide as one kilometre. During high tide, monkeys, Chitals and Wild Boars are also seen swimming across rivers and creeks.

Otters are by nature good swimmers and spend a major part of the day in river water and creeks.

Two varieties of dolphins are found here. In the upper stream, the Gangetic Dolphins can be usually spotted. But as one goes further down towards the sea, Irawaddy or Blind Dolphins seem to be quite common. Dolphins are highly efficient swimmers and feed mainly on fish from the deep water of the rivers.

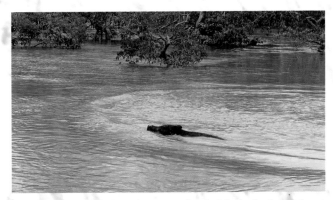

*Wild Boars crossing rivers is an occasional sight in the Sunderbans, rarely seen in other forests.*

## JAWS AND FANGS

The Sunderbans harbour one of the largest varieties of crocodiles in the world, known as the Estuarine Crocodile and found only in estuaries. Apart from the Sunderbans, they are also seen in a few other estaurine regions of India, such as Bhitarkanika, the estuarine region of the Bay of Bengal, and the rivers Brahmany and Baitarani.

There is a crocodile-breeding project in the Sunderbans, which is located at Bhagabatpur under South 24-Parganas forest division.

Being a member of the reptile family, snakes find a perfect hub in the Sunderbans. Among the various snakes found in the Sunderbans, the King Cobra is highly endangered and dwells in the densely forested areas. Nonetheless, the villagers are mostly bitten by the Common Krait and the Russels Viper. Both Spectacled and Monocled Cobras are found here. Green Pit Vipers are the other venomous snakes of the region. Green Vine Snakes, Ornamental Snakes and Rat Snakes are among the non-poisonous species found in the region.

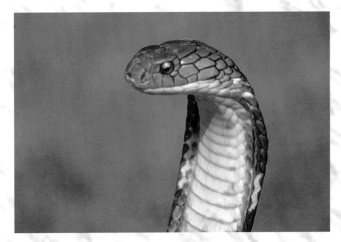

*King Cobra.*

*Immature Estuarine Crocodile sports black spots on its yellow-coloured body.*

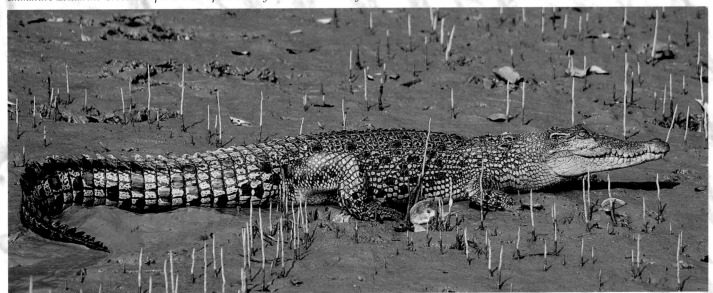

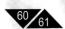

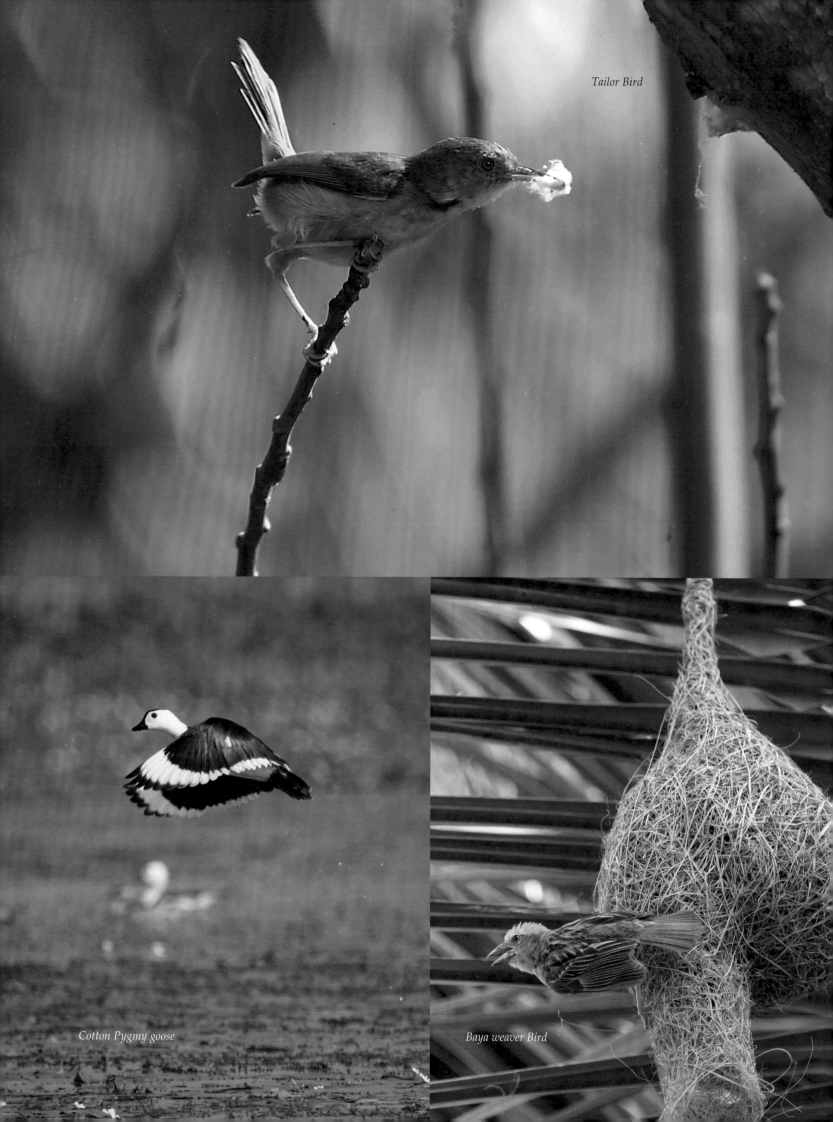

*Tailor Bird*

*Cotton Pygmy goose*

*Baya weaver Bird*

## WINGS

The Sunderbans offer a stupendous spread to birdwatchers and photographers.

Over 200 species of birds inhabit the region. The most rare species is the Goliath Heron. While Pond and Night Herons are most common in the mudflats, Grey, Purple and Little Green Herons are also spotted frequently.

Unusual varieties of birds such as the Mangrove Pitta and Mangrove Whistler are not so unusual in the swamps.

These feathered creatures are indeed a delightful and significant constituent of the delta, adding a dash of colour and beauty.

*A close kin of the Eurasian Curlew, the Whimbrel shares a keen resemblance with the bird because of its colour and the shape of its bill. Though Whimbrels are winter migrants to the mangrove, a large number have settled here permanently.*

## WORLD OF KINGFISHERS

The presence of as many as seven species of kingfishers adds another unique dimension to the mangrove forest. Most common and spectacular of them all is the Black-capped Kingfisher. It is usually found perched on branches of trees in most parts of the Sunderbans. But the bird is not very camera-friendly and when approached, it quickly flies away from tree to tree leaving the photographer very little chance to capture it on film.

However, photographers find some consolation in the Collared Kingfisher, which is less shy and quite approachable. Another very colourful kingfisher of the Sunderbans is the Brown-winged Kingfisher. With deep brown wings, paler underbelly and a strongly built red bill, the bird has a magnificent appearance.

Stork-billed Kingfishers are not as common as the ones mentioned above. Yet they are found in the areas of the forest that border the village. Pied and White-breasted Kingfishers are found throughout the year.

The rarest of all Kingfishers of the Sunderbans is the Ruddy Kingfisher. This pinkish bird is rarely spotted, and that too, mostly during winter.

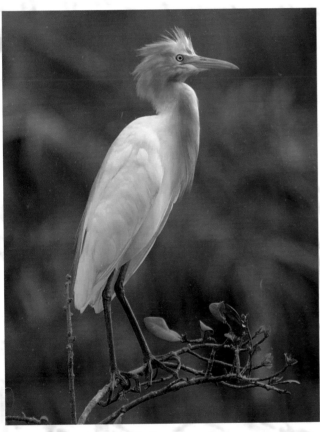

*A Cattle Egret in breeding plumage.*

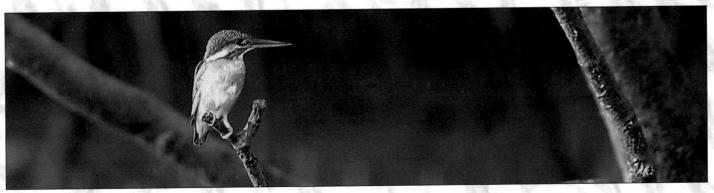

*The Common Kingfisher, as the name suggests, is the most common of all kingfishers found in the Sunderbans. Usually found patiently perched on a branch in order to catch a fish, this tiny creature is the smallest member of the kingfisher family.*

## EAGLE EYES

The Pariah Kite is the most commonly found raptor in the delta. A close second is the Osprey, which can be identified even from a distance by the black band behind its eyes.

The Brahminy Kite, though earlier considered to be a common bird of the region, is not spotted so frequently any more. The Crested Serpent Eagle is seen flying high in the sky or perched on the upper branches of trees. Shikras may be spotted near villages, where they easily find prey in the form of chickens and ducklings.

The elegant White-bellied Sea Eagle is found in the lower region of the forest towards the estuary.

Pallas's Fishing Eagle is an uncommon sight, and does not frequent any particular region within the Sunderbans.

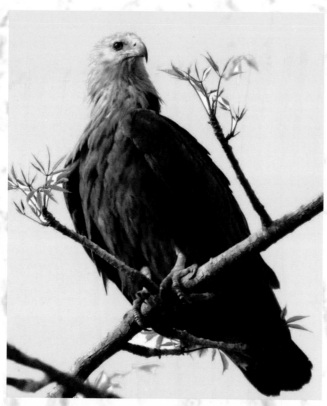

*Pallas's Fishing Eagle is rarely seen in the region.*

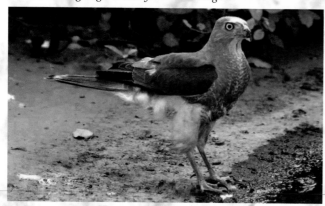

*The Shikra is an agile hunter and often seen soaring in the sky searching for prey.*

## JEWELS ON THE BRANCHES

The forest abounds in tree birds. There are some birds which are found throughout the Sunderbans, such as, the Green Bee-eater, Purple-rumped Sunbird, Tailor Bird, Rose-ringed Parakeet and Spotted Dove. Some birds which are usually not found in southern Bengal are also found here. These are the Green-billed Malkoha, Orange-breasted Pigeon and Chestnut-headed Bee-eater. Among the brightly coloured birds are Emerald Doves, Blue-tailed Bee-eaters and small Minivets.

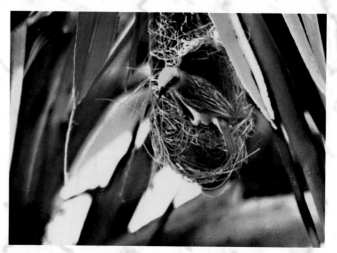

*Bayas are famous for weaving their nests with twigs and fibres of trees. Newly-built nests remain green for a few days after which they dry up and become brownish.*

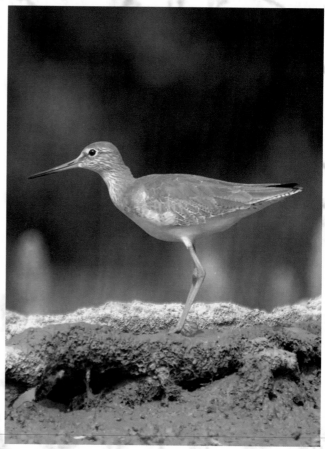

*A Redshank.*

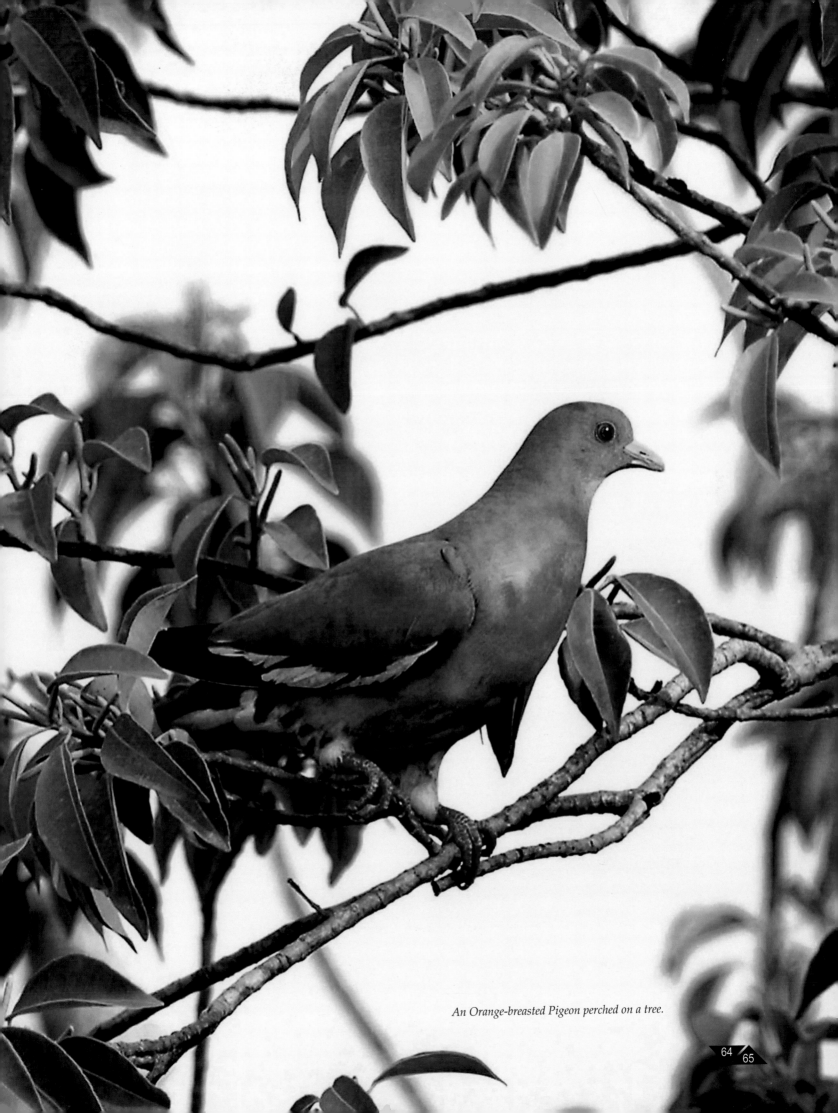

An Orange-breasted Pigeon perched on a tree.

# The Stunning
# Sea Face

The sea face of the Sunderbans turns hostile, especially between March and June. There are occasional depressions which originate in the Bay of Bengal during summer, causing severe hailstorms. Fierce winds bring devastation with uprooted trees being a common sight. The islands experience very high tide, which even affect the city of Kolkata. The mangroves act as a buffer against the storm.

The shores of Saimari, Mechua, Kalash and Bijeara, however, have an unmatched serene beauty. The virgin beaches are covered with golden sand. Hundreds of waders can be witnessed dancing with the waves of the emerald sea. In the backdrop of these soft beaches are dense forests of Casurina and other mangrove trees.

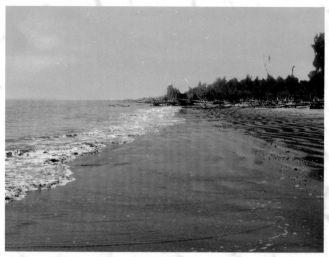

*The serene beauty of Bijeara sea face.*

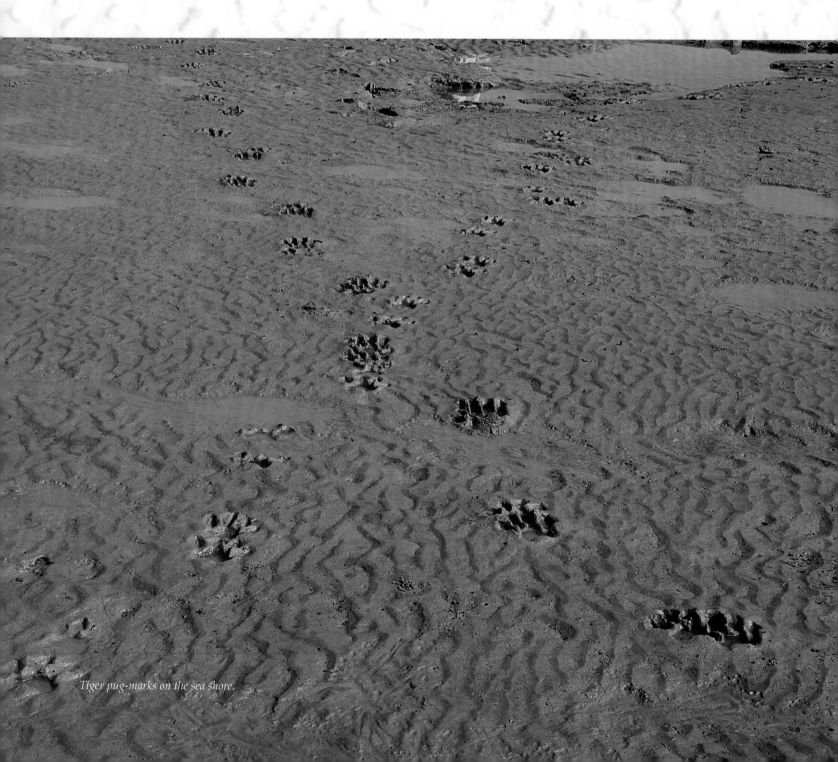

*Tiger pug-marks on the sea shore.*

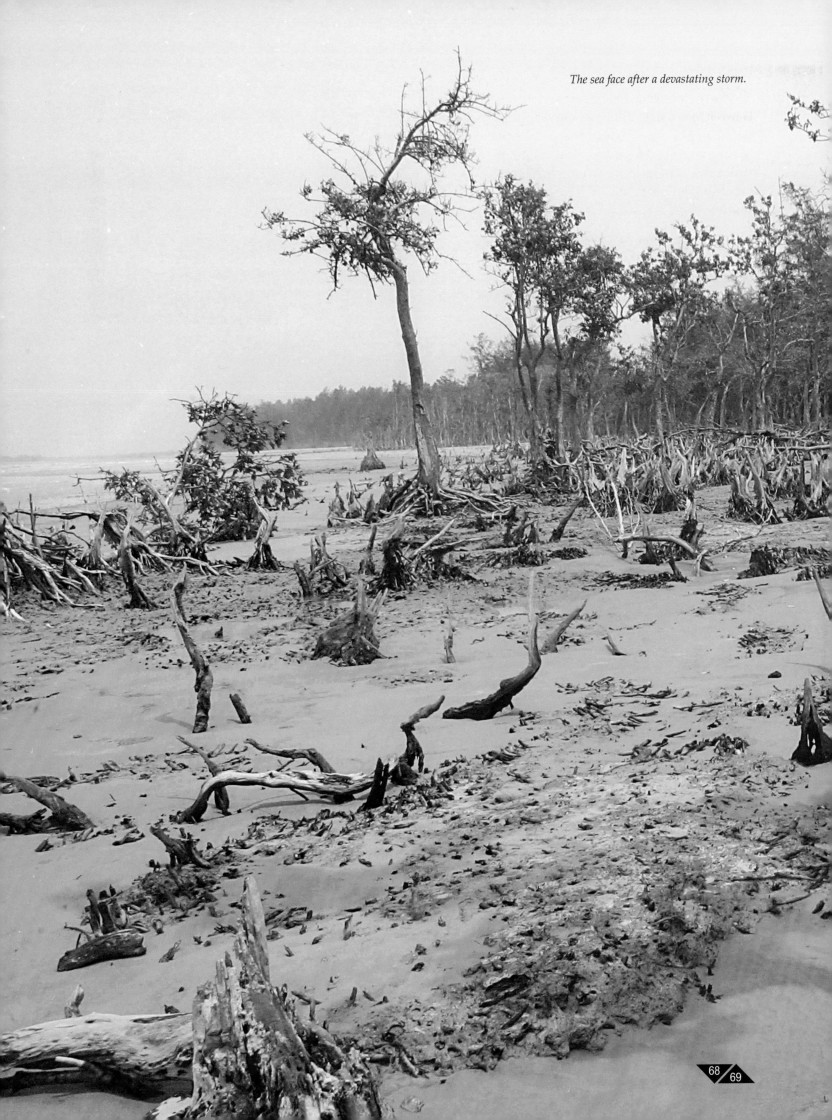

*The sea face after a devastating storm.*

*Small ornamental fish in a temporary puddle.*

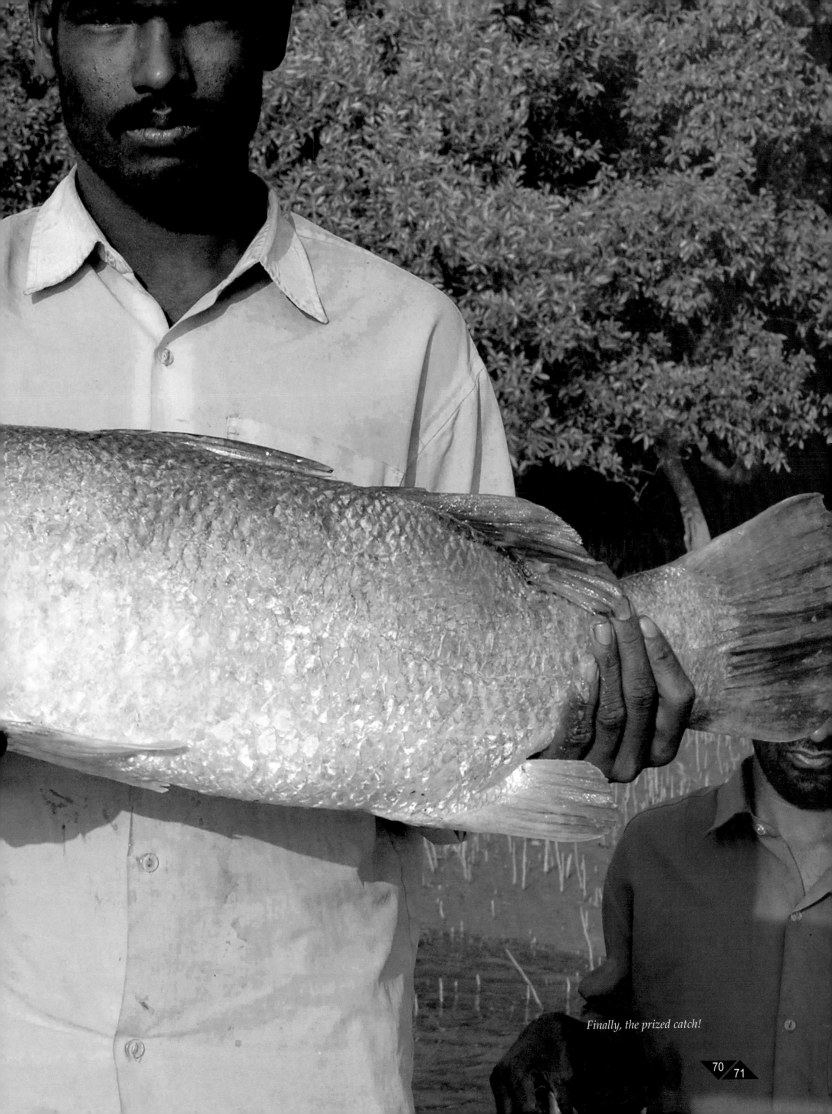

*Finally, the prized catch!*

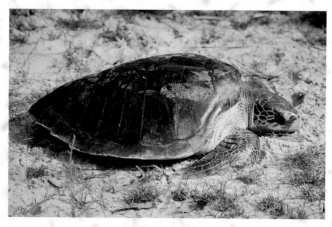

Olive Ridley Turtles come to these beaches to lay eggs from faraway oceans between the months of January and March. They go back to the sea as soon as the eggs are laid. The hatchlings come out after six weeks and head straight into the sea.

The nests and eggs of these turtles are often damaged by monitor lizards and hailstorms. In order to protect them, 'Project Tiger' sets up a temporary camp every year during the nesting season. Some eggs are collected and sent to the turtle-hatching centre at Sajnekhali.

*Olive Ridley Turtles come to the sandy beaches of the Bay of Bengal during winter months to lay eggs.*

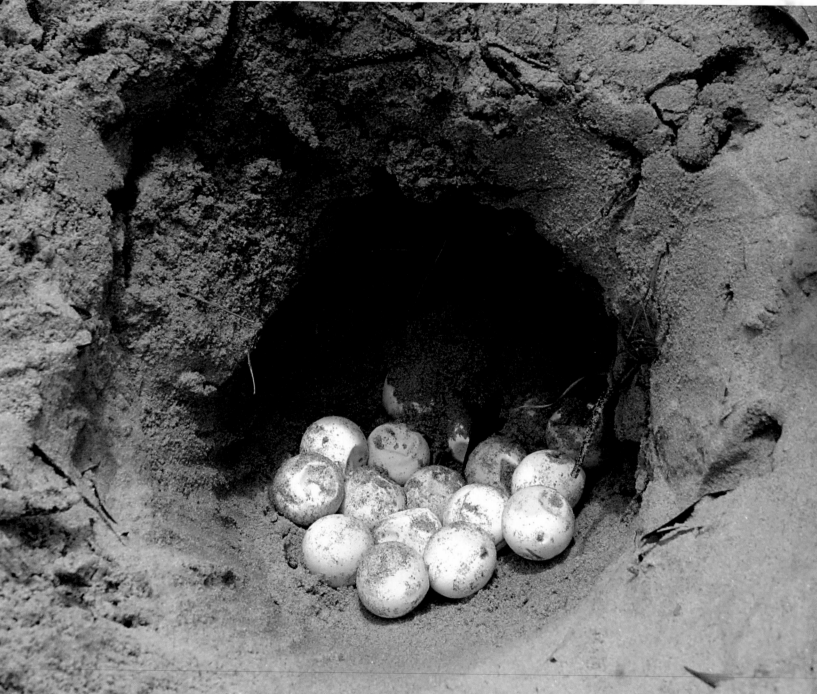

*Eggs of Olive Ridley in a nest on the sandy beach.*

*A pair of mudskippers.*

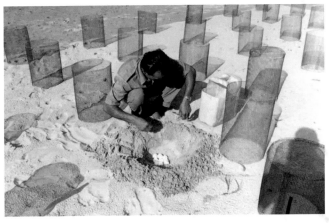

*Eggs are brought to the Olive Ridley Centre at Sajnekhali for ex-situ conservation.*

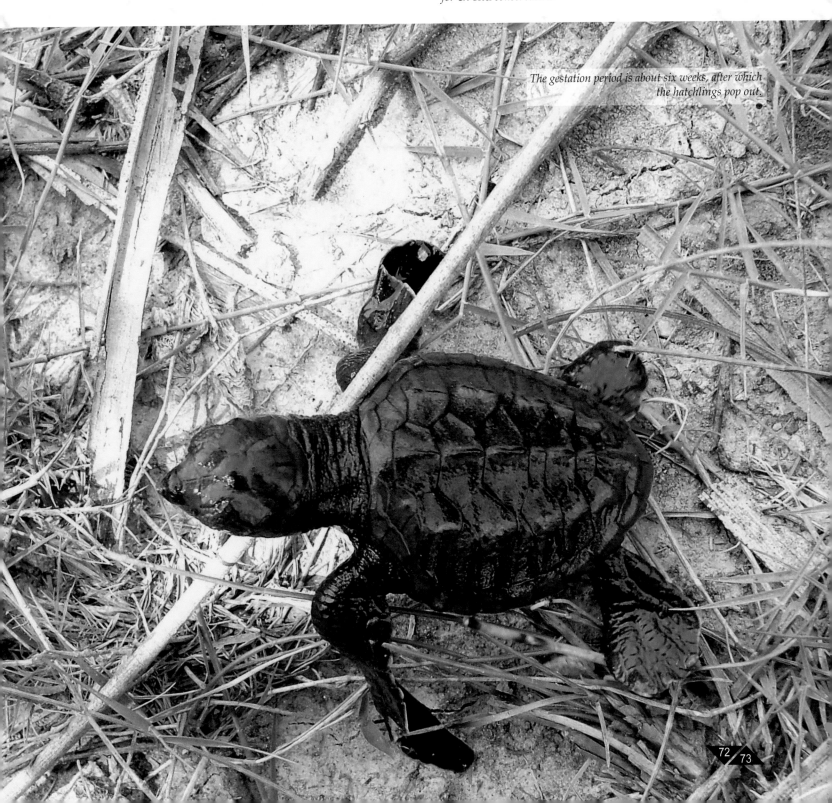

*The gestation period is about six weeks, after which the hatchlings pop out.*

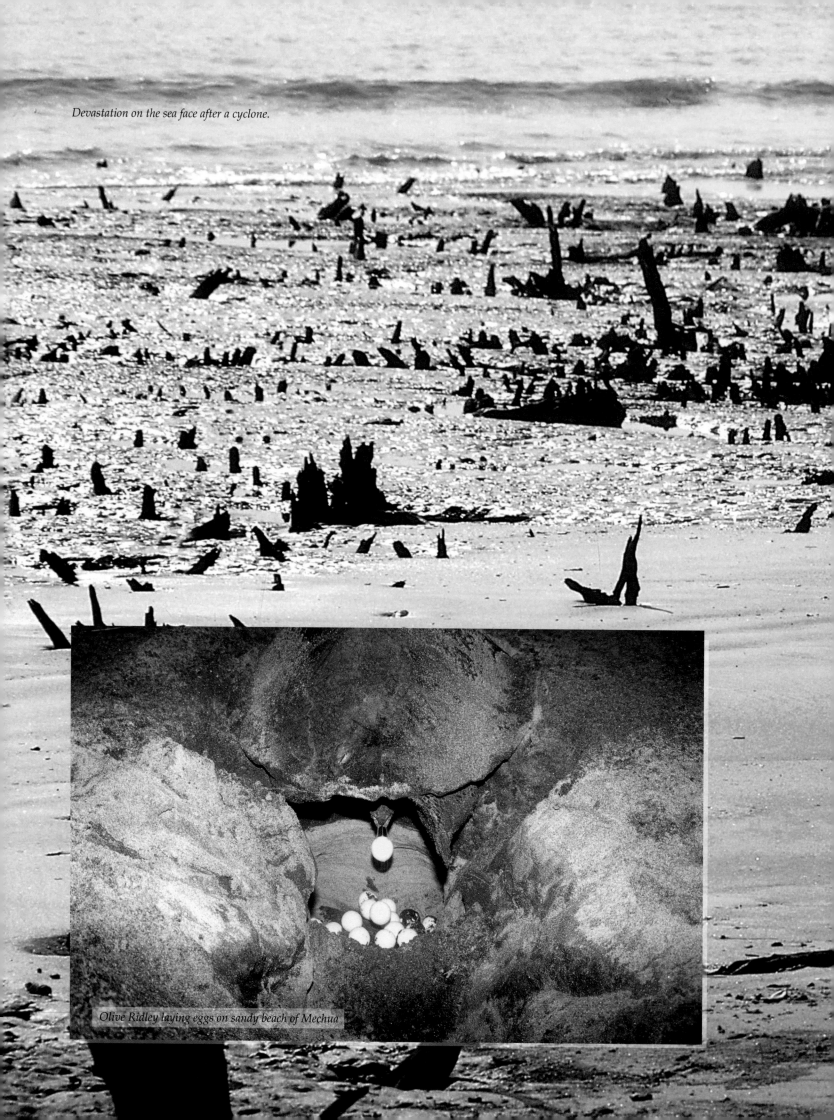

Devastation on the sea face after a cyclone.

Olive Ridley laying eggs on sandy beach of Mechua

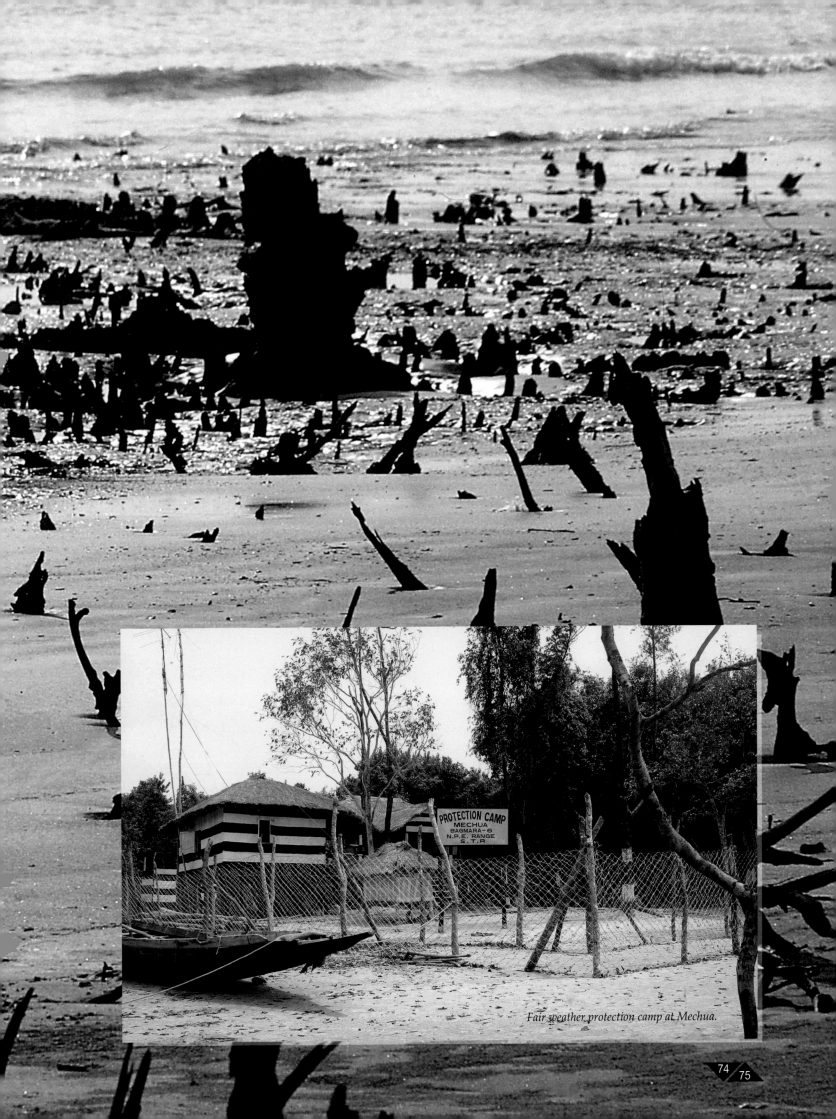

Fair weather protection camp at Mechua.

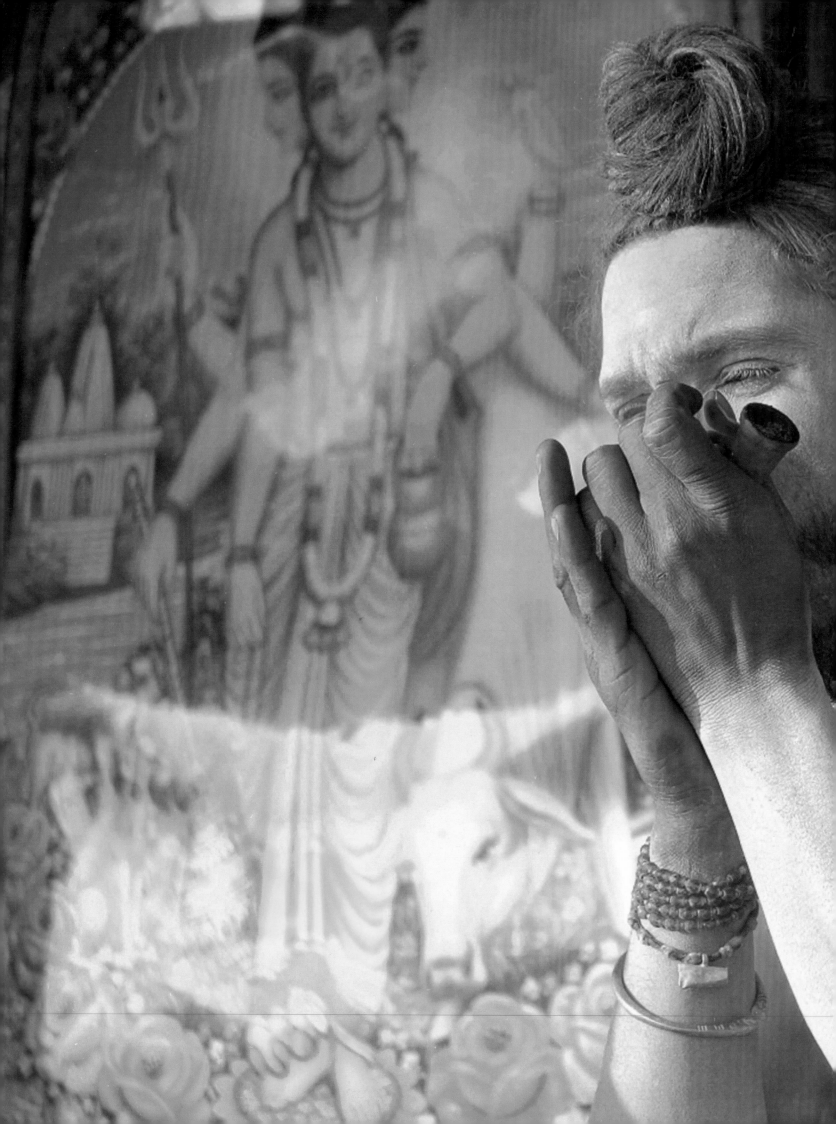

Bound by *Faith*

Most experts, till very recent times, believed that there was no archaeological evidence of the ancient times of lower Bengal. But some of the recent findings reveal that there were ports, temples and other archaeological remnants in different parts of the region. The remnants also prove that many ports and towns existed on the banks of the rivers at least 2,000 years ago, which now lie buried under silt or rivers that have dried up.

Some of the most important findings have been excavated from Dehulpota, Chakrathirtha, Chandraketugarh, Karanjali, Krishnachandrapur and many other places in and around lower Bengal. Some of these remnants, as proven by scientists, are believed to be 3,000 years old. Coins, idols of gods and goddesses, remains of prehistoric animals and earthen pots are among some of the important archaeological findings. However, the changing physical conditions of the region eliminated many human settlements and flourishing townships. Thus, it is almost impossible to trace the chronological history of the Sunderbans.

There are many ancient relics, like the remains of a temple at Netidhopani, spread all over the Sunderbans. Myths and legends play a vital role in tracing the missing links in the history of any region.

There are some historical truths, facts and incidents behind certain rituals and legends. The cult of worshipping animals and trees among locals definitely proves their pre-Aryan cultural ethos. The region was relatively isolated from the political nucleus of the country, which led to the development of an indigenous cult and culture of the land. Some myths and culture still persist here of which outsiders are unaware. Worshipping tigers and snakes is a sign of primitive culture. Another most interesting aspect is the religious amity between the Hindus and Muslims. Followers of both faiths, irrespective of their religious identity, have to face the same natural hazards, such as cyclones, tidal conditions and, last but not least, the ferocious tigers. Hence, both communities worship the same deities, gods and goddesses. The Hindu goddess,

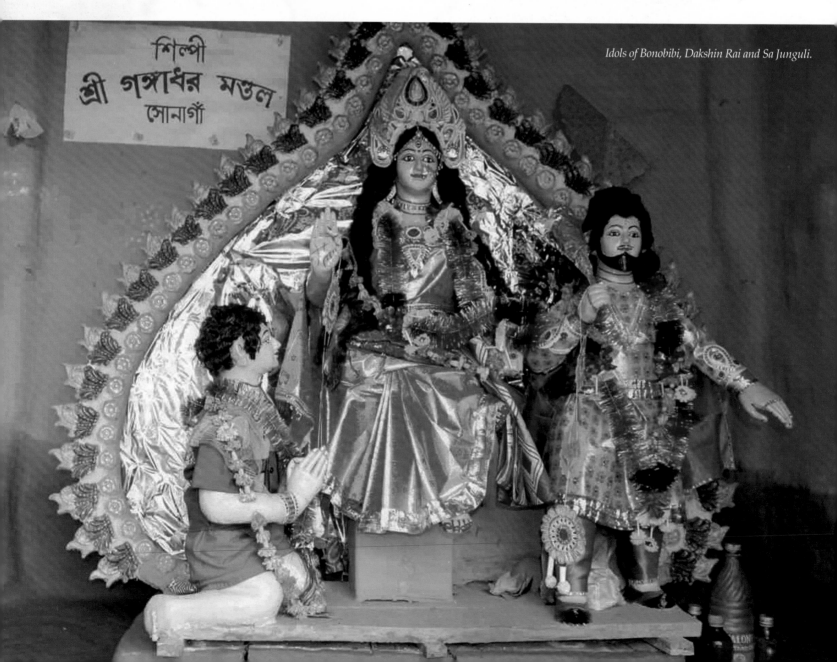

*Idols of Bonobibi, Dakshin Rai and Sa Junguli.*

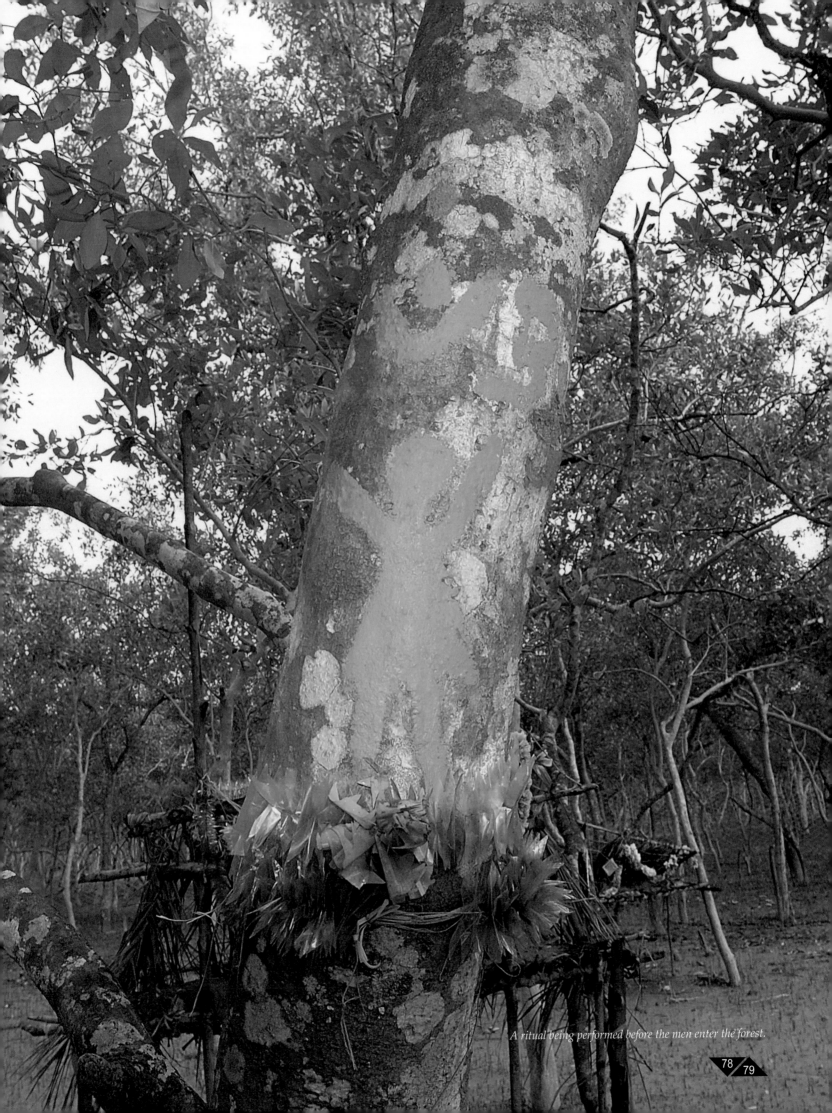

*A ritual being performed before the men enter the forest.*

*Ornamental Snake.*

'Bonodevi', in due course of time came to be known as 'Bonobibi' so that the Muslims could easily identify with her. The same theory holds true for 'Olaibibi' (from Olaichandi), 'Pir Mosnod Ali' (from Matcendra Nath), and 'Kalu Rai Khan' (from Kalu Rai) and so on. 'Bonobibi' is the universal Goddess of the Forest, who provides food and shelter.

Some gods and goddesses of the Sunderbans, worshipped for different reasons are as follow:

'Manasa' is worshipped in order to keep the venomous snakes happy; 'Jagatgauri' for protection against cobra; 'Olaichandi' for prevention of epidemic diseases like cholera; 'Manik Pir' for welfare of cows. Woodcutters, locally known as *'bouley'*, honey collectors, locally known as *'mouley'* and fisherman, known as *'jele'*, worship Dakshin Rai, Bonobibi, Gazi Saheb, Kalu Rai, and Sa Junguli to prevent all hazards.

## PROTECTION FROM TIGERS

Tigers are feared and worshipped all over the Sunderbans. Bonobibi, Dakshin Rai, Gazi Saheb and Sa Junguli are worshipped as protectors from tigers, all across the region by people who have to venture into the forest to earn their living. This tiger cult is non-Aryan by origin and is restricted to southern Bengal only. Special forms of worship of these gods and goddesses take place during Makar Sankranti, which is also the last day of the Bengali calendar month of 'Paush' (around 14th/15th January).

During Muslim rule, a large number of local inhabitants, mostly lower class Hindus, converted to Islam. Those who spread the Muslim religion were known as 'Pirs'. Some of these Pirs like Gazi Mubarak, Bioragazi, Barakhangazi, Gazi Badaruddin and Gazi Saheb are still remembered as 'Panch Pir' throughout the Sunderbans. Pir Gazi Mubarak's Darga at Ghutiarisarif on the Sealdah-Canning Railway line is the most famous among local people. The name of Gazi Badaruddin is associated with the boatmen of the Sunderbans, who whilst sailing, chant his name invariably as Gazi Badar-Badar. This indicates the popularity of the Pirs and their influence, which has made them immortal.

## SAFETY FROM SNAKES

In some stories, Manasa is the Goddess of Water or Bishahari, a goddess powerful enough to heal all diseases.

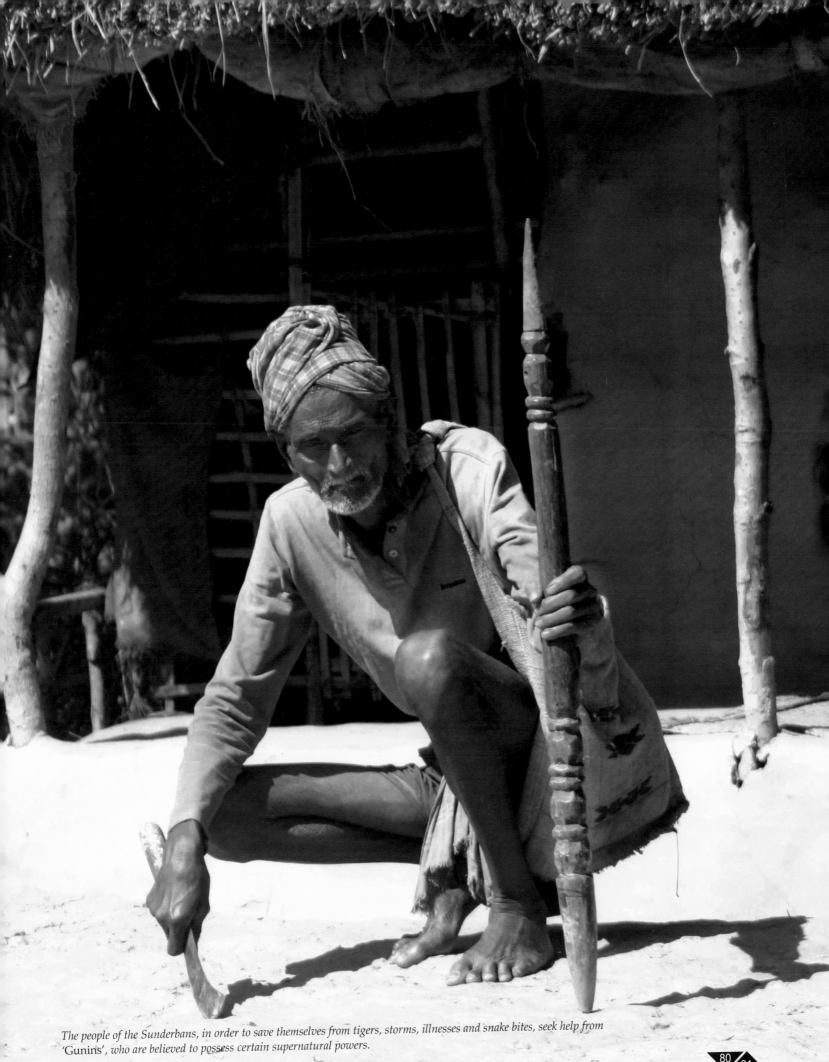

The people of the Sunderbans, in order to save themselves from tigers, storms, illnesses and snake bites, seek help from 'Gunins', who are believed to possess certain supernatural powers.

Dharma and Manasa used to be worshipped together but later on the worship of Manasa as the Goddess of Snakes became independent of Dharma and she began to be worshipped in different places in various forms. Manasa idols are nothing but simple earthen pots decorated with snake hoods. Their shapes, however, vary from place to place. Though the Goddess is worshipped in Bengal, she is more popular among the lower class.

## SUPERNATURAL POWERS

'Gunins' are a revered lot among the people of the Sunderbans. They are believed to have supernatural powers by which they can drive away tigers. From time immemorial, Gunins have had tremendous influence on fishermen, honey collectors and woodcutters. By chanting mantras, they gain strength of mind.

Ojhas, on the other hand, are village doctors who are believed to possess supernatural powers and can heal snake bites through their rituals and mantras.

*Sadhus at Sagar Mela.*

## CELEBRATION TIME

The most popular festival of the region is the *Sagar Mela*. It is a religious festival of the Hindus. A temple of a sage, Kapil Muni, is situated in Sagar Island and which looks out to the sea. On the last day of the Bengali calendar

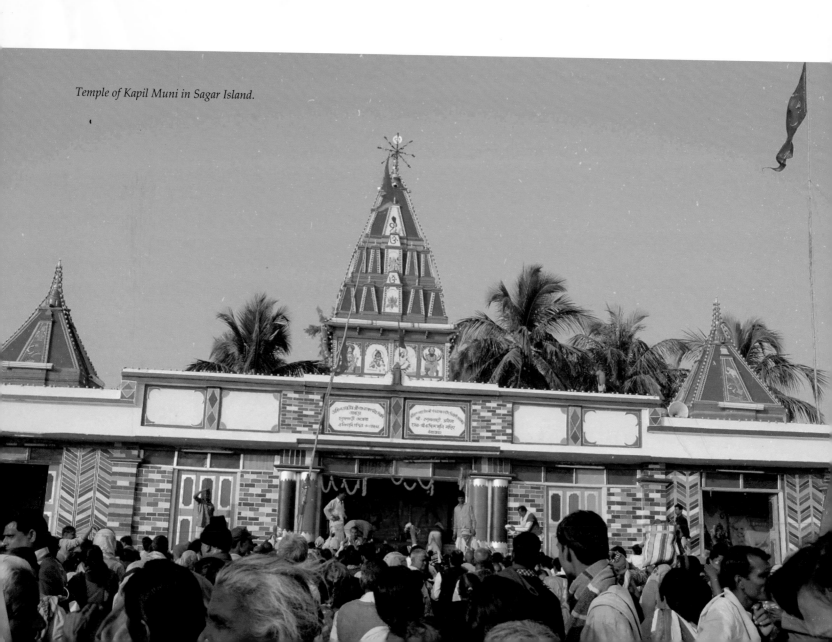

*Temple of Kapil Muni in Sagar Island.*

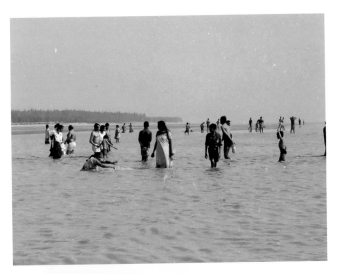

*Pilgrims take a holy dip.*

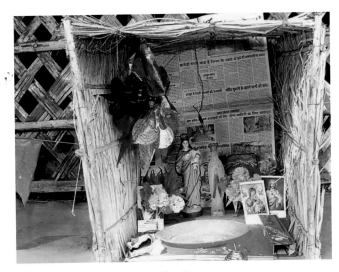

*Christmas celebrations in a small village.*

month, *Paush*, almost a million pilgrims visit the spot to take a holy dip. A week-long fair takes place on the sandy beach, attracting sadhus and holy men from all over the country.

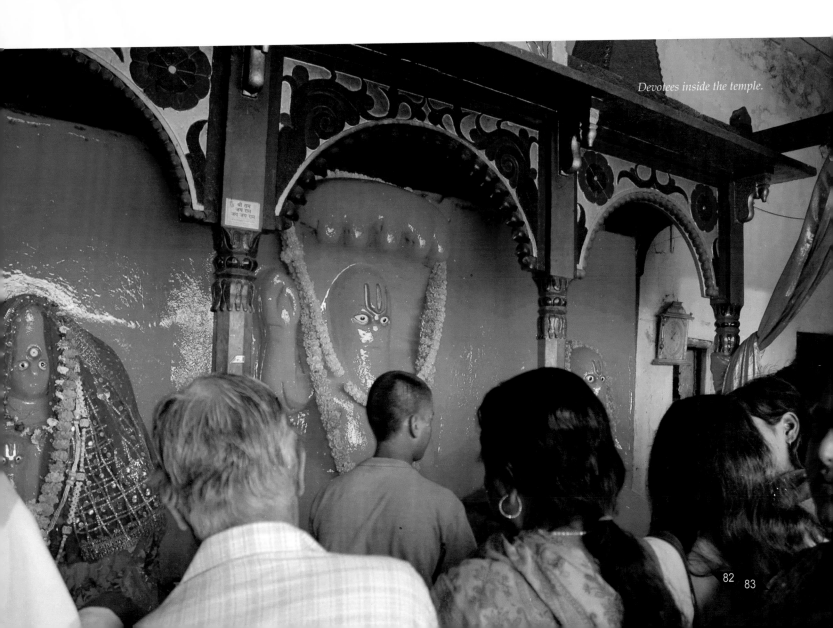

*Devotees inside the temple.*

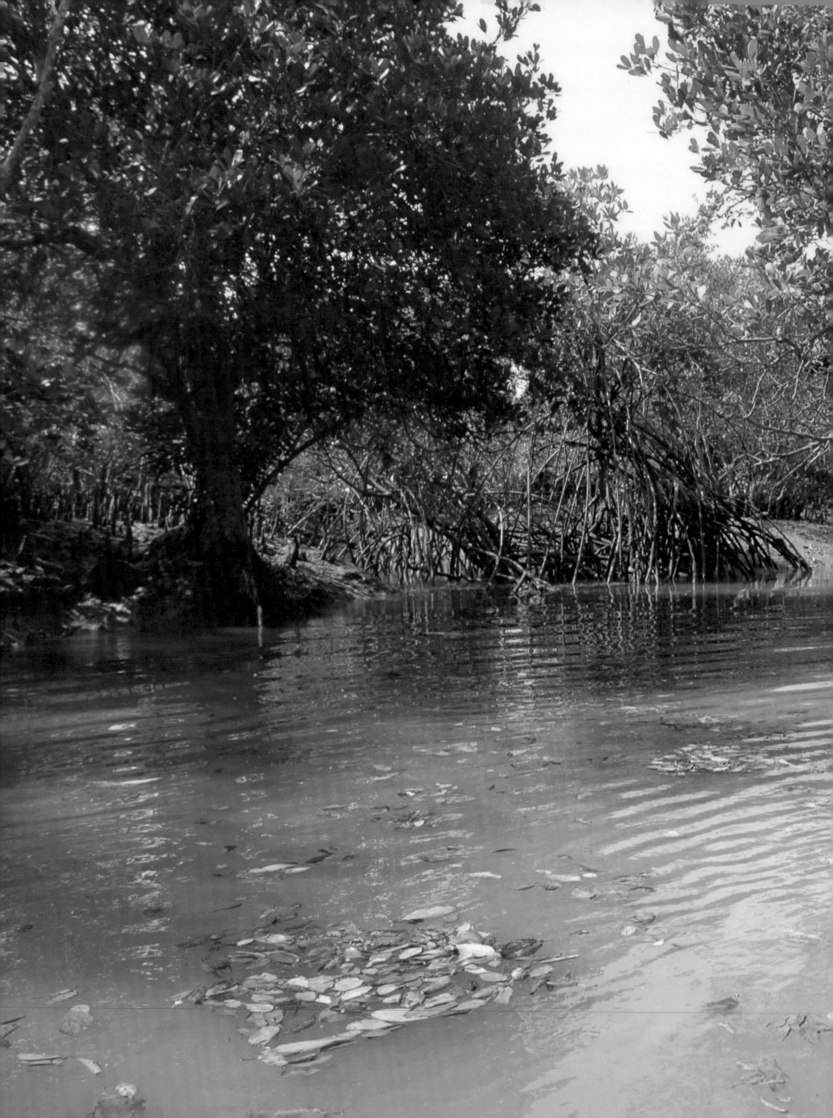

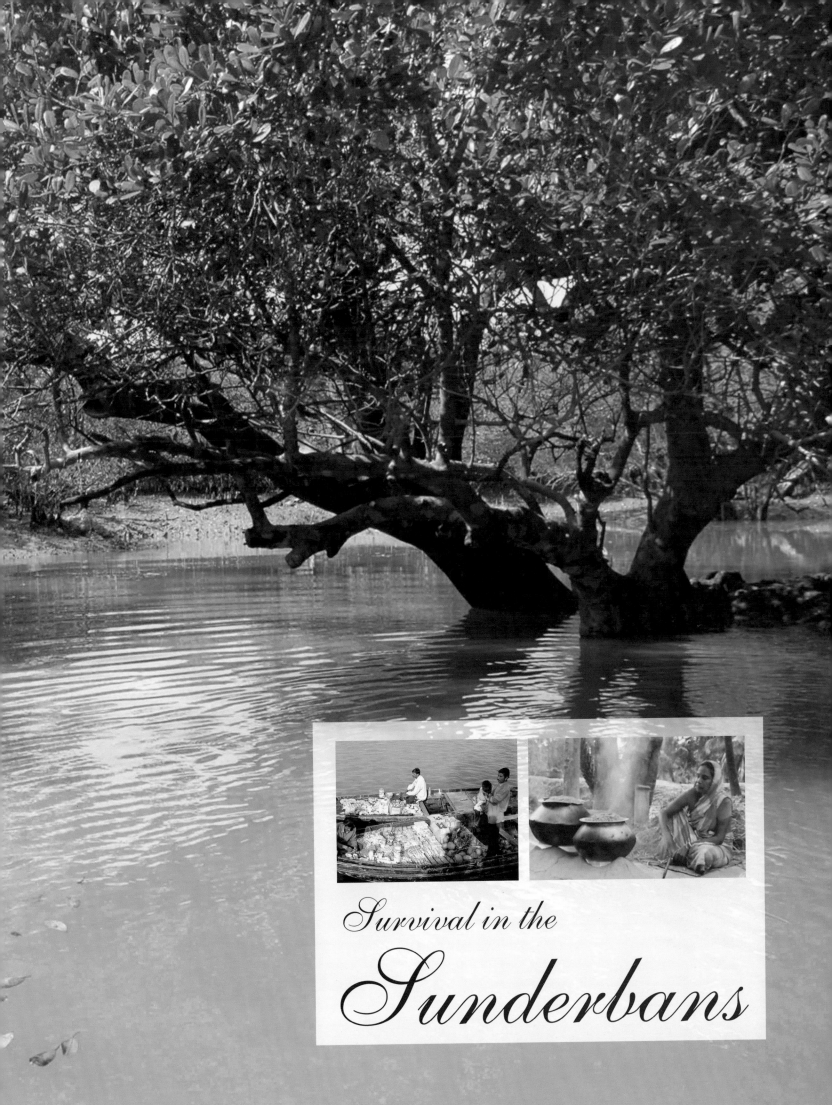

Survival in the
*Sunderbans*

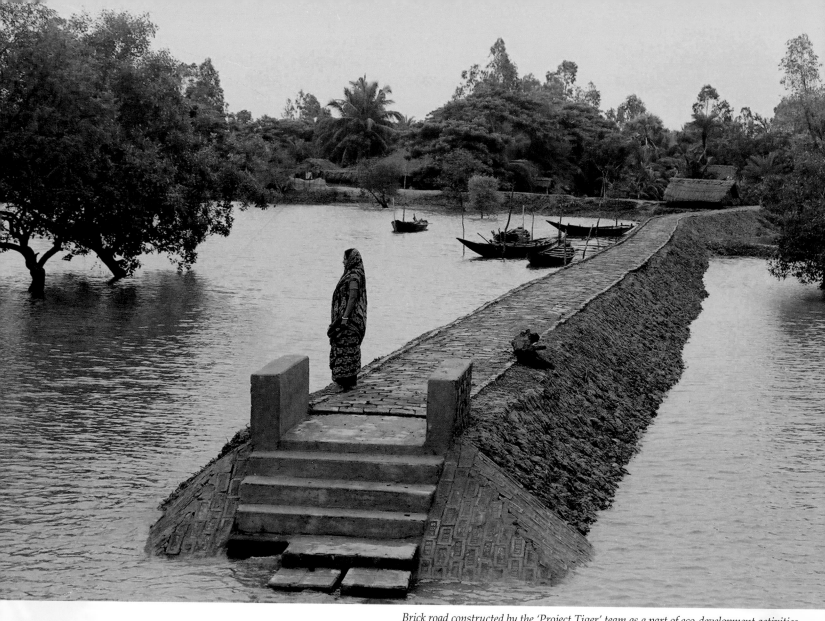

*Brick road constructed by the 'Project Tiger' team as a part of eco-development activities.*

Life is a constant struggle for the people of the Sunderbans. They are compelled to combat all natural hazards such as storms, floods and tidal conditions.

There are no proper roads. During the monsoons, the roads become exceedingly slippery making it risky even to walk.

Lack of potable water is another big problem. There are a few fresh water sources but there people have to queue up for hours to get a pot of drinking water.

Medical facility is scarce in the villages and the situation would have been worse but for the meagre assistance provided by non-government organizations.

People are mostly dependant on the mono-cropping agricultural practice, which does not yield much profit.

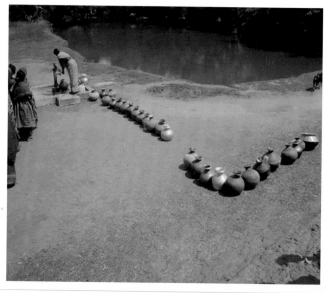

*Pots in line waiting to be filled in front of a new deep tubewell installed by the 'Sunderbans Tiger Reserve'.*

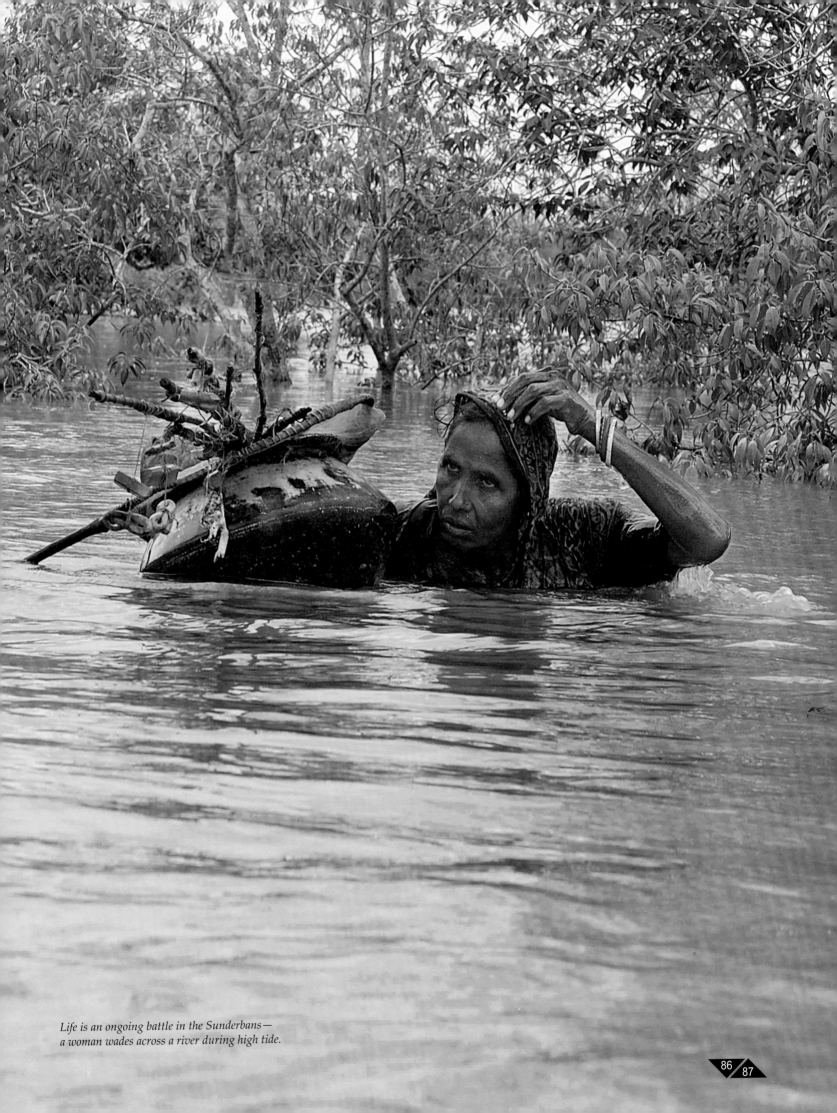

Life is an ongoing battle in the Sunderbans—
a woman wades across a river during high tide.

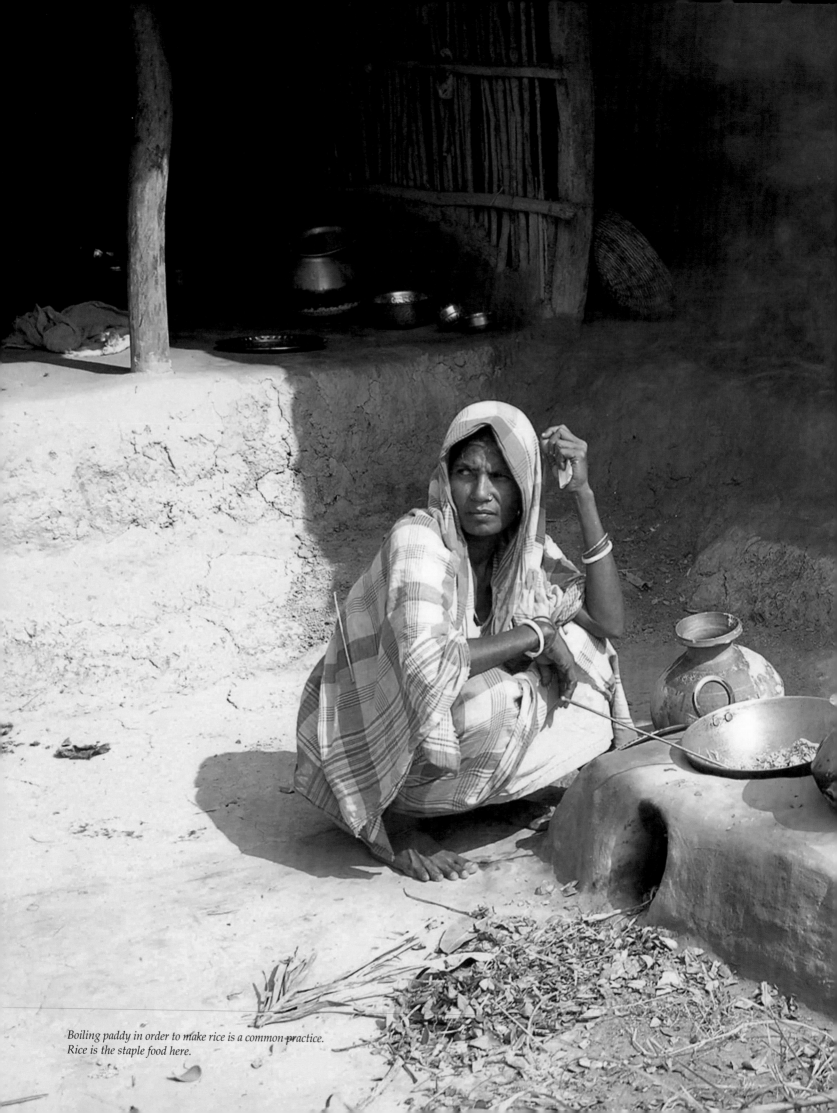

*Boiling paddy in order to make rice is a common practice. Rice is the staple food here.*

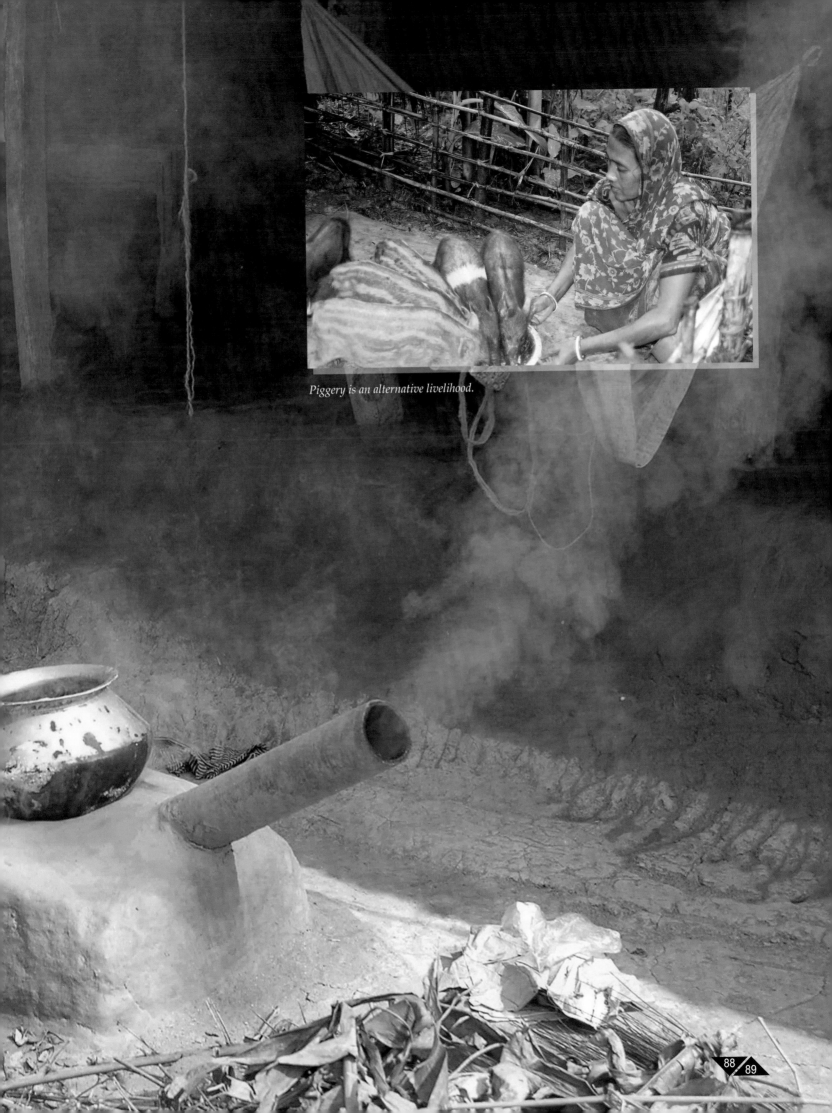

Piggery is an alternative livelihood.

# Trawlers are used for large-scale fishing.

Fishermen have adopted various methods depending on the kind of resources available. Some use hand nets, while others use country boats. Trawlers are also used for large-scale fishing.

Another common practice is the collection of prawn seedlings. Usually women and children drag rectangular fishing nets along the banks and collect tiny, almost invisible seedlings of prawns. These are supplied to the big prawn farmers. While collecting the prawn seedlings, they throw away all other small animals and fish caught in their nets, on the banks, causing an immense loss to aquatic biodiversity.

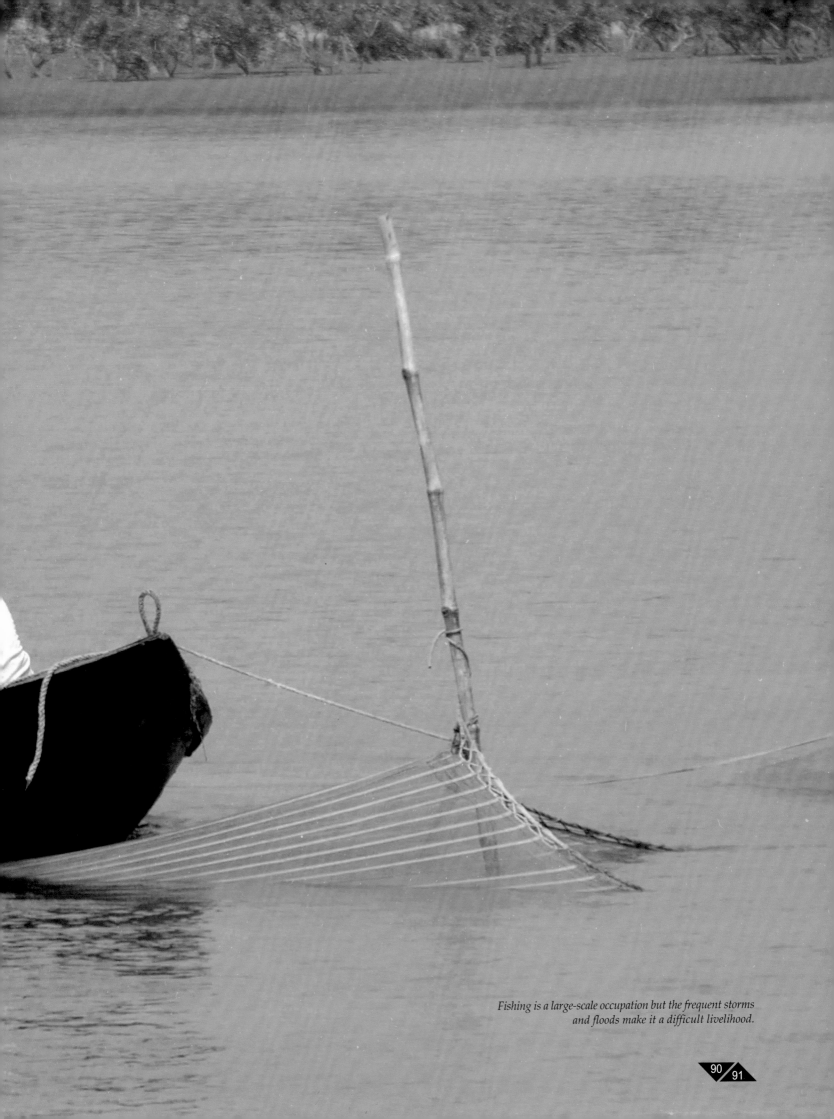

*Fishing is a large-scale occupation but the frequent storms and floods make it a difficult livelihood.*

*A village woman putting 'sindoor' (vermilion) on her forehead.*

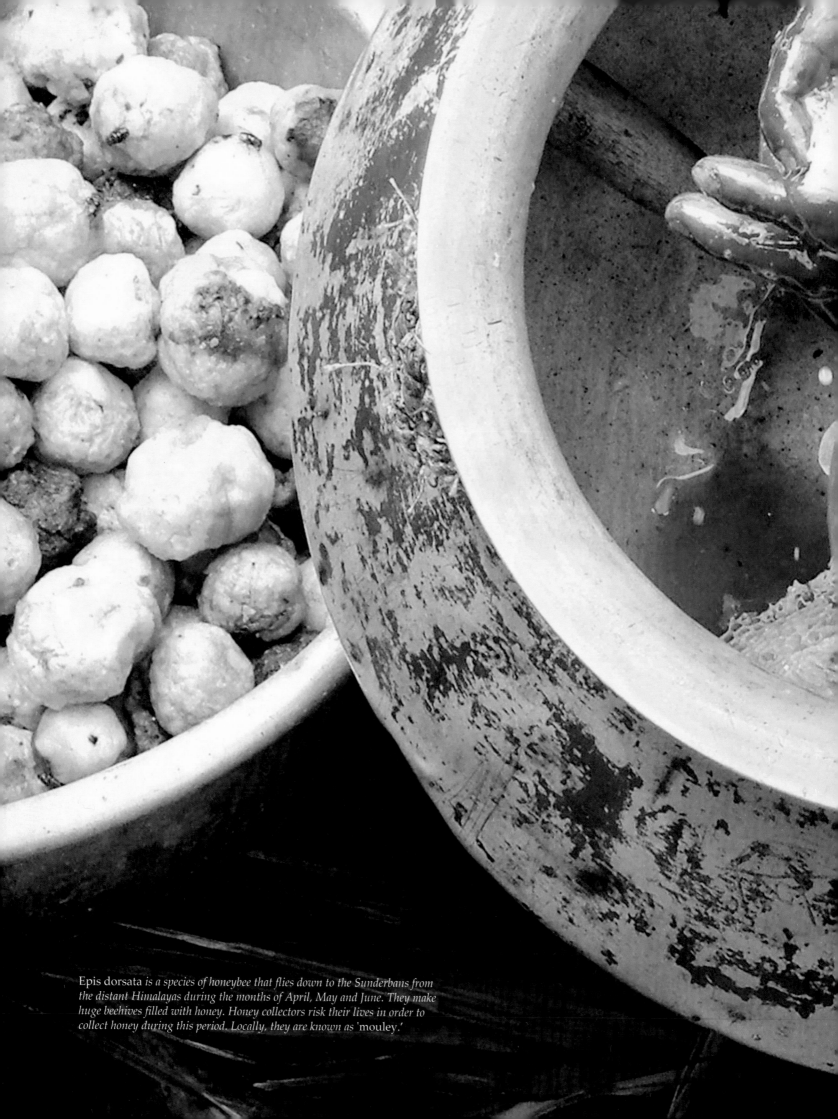

Epis dorsata *is a species of honeybee that flies down to the Sunderbans from the distant Himalayas during the months of April, May and June. They make huge beehives filled with honey. Honey collectors risk their lives in order to collect honey during this period. Locally, they are known as 'mouley.'*

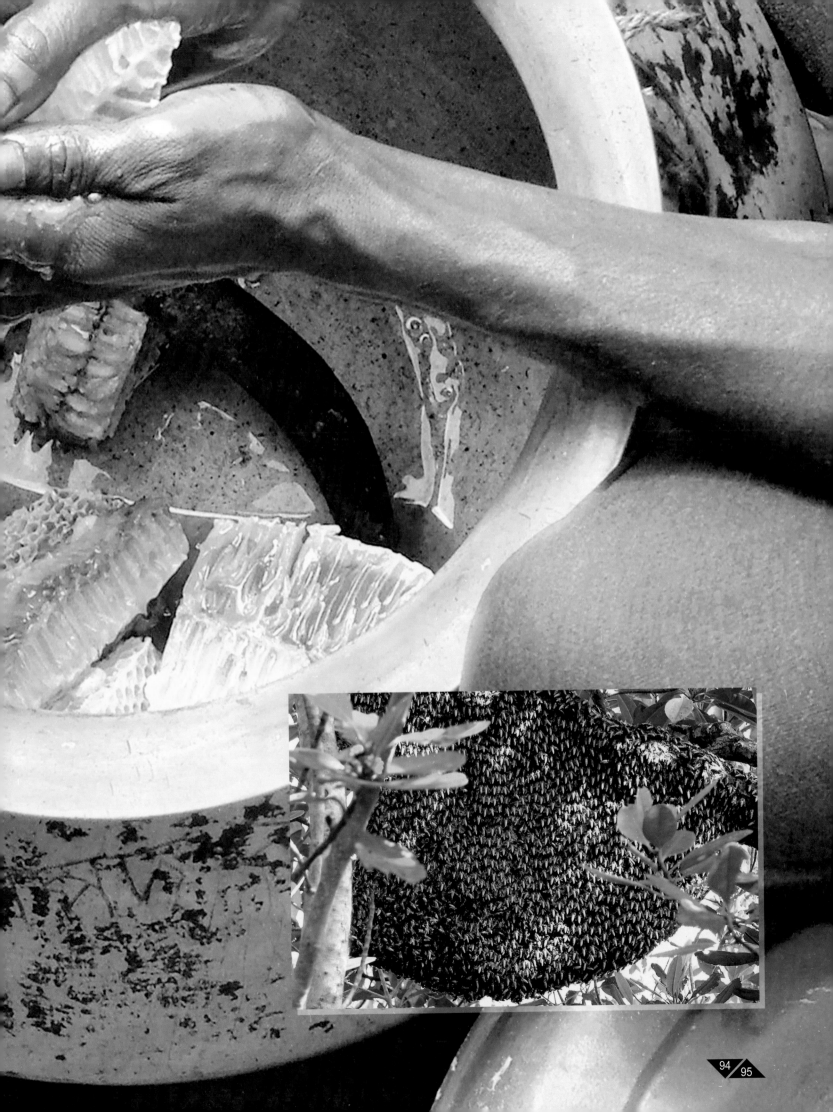

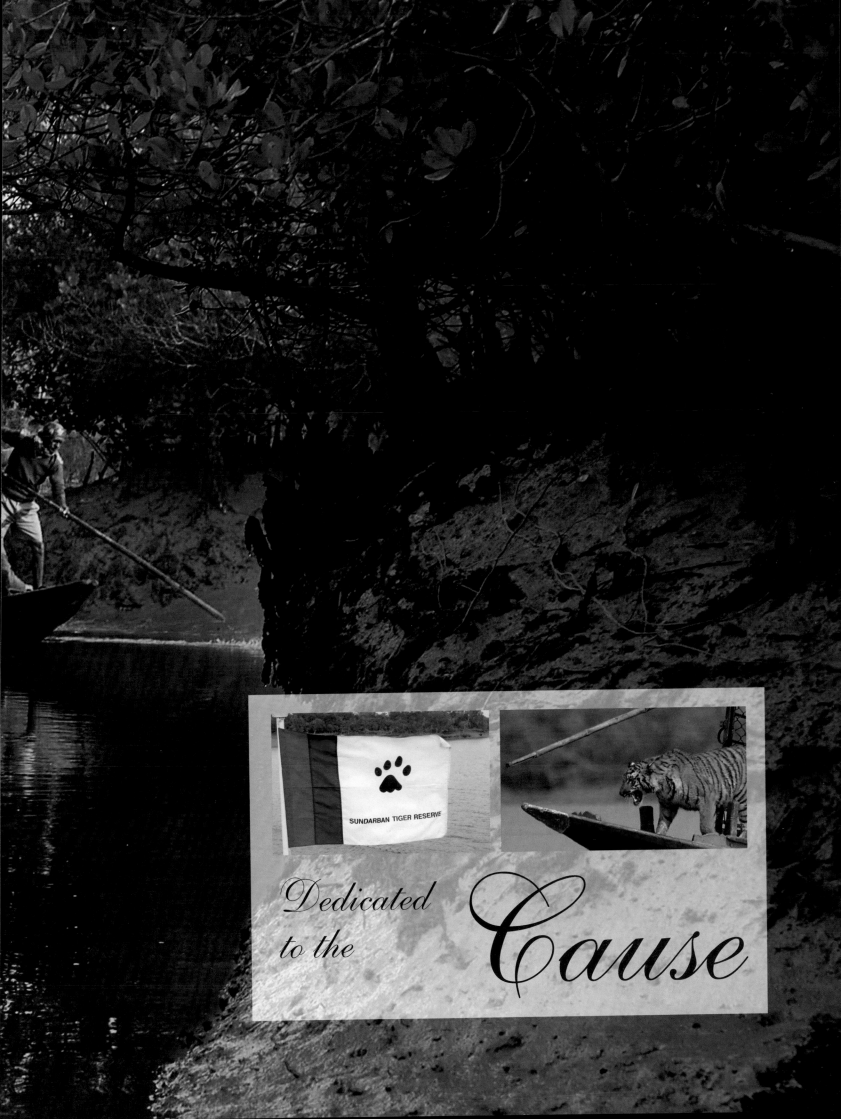

SUNDARBAN TIGER RESERVE

*Dedicated
to the*

*Cause*

*R*eclamation of land for agriculture in the latter half of the 19th century led to the Swamp Deer *(Aervus devaucelli),* Hog Deer *(Axis porcinus)* and Barking Deer *(Muntiacus muntjak)* becoming extinct. The Javan Rhino *(Rhinoceros sondaicus)* and the Wild Buffalo *(Bubalus bubalis)* have also become extinct.

Prior to 1973, the year 'Project Tiger' was launched, the entire Sunderbans were subjected to harvesting of natural resources. After 'Project Tiger' was announced, the focus shifted to promoting the conservation of the natural ecosystem by mitigating man-induced limiting factors and restoring the forest to its natural state.

The conservation strategy aims at preservation of bio-diversity of both flora and the fauna in the unique mangrove ecosystem, using the tiger as an indicator species. The entire forest has strict management zones. It has restricted fishing and honey collection, which is permissible in the South 24-Parganas Forest Division and in the buffer zone (excluding Sajnekhali Wildlife Sanctuary) of the Sunderbans Tiger Reserve. No activity except protection and research are allowed in the Sunderbans National Park, which constitutes the Core Zone. Eco-tourism is allowed everywhere in the Sunderbans, except the Core Zone.

*The authorities seize logs felled illegally.*

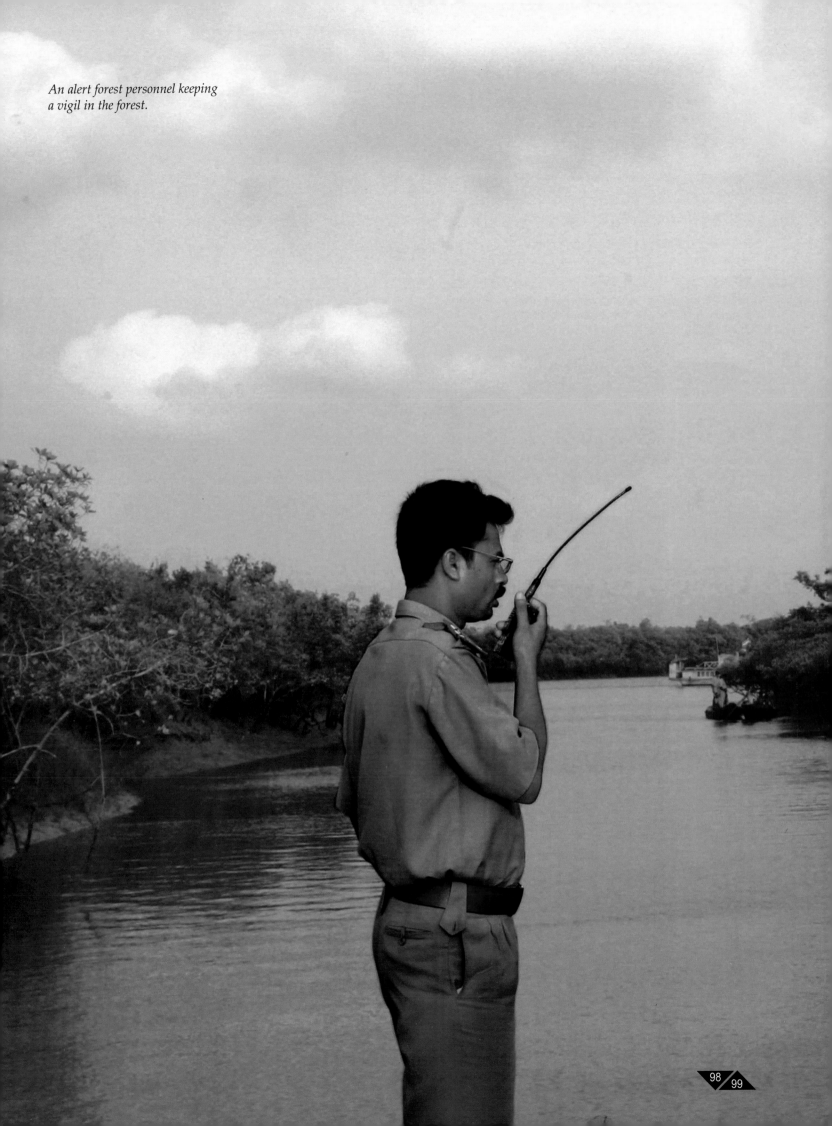

*An alert forest personnel keeping a vigil in the forest.*

In order to deal with man-animal conflict, a cause of grave concern, the management in the past, used 'human masks' and 'electrified dummies' to discourage tigers from attacking human beings. However, these measures did not bring about the expected results. In recent years, the strategy of restricting entry of fishermen in the Core Zone, and awareness generation have produced encouraging results and tiger attacks on humans have gone down drastically. At present, about five people are killed by tigers every year in the Sunderbans, compared to the former average of fifteen.

Sometimes tigers stray into villages at night, and risk getting killed if they fail to return to the forest before dawn. In a bid to ward off the animal, the villagers end up injuring or killing it. In doing so, sometimes the villagers themselves get hurt or killed. To combat the problem, the management has built a nylon net fence on the forest-village interface. This has helped in reducing the number of straying tigers drastically.

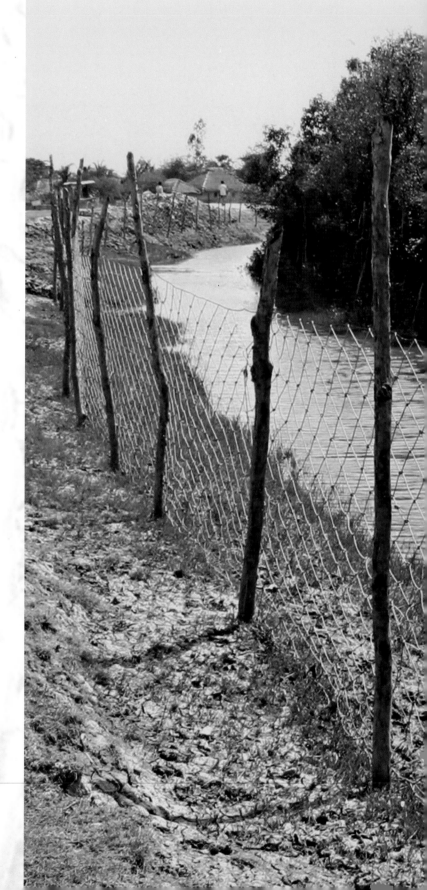

*Nylon nets have been installed along the river banks to prevent tigers from straying into villages.*

*Tourism is allowed in the buffer area of the Sunderbans Tiger Reserve. Tourists are not allowed to enter the Core Zone.*

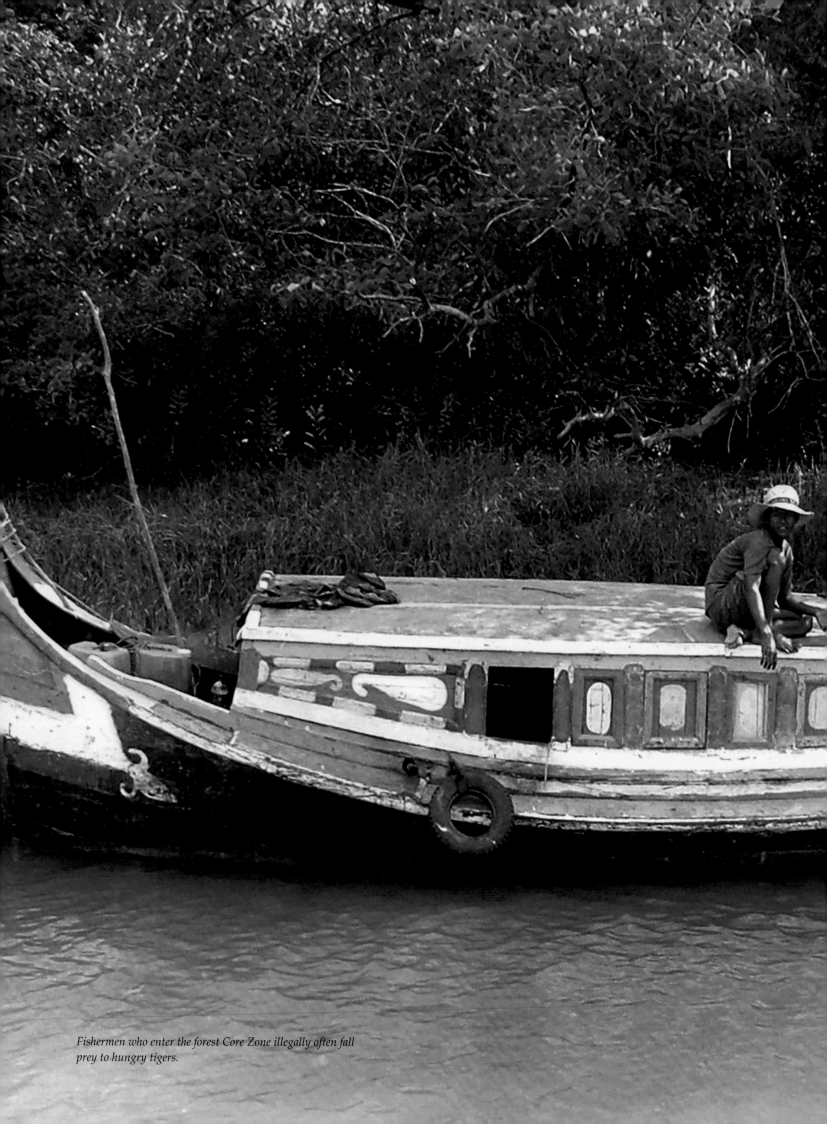

*Fishermen who enter the forest Core Zone illegally often fall prey to hungry tigers.*

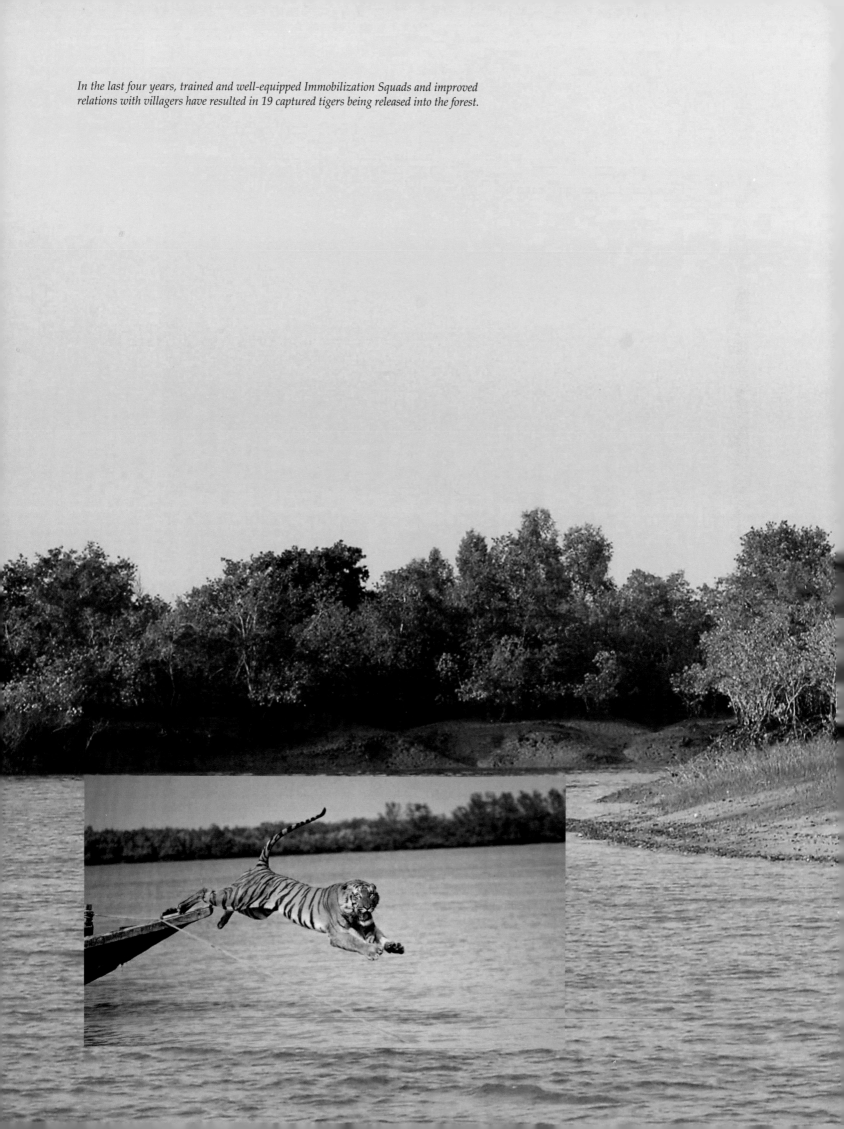

*In the last four years, trained and well-equipped Immobilization Squads and improved relations with villagers have resulted in 19 captured tigers being released into the forest.*

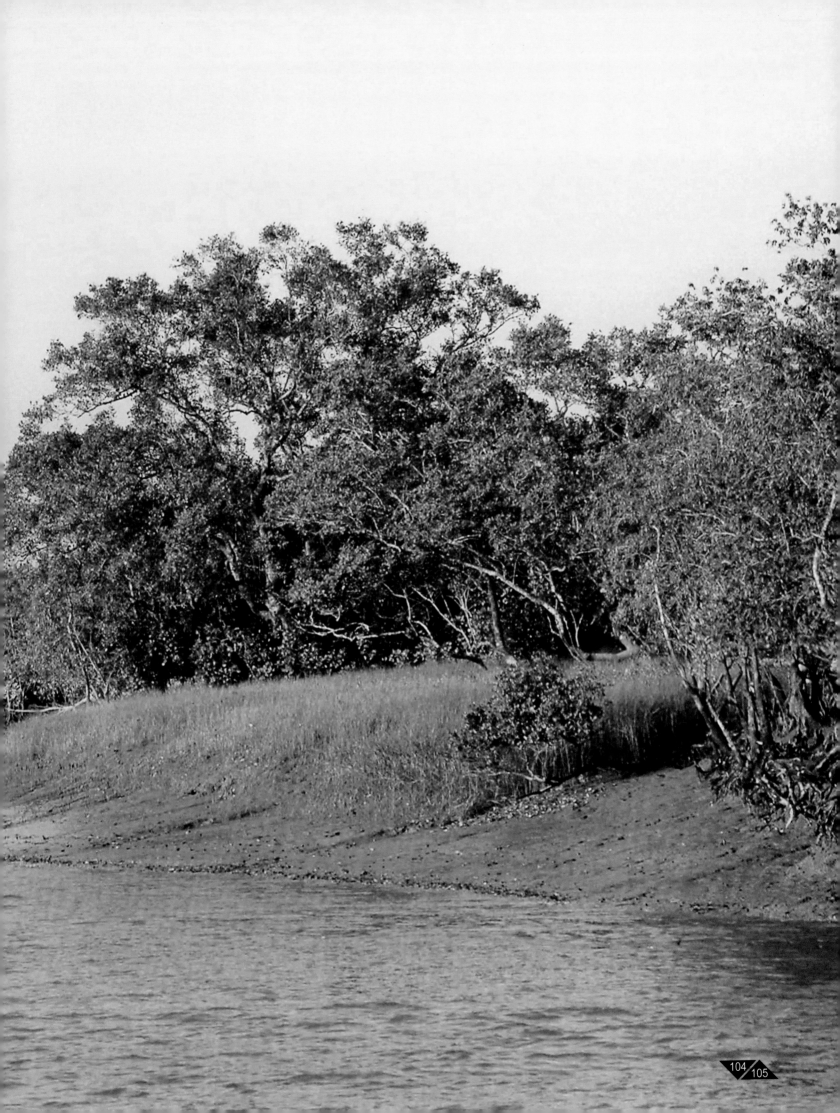

To replenish the Estuarine Crocodile stock an artificial breeding programme is being run at Bhagbatpur where over 400 hatchlings have been successfully reared and released into the Sunderbans.

The beaches of the Sunderbans are a favourite hatching ground for marine turtles, especially the Olive Ridley Turtle. An artificial breeding programme for Olive Ridley Turtles has been in operation at Sajnekhali for the last ten years.

The monitoring of the ecosystem using the tiger as an indicator species is carried out every second year. The latest monitoring exercise, a shift from the earlier Pug-Mark Count method, was conducted in January 2006 with the Sign Survey Approach. The census reports of 2004 indicate that there are more than 270 tigers in the Indian Sunderbans.

In this land of tigers, where there are man-tiger conflicts, the management has formed Protection Committees in fringe villages to improve the quality of life of the villagers through various eco-developmental activities. This has reduced biotic interference on the forest.

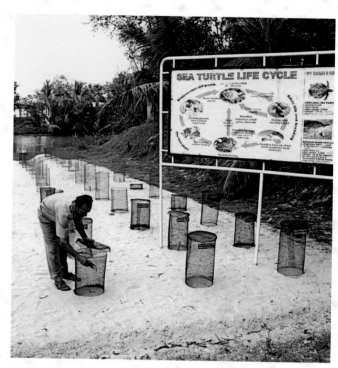

*The Sea Turtle Conservation Centre at Sajnekhali.*

*The manager of the Sunderbans Tiger Reserve directing his staff.*

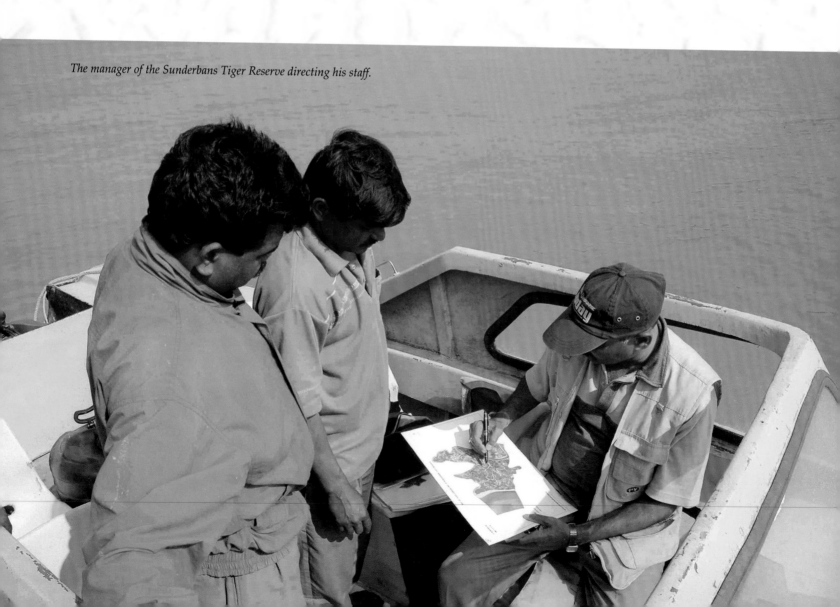

To ensure the protection of this natural treasure, camps with trained personnel have been set up at strategic locations. Firearms, wireless telecommunication sets and watercrafts have been provided. Additional resources such as geographical positioning system, radio collars, camera traps, satellite phones and satellite monitors and other modern technological aids have been implemented successfully. The area is being managed according to the approved 'Management Plan' with special emphasis on nature education and awareness creation among fringe villages and schools.

In order to encourage eco-tourism, many watchtowers and caged paths have been constructed and tourist boats and launches have been granted permits in some restricted zones by the management.

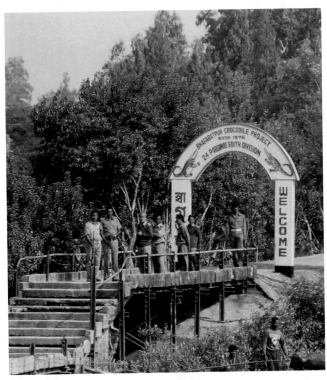

*The Crocodile Breeding Project at Bhagabatpur.*

*A temporary watchtower at Mechua.*

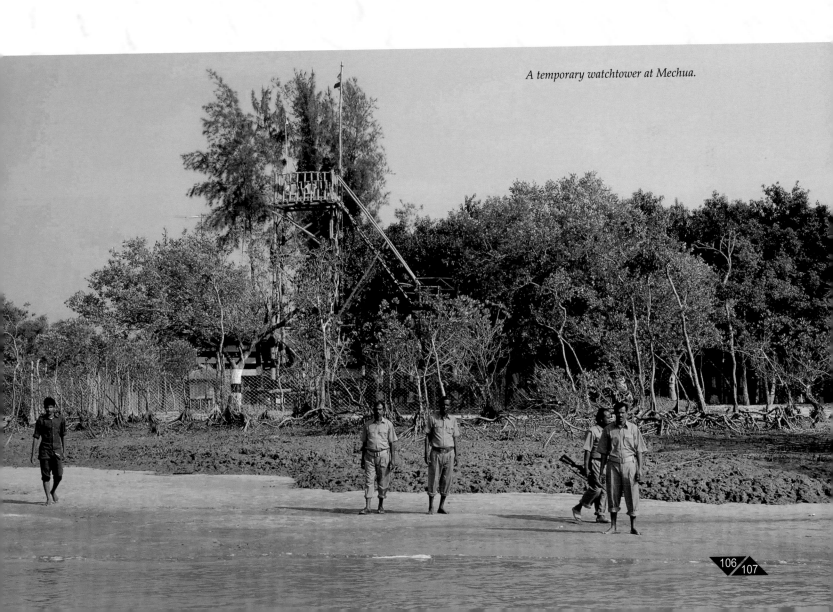

# TOURIST HAVEN

The eerie mangroves, the elusive tigers, the colourful fiddlers, the serene sea face and hundreds of species of winged jewels have made the Sunderbans an ideal tourist destination, with over 60,000 visitors to the Sunderbans Project Tiger zone. The infrastructural facilities range from high-end to low-end.

The management authorities of the Sunderbans also provide various facilities to tourists. The Project Tiger authorities permit tourism in the buffer areas but it is totally prohibited in the Core Zone. The entire Project Tiger area has been declared a no-plastic, no-microphone zone and an eco-squad has been engaged to collect the litter thrown by the tourists. Trained eco-guides are provided by the management.

The facilities provided by different departments of the state are stated below:

## Sajnekhali Tourist Interpretation Centre and Watchtower

In order to explain different aspects of the mangrove forests of the Sunderbans, a Mangrove Interpretation Centre has also been constructed at Sajnekhali.

The Project Tiger authorities have constructed a

*The Sudhanyakhali Watchtower.*

watchtower and a sweet water pool thus providing tourists a fine view of wildlife drinking at the pool. A few Estuarine Crocodiles are also kept in the pool.

A centre for breeding the rare River Terrapin has been set up at Sajnekhali.

The State Tourism Department has developed a multi-room tourist lodge at a reasonable rate in Sajnekhali. Dining facilities are also available here.

## Sudhanyakhali Watchtower

Another watchtower has been constructed at an important location in Sudhanyakhali, which also has a sweet water pond. Chital Deer, Wild Boar, Water Monitors and tigers can occasionally be spotted at the pool.

## Do-Banki Canopy Walk

About two and a half kilometres away from Sajnekhali at Do-Banki is a 150 metre-long canopy trail which leads to a watchtower. A Deer Acclimatisation Centre has been developed here.

## Netidhopani Watchtower

A watchtower has been set up at Netidhopani. Wildlife can be viewed from here along the observation line developed by the Project Tiger authorities.

The ruins of a temple and an ancient brick road indicate the existence of an old civilization in the region.

An annual festival takes place at the temple of Bonobibi located at Netidhopani

## Sunderkati Eco-Complex

An eco-complex has been developed at Sunderkati by the South 24-Parganas Forest Division and is equipped with a watchtower and a small interpretation centre.

## Burir Dabri Cage Trail

A 200-metre long walking trail covered by nylon net and a woven wire mesh to resist attack by tigers and to enable the tourists to walk amidst the mangrove forest has been developed by 'Project Tiger' in Burir Dabri. There is a watchtower as well.

## Bhagabatpur Crocodile Project

On the northern bank of the River Saptamukhi, an Estuarine Crocodile Breeding Project has been set up by the forest department. It is located opposite the Lothian Island. The objective of this project is to breed and hatch eggs of Estuarine Crocodiles in captivity and subsequently release them in the wild. Tourists are welcome at the project and the interpretation centre adjacent to it.

*The Mangrove Trail Park.*

## Lothian Island and Wildlife Sanctuary

Other than tigers, there are many more wild animals in this 38-sq km sanctuary.

One can walk in the mangrove forest without the fear of tigers and enjoy wildlife and wilderness. The view of the setting sun from Lothian is magnificent.

## Haliday Island and Wildlife Sanctuary

No tigers are found on this island. There are Chital Deer, Wild Boars and Rhesus Monkeys in this tiger-free zone of the Sunderbans. One can observe different mangrove tree species, crabs and mudskippers from close quarters. The sanctuary is located on the River Matla.

## FACTFILE

| | |
|---|---|
| Latitude & Longitude | : $21^0 32''$ and $22^0 40''$ north |
| | Latitude $88^0 03''$ and Longitude $89^0$ east |
| Nearest Airport | : Netaji Subhas Chandra Bose International Airport, Kolkata |
| Nearest Railway Station | : Canning (Sealdah Section) |
| Territory | : Total area including Bangladesh—26,000 sq km Indian Sunderbans—9,630 sq km Reserved Forest—4,263 sq km Project Tiger—2,585 sq km |
| Climate | : Hot and humid summer Pleasant winter Turbulent water during summers |

| | |
|---|---|
| Islands | : 54 inhabited and 48 habitat Total—102. |
| Entry Points | : Sonakhali, Jharkhali, Godkhali, Canning, Namkhana |
| Status | : National Park Wildlife Sanctuary Project Tiger Biosphere Reserve World Heritage Site |
| Temperature | : Summer: $29^0$ C Winter: $20^0$ C Average: $25^0$ C |
| Flora | : True mangrove—26 Associate mangrove—29 Back mangrove—29 |
| Major Fauna | : Tiger, Fishing Cat, Chital Deer, Rhesus Monkey, Wild Boar, Smooth Coated Otter, Estuarine Crocodile, Water Monitor Lizard, King Cobra, Batagur Baska and Olive Ridley Turtle |
| Principal Rivers of Sunderbans | : Thakuran, Saptamukhi, Matla, Gosaba, Raimongol, Bidyadhari, Jhila and Ichamoti |
| Religion | : Hinduism, Islam and Christianity |
| Local Language | : Bengali |
| Principal Occupation | : Agriculture, Labour, Fishing and Honey collection |
| Administrative Divisions | : Sunderbans Tiger Reserve South 24 Parganas Forest Division |
| Administrative heads | : Overall Charge - Director, Sunderbans Biosphere Reserve. In charge of Sunderbans Tiger Reserve <br> - Conservator of Forests and The Field Director. In charge of 24-Parganas South Division <br> - Divisional Forest Officer, 24-Parganas South Division |

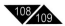

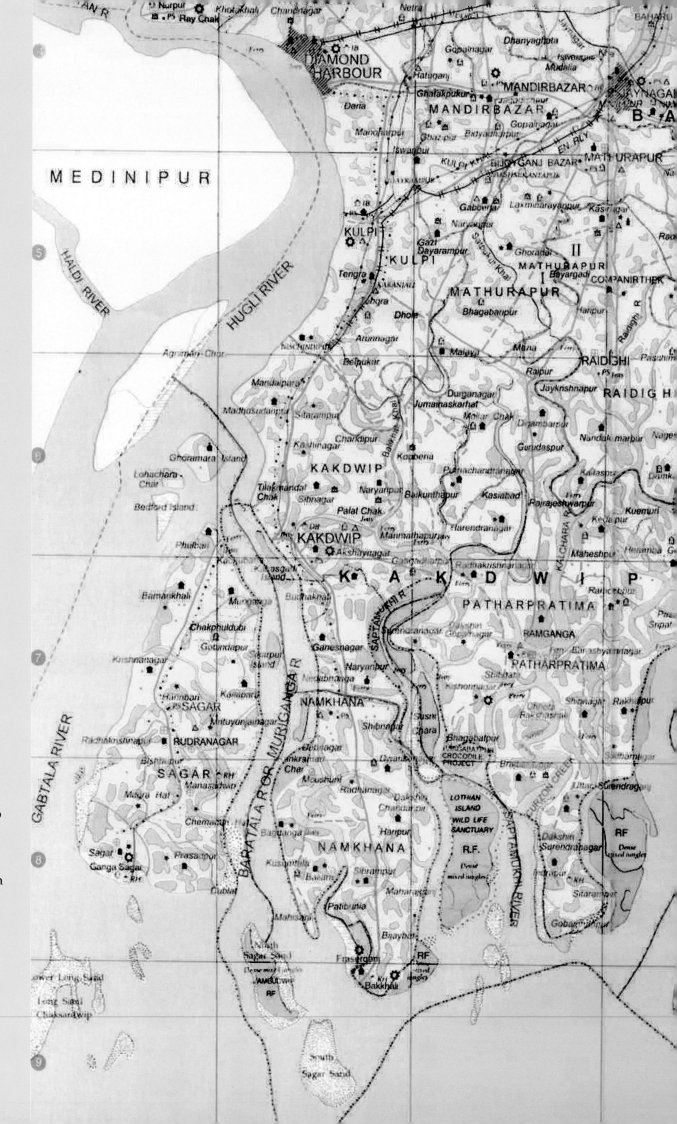

N

MEDINIPUR

**Sunderbans Map**
(Not to scale)

**Total area**
including Bangladesh
26,000 sq km

**Indian Sunderbans**
9,630 sq km

**Reserved Forest**
4,263 sq km

**Project Tiger**
2,585 sq km

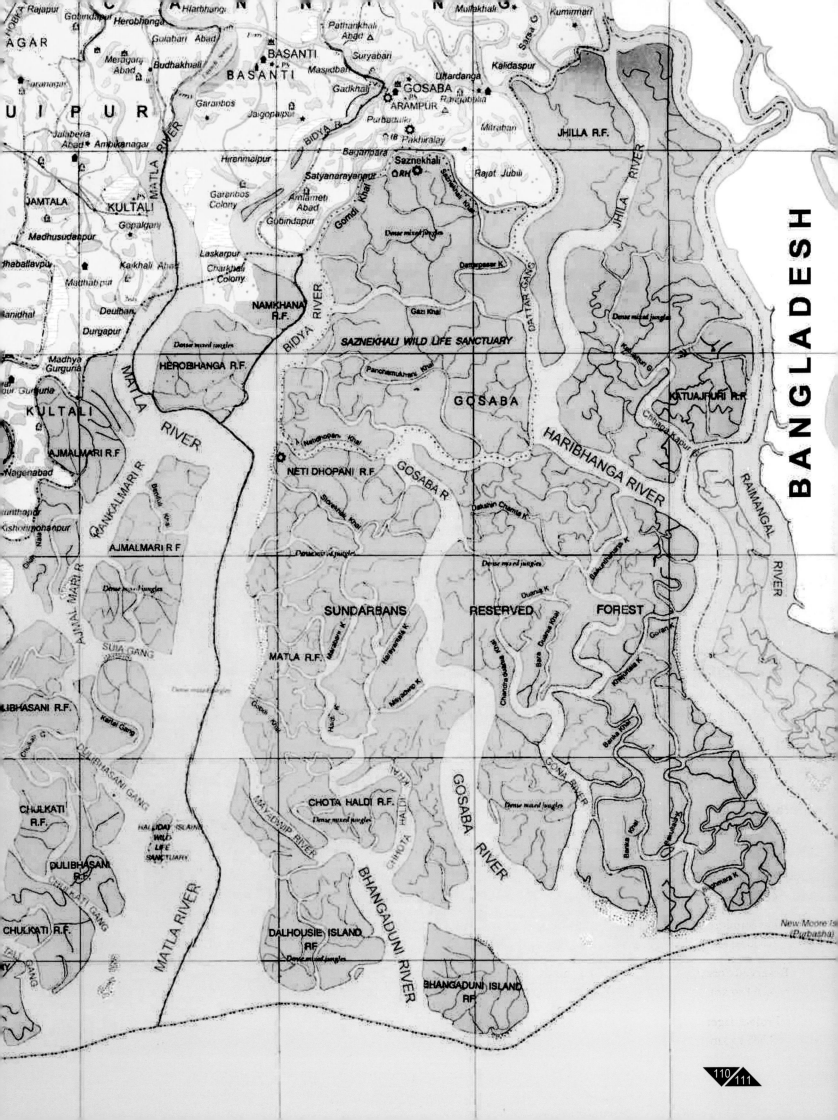

BANGLADESH

# USEFUL ADDRESSES

Principal Chief Conservator of Forest
Aranya Bhaban
Salt Lake
Kolkata-700 091
Tel: 033 2335 8580

Principal Chief Conservator of Forest
Wildlife and Chief Wildlife Warden
Bikash Bhaban
Salt Lake
Kolkata-700 091
Tel: 033 2334 6900

Chief Conservator of Forests and Director
Sunderbans Biosphere Reserve
Bikash Bhaban
Salt Lake
Kolkata-700 091
Tel: 033 2321 1529

Conservator of Forests and Field Director
Sunderbans Tiger Reserve
Canning
South 24-Parganas
Tel: 03218 2566 159

Tourism Centre
3/2 BBD Bag
Kolkata-700 001
Tel: 033 2210 3199/2248 5168/ 2248 5917

Tagore Society for Rural Development
46B Arabindo Sarani
Kolkata-700 005
Tel: 033 2555 2433

Nature Environment & Wildlife Society
10 Chowringhee Terrace
Kolkata-700 020
Tel: 033 2223 4148

W W  Eastern Region
First Floor
Tata Centre
43 J L Nehru Road
Kolkata-700 071
Tel: 033 2288 3038

Institute of Climbers & Nature Lovers
13G Lake Terrace
Ground Floor
Sontoshpur
Kolkata-700 075
Tel: 033 2416 6286

Quest
112 Ananda Palit Road
Kolkata-700 014
Tel: 033 2416 2737

*Sonakhali is an entry point to the Sunderbans Tiger Reserve.*

# CHECKLIST

| Local Name | Scientific Name | Local Name | Scientific Name |
|---|---|---|---|
| Harguza | Acanthus ilicifolius L. | Banventhi | Hibiscus tetraphyllus Robx. |
| Lata Harguza | Acanthus volubilis Wall. | Garia | Kandelia candel (L.) Druce |
| Tora | Aegialitis rotundifolia Roxb. | Kripal | Lumnitzera racemosa Willd. |
| Khalsi | Aegiceras corniculatum (L.) Blancs | Chotomanda | Macrosolen cochinchinensis (Lour.) Von |
| Piara Bani | Avicennia marina (Forssk.) Vierh. | Golpata | Nypa fruticans (Thumb.) Wurmb. |
| Jath Bani | Avicennia officinalis L. | Hental | Phoenix paludosa Roxb. |
| Kal Bani | Avicennia alba Blume | Dhanighash | Porteresia coarctata (Roxb.) Takeoka |
| Amur | Aglaia cuculata (Roxb.) Pellegrin | Keya | Pandanus foetidus Roxb. |
| Hudo | Acrostichum aureum L | Keya kata | Pandanus tectorius Soland exParkinson |
| Bakul Kankra | Bruguiera cylindrica (L.) Blume | Garjan | Rhizophora apiculata Blume |
| Kankra | Bruguiera gymnorrhiza (L.) Lamk. | Garjan | Rhizophora mucronata Lamk. |
| Kankra | Bruguiera sexangula (Lour.) Poir | Nona Jhajhi | Ruppia maritime L. |
| Bakul Kankra | Bruguiera parviflora (Roxb.) W. & A. | Giria sak | Suaeda nudiflora Roxb. |
| Lata Sundari | Brownlowai tersa (L.) Kosterm | Giria sak | Suaeda maritima Dumort |
| Bhola Sundari | Brownlowai lanceolata Benth. | Baolilata | Sarcolobus globosus Wall. |
| Singer | Cynometra ramiflora L. | Nona sak | Salicornia brachiata Roxb. |
| Akas Bell | Cassytha filiformis L. | Keora | Sonneratia apetala Buch. Ham. |
| Bonjui | Clerodendrum inerme (L) Gaertn. | Chak Keora | Sonneratia caseolaris Engler |
| Sukhdarshan | Crinium defixum Ker-Gaw | Ora | Sonneratia griffithii Kurz. |
| Moth Garan | Ceriops tagal (Perr.) Robins | Ora | Sonneratia alba Smith |
| Jath Garan | Ceriops decandra (Griff.) Ding Hou | Paras | Thespesia populnea (L.) Sola. ex. Corr. |
| Panlata | Derris trifoliata Lour. | Paras | Thespesia populneoides (Roxb.) Kostel |
| Noalata | Derris scandens Benth | Ban Carpass | Thespesia lampus (Cav.) Dalz. & Gibs. |
| Baromanda | Dendropthoe falcate (Linn. F.) Etting | Jhau | Tamarix troupii Hole |
| Genwa | Excoecaria agallocha L. | Lal Jhau | Tamarix dioica Roxb. |
| | Excoecaria bicolar Hassak | Ban Jhau | Tamarix gallica L. |
| Dudhilata | Finlaysonia obovata Wall. | Manda | Viscum orientale Willd |
| Nona hatisur | Heliotrophium curassavicum L. | Manda | Viscum monoicum Roxb. |
| Sundari | Heritiera fomes Buch. Ham. | Dhundul | Xylocarpus granatum Koen. |
| Sundari | Heritiera littoralis Dryander | Passur | Xylocarpus mekongensis Pieree |
| Bhola | Hibiscus tiliaceus L. | | |

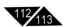

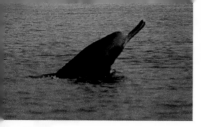  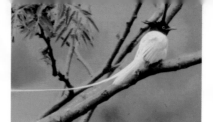 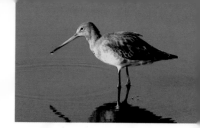

## MAJOR MAMMALS

| | |
|---|---|
| Royal Bengal Tiger | *Panthera tigris tigris* |
| Fishing Cat | *Felis viverrina* |
| Rhesus Macaque | *Macaca mulatta* |
| Axis Deer or Chital | *Axix axix* |
| Indian Wild Boar | *Sus scrofa* |
| Finless Porpoise | *Neophocaena phocaenoides* |
| Gangetic Dolphin | *Platanista gangetica* |
| Smooth Indian Otter | *Lutra perspicillata* |
| Irawaddy Dolphin | *Orcaella brevirostris* |

## EXTINCT MAMMALS

| | |
|---|---|
| Javan Rhinoceros | *Rhinoceros sondaicus* |
| Swamp Deer | *Cervus duvauceli* |
| Wild Buffalo | *Bubalus bubalis* |
| Barking Deer or Muntjac | *Muntiacus muntjak* |

## MAMMALS RECORDED IN RECLAIMED AREA

| | |
|---|---|
| House Shrew | *Suncus murinus* |
| Jungle Cat | *Felis chaus* |
| Jackal | *Canis aureus* |
| Indian Fox | *Vulpes bengalensis* |
| Small Indian Civet | *Viverricula indica* |
| Common Palm Civet | *Paradoxurus hermaphroditus* |
| Common Grey Mongoose | *Herpestes edwardsi* |
| Five-stripped Palm Squirrel | *Funambulus pennanti* |
| Field Mouse | *Mus booduga* |
| Mole Rat | *Bandicota indica* |
| Common Rat | *Rattus rattus* |
| House Mouse | *Mus musculus* |
| Indian Flying Fox | *Pteropus giganteus* |
| Short-Nosed Fruit Bat | *Cynopterus sphinx* |
| Lesser Yellow Bat | *Scotophilus kuhlii* |
| Indian False Bat | *Megaderma lyra* |
| Lesser Rat-tailed | *Rhinopoma hardwickii* |
| Pigmy Pipistrelle | *Pipistrellus mimu* |

## BIRDS: Indications

| | |
|---|---|
| Resident | R |
| Breeder | B |
| Summer Migrant | S |
| Migration within Subcontinent | M |
| Passage Migrant | P |
| Winter Migrant | W |
| Vagrant | V |
| Localised or Patchily Distributed (eg. LB = Local Breeding) | L |
| Status Unknown | ? |
| Abundant | 5 |
| Common | 4 |
| Fairly Common | 3 |
| Uncommon | 2 |
| Rare | 1 |

### PHASIANIDAE: PARTRIDGES, FRANCOLINS SNOWCOCKS, QUAILS...PHEASANTS

| | | | |
|---|---|---|---|
| 1. | Red Jungle Fowl | *Gallus gallus* | R 5 |

### DENDROCYGNIDAE: WHISTLING DUCK

| | | | |
|---|---|---|---|
| 2. | Lesser Whistling Duck | *Dendrocygna javanica* | R 2 |

### ANATIDAE: SWANS, GEESE... DUCKS

| | | | |
|---|---|---|---|
| 3. | Ruddy Shelduck | *Tadorna ferruginea* | WML 2 |
| 4. | Cotton Pygmy-Goose | *Nettapus coromandelianus* | R 2 |
| 5. | Gadwall | *Anas strepera* | WL 2 |
| 6. | Northern Shoveller | *Anas clypeata* | WL 2 |
| 7. | Northern Pintail | *Anas acuta* | WL 2 |
| 8. | Red-Crested Pochard | *Rhodonessa rufina* | WL 2 |
| 9. | Ferruginous Pochard | *Aythya nyroca* | WL 1 |
| 10. | Bae's Pochard | *Aythya baeri* | WL 1 |

### PICIDAE: WRYNECKS, PICULETS...WOODPECKERS

| | | | |
|---|---|---|---|
| 11. | Eurasian Wryneck | *Jynx torquilla* | W 2 |
| 12. | Fulvous-breasted Woodpecker | *Dendrocopos macei* | R 3 |

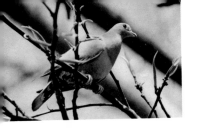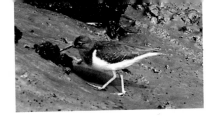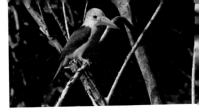

| 13. | Streak-throated Woodpecker | *Picus xanthopygaeus* | R 3 |
|---|---|---|---|
| 14. | Common Flameback | *Dinopium javanense* | R 2 |
| 15. | Black-rumped Flameback | *Dinopium benghalense* | R 4 |
| 16. | Greater Flameback | *Chrysocolaptes lucidus* | R 3 |

### MEGALAIMIDAE : ASIAN BARBETS

| 17. | Blue-throated Barbet | *Megalaima asiatica* | R 5 |
|---|---|---|---|
| 18. | Coppersmith Barbet | *Megalaima haemacephala* | R 2 |

### UPUPIDAE: HOOPOE

| 19. | Common Hoopoe | *Upupa epops* | W 2 |
|---|---|---|---|

### ALCEDINIDAE: SMALL KINGFISHERS

| 20. | Common Kingfisher | *Alcedo atthis* | R 3 |
|---|---|---|---|

### HALCYONIDAE: LARGE KINGFISHERS

| 21. | Brown-winged Kingfisher | *Halcyon amauroptera* | R 2 |
|---|---|---|---|
| 22. | Ruddy Kingfisher | *Halcyon coromanda* | R 1 |
| 23. | White-throated Kingfisher | *Halcyon smyrnensis* | R 2 |
| 24. | Black-capped Kingfisher | *Halcyon pileata* | RL 4 |
| 25. | Collared Kingfisher | *Todiramphus chloris* | RL 4 |

### CERYLIDAE: PIED KINGFISHERS

| 26. | Pied Kingfisher | *Ceryle rudis* | R 2 |
|---|---|---|---|

### MEROPIDAE: BEE-EATERS

| 27. | Green Bee-eater | *Merops orientalis* | RL 3 |
|---|---|---|---|
| 28. | Blue-tailed Bee-eater | *Merops philippinus* | SM 3 |
| 29. | Chestnut-headed Bee-eater | *Merops Leschenaulti* | WM 2 |

### CUCUIDAE: CUCKOOS

| 30. | Pied Cuckoo | *Clamator jacobinus* | SM 2 |
|---|---|---|---|
| 31. | Chestnut-winged Cuckoo | *Clamator coromandus* | SM 1 |

| 32. | Common Haw Cuckoo | *Hierococcyx varius* | RL 3 |
|---|---|---|---|
| 33. | Indian Cuckoo | *Cuculus micropterus* | M 2 |
| 34. | Oriental Cuckoo | *Cuculus saturatus* | WM 2 |
| 35. | Lesser Cuckoo | *Cuculus poliocephalus* | WM 1 |
| 36. | Grey-bellied Cuckoo | *Cacomantis passerinus* | R 1 |
| 37. | Plaintive Cuckoo | *Cacomantis merulinus* | SM3 |
| 38. | Asian Koel | *Eudynamys scolopacea* | R 2 |
| 39. | Green-billed Malkoha | *Phaenicophaeus tristis* | R 3 |

### CENTROPODIDAE: COUCALS

| 40. | Greater Coucal | *Centropus sinensis* | R 5 |
|---|---|---|---|

### PSITTACIDAE: PARROTS

| 41. | Rose-ringed Parakeet | *Psittacula Krameri* | R 5 |
|---|---|---|---|

### APODIDAE: SWIFTS

| 42. | Asian Palm Swift | *Cypsiurus balasiensis* | R 4 |
|---|---|---|---|

### STRIGIDAE: OWLS

| 43. | Oriental Scops Owl | *Otus sunia* | R 4 |
|---|---|---|---|
| 44. | Collared Scops Owl | *Otus bakkamoena* | R 2 |
| 45. | Brown Fish Owl | *Ketupa zeylonensis* | R 2 |
| 46. | Spotted Owl | *Athene brama* | R 3 |

### CAPRIMULGIDAE: NIGHTJARS

| 47. | Large-tailed Nightjar | *Caprimulgus macrurus* | R 5 |
|---|---|---|---|

### COLUMBIDAE: PIGEONS... DOVES

| 48. | Laughing Dove | *Streptopelia senegalensis* | RL 2 |
|---|---|---|---|
| 49. | Spotted Dove | *Streptopelia chinensis* | RL 4 |
| 50. | Red-collared Dove | *Streptopelia tranquebarica* | W 2 |
| 51. | Eurasian-collared Dove | *Streptopelia decaoto* | R 5 |
| 52. | Emerald Dove | *Chalcophaps indica* | RL 1 |
| 53. | Orange-breasted Green Pigeon | *Treron bicincta* | RL 4 |

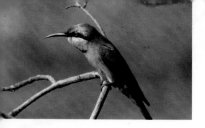 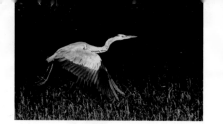 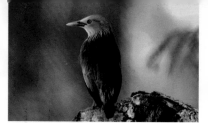 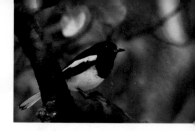

| 54. | Yellow-footed Green Pigeon | *Treron phoenicoptera* | RL 2 |
|---|---|---|---|

### RALLIDAE: RAILS, GALLINULES... COOTS

| 55. | Slaty-legged Crake | *Rallina eurizonoides* | RLWM |
|---|---|---|---|
| 56. | White-breasted Waterhen | *phoenicurus* | RL 3 |
| 57. | Common Coot | *Fulica atra* | WL 2 |

### SCOLOPACIDAE: SNIPES, CURLEWS, SANDPIPERS, ETC.

| 58. | Pintail Snipe | *Gallinago stenura* | W 1 |
|---|---|---|---|
| 59. | Common Snipe | *Gallinago gallinago* | WL 2 |
| 60. | Black-tailed Godwit | *Limosa limosa* | W 2 |
| 61. | Bar-tailed Godwit | *Limosa lapponica* | W 2 |
| 62. | Whimbrel | *Numenius phaeopus* | W 5 |
| 63. | Eurasian Curlew | *Numenius arquata* | RW 3 |
| 64. | Spotted Redshank | *Tringa erythropus* | W1 |
| 65. | Common Redshank | *Tringa tetanus* | RW 5 |
| 66. | Common Greenshank | *Tringa nebularia* | W 2 |
| 67. | Green Sandpiper | *Tringa ochropus* | W 2 |
| 68. | Wood Sandpiper | *Tringa glareola* | WL 2 |
| 69. | Terek Sandpiper | *Xenus cinereus* | W 3 |
| 70. | Common Sandpiper | *Actitis hypoleucos* | RW 5 |
| 71. | Ruddy Turnstone | *Arenaria interpres* | W 2 |
| 72. | Asian Dowitcher | *Limnodromus semipalmatus* | W1 |
| 73. | Great Knot | *Calidris tenuirostris* | W 2 |
| 74. | Little Stint | *Calidris minuta* | W 1 |
| 75. | Temmink's Stint | *Calidris temmincki* | W 2 |
| 76. | Dunlin | *Calidris alpine* | W 1 |
| 77. | Curlew Sandpiper | *Calidris ferruginea* | W 1 |

### ROSTRATULIDAE: PAINTED-SNIPES

| 78. | Greater Painted Snipes | *Rostratula bengalensis* | RL 2 |
|---|---|---|---|

### JACANIDAE: JACANAS

| 79. | Pheasant-tailed Jacana | *Hydrophasianus chirurgus* | RL 2 |
|---|---|---|---|
| 80. | Bronze-winged Jacana | *Metopidius indicus* | RL 2 |

### BURHINIDAE: THICK-KNEES

| 81. | Eurasian Thick-knee | *Burhinus oedicnemus* | RL 1 |
|---|---|---|---|
| 82. | Great Thick-knee | *Esacus recurvirostris* | RL 3 |

### CHARADRIIDAE: OYSTERCATCHERS, AVOCETS, STILTS... LAPWINGS

| 83. | Eurasian Oystercatcher | *Haematopus ostralegus* | W 2 |
|---|---|---|---|
| 84. | Pacific Golden Plover | *Pluvialis fulva* | W 4 |
| 85. | Grey Plover | *Pluvialis squatarola* | W 1 |
| 86. | Little Ringed Plover | *Charadrius dubius* | W 3 |
| 87. | Kentish Plover | *Charadrius alexandrinus* | RW 4 |
| 88. | Lesser Sand Plover | *Charadrus mongolus* | W 3 |
| 89. | Greater Sand Plover | *Charadrius leschenaultii* | W 3 |
| 90. | Grey-headed Lapwing | *Vanellus cinereus* | W 2 |
| 91. | Red-wattled Lapwing | *Vanellus indicus* | R 1 |

### LARIDAE: GULLS... TERNS

| 92. | Pallas's Gull | *Larus ichthyaetus* | W 3 |
|---|---|---|---|
| 93. | Brown-headed Gull | *Larus brunnicephalus* | W 3 |
| 94. | Black-headed Gull | *Larus ridibundus* | W 3 |
| 95. | Gull-billed Tern | *Gelochelidon nilotica* | W 2 |
| 96. | Caspian Tern | *Sterna caspia* | WML 2 |
| 97. | Great Crested Tern | *Sterna bergii* | W 2 |
| 98. | Common Tern | *Sterna hirundo* | W 2 |
| 99. | Whiskered Tern | *Chlidonias hybridus* | RMW 4 |

### ACCIPITRIDAE: OSPREY, HAWKS, EAGLES, HARRIERS...VULTURES

| 100. | Osprey | *Pandion Haliaetus* | W 3 |
|---|---|---|---|
| 101. | Oriental Honey-Buzzard | *Pernis ptilorhyncus* | RLW 3 |

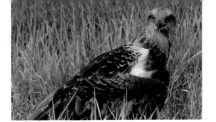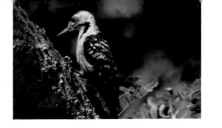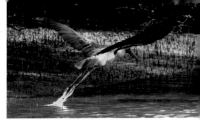

| 102. Black Kite | Milvus migrans | RMW 2 |
|---|---|---|
| 103. Brahminy Kite | Haliastur Indus | R 4 |
| 104. White-billed Sea Eagle | Haliaeetus leucogaster | R 4 |
| 105. White-rumped Vulture | Gyps Bengalensis | R 2 |
| 106. Short-toed Snake Eagle | Circaetus gallicus | W 2 |
| 107. Crested Serpent Eagle | Spilornis cheela | R 2 |
| 108. Pied Harrier | Circus melanoleucos | W 2 |
| 109. Shikra | Accipiter badius | R 4 |
| 110. Greater Spotted Eagle | Aquila clanga | W 2 |

**FALCONIDAE: FALCONS**

| 111. Red-necked Falcon | Falco chicquera | R 2 |
|---|---|---|

**PODICIPEDIDAE: GREBES**

| 112. Little Grebe | Tachybaptus ruficollis | R 2 |
|---|---|---|

**ANHINGIDAE: DARTER**

| 113. Darter | Anhinga melanogaster | RL 1 |
|---|---|---|

**PHALACROCORACIDAE: CORMORANTS**

| 114. Little Cormorant | Phalacrocorax niger | RBL 3 |
|---|---|---|
| 115. Indian Cormorant | Phalacrocorax fuscicollis | RBL 2 |

**ARDEIDAE: HERONS...BITTERNS**

| 116. Little Egret | Egretta garzetta | R 3 |
|---|---|---|
| 117. Grey Heron | Ardea cinerea | RL 2 |
| 118. Goliath Heron | Ardea goliath | ? 3 |
| 119. Purple Heron | Ardea purpurea | RBL 2 |
| 120. Great Egret | Casmerodius albus | R 5 |
| 121. Intermediate Egret | Mesophoyx intermedia | ? 1 |
| 122. Cattle Egret | Bubulcus ibis | RBL 3 |
| 123. Indian Pond Heron | Ardeola grayii | R 5 |
| 124. Little Heron | Butorides striatus | R 4 |
| 125. Black-crowned Night Heron | Nycticorax nycticorax | RBL 3 |
| 126. Yellow Bittern | Ixobrychus sinensis | RL 2 |

| 127. Cinnamon Bittern | Ixobrychus cinnamomeus | R 1 |
|---|---|---|
| 128. Black Bittern | Dupetor flavicollis | R 2 |

**THRESKIORNITHIDAE: IBISES... SPOONBILLS**

| 129. Black-headed Ibis | Threskiornis melanocephalus | ? 1 |
|---|---|---|

**PELECANIDAE: PELICANS**

| 130. Great White Pelican | Pelecanus onocrotalus | V 1 |
|---|---|---|

**CICONIIDAE: STORKS**

| 131. Asian Openbill | Anastomus oscitans | RL 4 |
|---|---|---|
| 132. Black-necked Stork | Ephippiorhynchus asiaticus | RL 2 |
| 133. Lesser Adjutant | Leptoptilos javanicus | RL 3 |

**PITTIDAE: PITTAS**

| 134. Indian Pitta | Pitta brachyura | RM 1 |
|---|---|---|
| 135. Mangrove Pitta | Pitta megarhyncha | R 2 |

**IRENIDAE: FAIRY BLUEBIRDS... LEAFBIRDS**

| 136. Golden-fronted Leafbird | Chloropsis aurifrons | R 2 |
|---|---|---|

**LANIIDAE: SHRIKES**

| 137. Brown Shrike | Lanius cristatus | W 4 |
|---|---|---|
| 138. Long-tailed Shrike | Lanius schach tricolor | RM 2 |

**CORVIDAE: WHISTLERS, TREEPIES, CROWS, WOOD SWALLOWS, ORIOLES, CUCKOOSHRIKES, MINIVETS, FANTAILS, DRONGOS, ETC.**

| 139. Mangrove Whistler | Pachycephala grisola | R 2 |
|---|---|---|
| 140. Rufous Treepie | Dendrocitta vagabunda | R 4 |
| 141. House Crow | Corvus splendens | R 2 |
| 142. Large-billed Crow | Corvus macrorhynchos | R 2 |
| 143. Ashy Woodswallow | Artamus fuscus | RL 3 |
| 144. Black-naped Oriole | Oriolus chinensis | R 2 |
| 145. Black-hooded Oriole | Oriolus xanthornus | R 4 |
| 146. Large Cuckooshrikes | Coracina macei | R 3 |

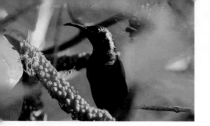 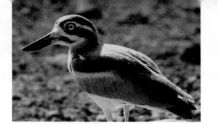 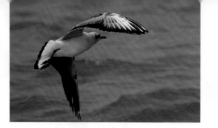 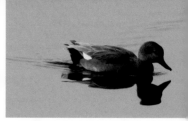

| 147. | Black-winged Cuckooshrike | *Coracina melaschistos* | R 2 |
|---|---|---|---|
| 148. | Black-headed Cuckooshrike | *Coracina melanoptera* | RL 3 |
| 149. | Small Minivet | *Pericrocotus cinnamomeus* | R 4 |
| 150. | White-throated Fantail | *Rhipidura albicollis* | R 4 |
| 151. | Black Drongo | *Dicrurus macrocercus* | RL 3 |
| 152. | Ashy Drongo | *Dicrurus leucophaeus* | M 2 |
| 153. | Bronzed Drongo | *Dicrurus aeneus* | R 5 |
| 154. | Spangled Drongo | *Dicrurus hottentottus* | RL 3 |
| 155. | Asian Paradise Flycatcher | *Terpsiphone paradisi* | SM 2 |
| 156. | Common Iora | *Aegithina tiphia* | R 4 |
| 157. | Common Woodshrike | *Tephrodornis pondicerianus* | R 2 |

### MUSCICAPIDAE: THRUSHES, FLYCATCHERS...CHATS

| 158. | Orange-headed Thrush | *Zoothera citrina* | R 2 |
|---|---|---|---|
| 159. | Tickell's Thrush | *Turdus unicolor* | R 2 |
| 160. | Red-throated Flycatcher | *Ficedula parva* | W 3 |
| 161. | Verditer Flycatcher | *Eumyias thalassina* | W 3 |
| 162. | Blue-throated Flycatcher | *Cyornis rubeculoides* | R 2 |
| 163. | Oriental Magpie Robin | *Copsychus saularis* | R 4 |
| 164. | White-rumped Shama | *Copsychus malabaricus* | R 2 |
| 165. | Indian Robin | *Saxicoloides fulicata* | R 2 |

### STURNIDAE: STARLINGS... MYNAS

| 166. | Chestnut-tailed Starling | *Sturnus malabaricus* | RL 3 |
|---|---|---|---|
| 167. | Asian Pied Starling | *Sturnus contra* | R 4 |
| 168. | Common Myna | *Acidotheres tristis* | R 3 |
| 169. | Jungle Myna | *Acidotheres fuscus* | R 5 |

### HIRUNDINIDAE: SWALLOWS... MARTINS

| 170. | Barn Swallow | *Hirundo rustica* | RMW 5 |
|---|---|---|---|

### PYCNONOTIDAE: BULBULS

| 171. | Red-whiskered Bulbul | *Pycnonotus jocosus* | R 4 |
|---|---|---|---|
| 172. | Red-vented Bulbul | *Pycnonotus cafer* | R 5 |

### CISTICOLIDAE: AFRICAN WARBLERS

| 173. | Yellow-bellied Prinia | *Prinia flaviventris* | RL 2 |
|---|---|---|---|
| 174. | Ashy Prinia | *Prinia socialis* | R 2 |
| 175. | Plain Prinia | *Prinia inornata* | RL 2 |

### ZOSTEROPIDAE: WHITE-EYES

| 176. | Oriental White-eye | *Zosterops palpebrosus* | R 5 |
|---|---|---|---|

### SYLVIIDAE: WARBLERS, GRASSBIRDS, LAUGHING THRUSHES...BABBLERS

| 177. | Blyth's Reed Warbler | *Acrocephalus dumetorum* | W 4 |
|---|---|---|---|
| 178. | Clamorous Reed Warbler | *Acrocephalus stentoreus* | R 2 |
| 179. | Common Tailorbird | *Orthotomus sutorius* | R 5 |
| 180. | Common Chiffchaff | *Phylloscopus collybita* | W 4 |
| 181. | Dusky Warbler | *Phylloscopus fuscatus* | W 3 |
| 182. | Hume's Warbler | *Phylloscopus humei* | W 5 |
| 183. | Greenish Warbler | *Phylloscopus trochiloides* | W 5 |
| 184. | Large-billed Leaf Warbler | *Phylloscopus magnirostris* | W 2 |
| 185. | Puff-throated Babbler | *Pellorneum ruficeps* | W 2 |
| 186. | Indian Scimitar Babbler | *Pomatorhinus horsfieldii* | R 4 |
| 187. | Striped Tit-Babbler | *Macronous gularis* | R 5 |
| 188. | Chestnut-capped Babbler | *Timalia pileata* | R 2 |
| 189. | Yellow-eyed Babbler | *Chrysomma sinense* | R 2 |
| 190. | Striated Babbler | *Turdoides earlei* | R 3 |
| 191. | Jungle Babbler | *Turdoides striatus* | R 5 |

### NECTARINIIDAE: FLOWERPECKERS...SUNBIRDS

| 192. | Pale-billed Flowerpecker | *Dicaeum erythrorhynchos* | R 4 |
|---|---|---|---|
| 193. | Scarlet-backed Flowerpecker | *Dicaeum cruentatum* | R 3 |

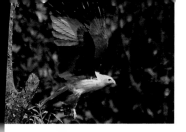
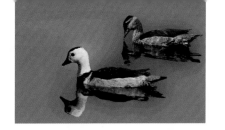
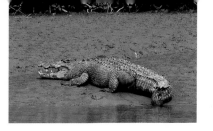

| | | |
|---|---|---|
| 194. Purple-rumped Sunbird | *Nectarinia zeylonica* | R 4 |
| 195. Purple Sunbird | *Nectarinia asiatica* | R 5 |
| 196. Loten's Sunbird | *Nectarinia lotenia* | ? 3 |

### PASSERIDAE: SPARROWS, WAGTAILS, PIPITS, WEAVERS...ESTRILDINE FINCHES

| | | |
|---|---|---|
| 197. House Sparrow | *Passer domesticus* | RL 2 |
| 198. Forest Wagtail | *Dendronanthus indicus* | P 2 |
| 199. White Wagtail | *Motacilla alba* | W |
| 220. Grey Wagtail | *Motacilla cinerea* | WL 3 |
| 201. Baya Weaver | *Ploceus philippinus* | RL 2 |
| 202. Scaly-breasted Munia | *Lonchura punctulata* | RL 2 |
| 203. Black-headed Munia | *Lanchura malacca* | RL 2 |

### LIZARDS AND CROCODILES

| | | |
|---|---|---|
| 1. | Tokay | *Gekko gecko* |
| 2. | House Gecko | *Hemidactylus flaviviridis* |
| 3. | Grey House Gecko | *Hemidactylus brookii* |
| 4. | Garden Lizard | *Calotes versicolor* |
| 5. | Chamaeleon | *Chamaeleon zeylanicus* |
| 6. | —— | *Mabuya carinata* |
| 7. | Water Monitor, (Salvator Lizard) | *Varanus salvator* |
| 8. | Monitor Lizard | *Varanus flavescens* |
| 9. | Estuarine Crocodile | *Crocodylus porosu* |

### TURTLES, TORTOISES, TERRAPINS

| | | |
|---|---|---|
| 1. | River Terrapin | *Batagur baska* |
| 2. | Painted Roofed Turtle | *Kachuga kachuga* |
| 3. | —— | *Kachuga tecta* |
| 4. | Spotted Pond Turtle | *Geoclemys hamiltonii* |
| 5. | Indian Flapshell Turtle | *Lissemys punctata* |
| 6. | Coast Soft Shell | *Pelochelys bibroni* |

| | | |
|---|---|---|
| 7. | Narrow-headed Soft Shell Turtle | *Chitra indica* |
| 8. | Olive Ridley Turtle | *Lepidochelys olivacea* (Sea turtle) |
| 9. | Green Turtle | *Chelonia mydas* (Sea turtle) |
| 10. | Hawksbilled Turtle | *Eretmochelys imbricata* (Sea turtle) |

# Acknowledgements

We are thankful to the entire staff of the Sunderbans Tiger Reserve
who have extended tremendous support in preparing the book.

~

We acknowledge the contribution of the photographers
who have helped us vividly illustrate this book.

~

We convey our regards to Ms. Meera Bhattacharya, Mr. A.K. Pattanayak and
Mr. Prasun Mukherjee for their inspiration in writing this book.

~

We would like to convey our sincere gratitude to Mr. Arin Ghosh,
Mr. K.C. Gayen, Mr. S.B. Mondal, Mr. P.D. Bandopadhyay,
Dr. Rajesh Gopal, Mr. M.A. Sultan, Mr. A.K. Raha, Mr. S.S. Bist,
Mr. M.N. Majhi and Ms. Suchetana Bhattacharya.

~

We are grateful to Ms. Ajanta Dey and Mr. Partha Dey and
Ms. Barnali Roy for their valuable contribution.

~

We thankfully acknowledge the assistance provided by
Ms. Soumeta Medhora, Mr. Prasanta Mukherjee,
Ms. Jayashree Roy Chowdhury, Ms. Sadhana Deep Vyas and
Ms. Rakhi Roy Chowdhury.

~

Photo credits: Partho Dey: 14 (below right), 30 (below), 69, 81, 90-91, 92-93
Arun Mullick: 13 (inset, left), 33 (3 insets), 34, 52 (main), 65, 94, 95
Kajol Datta: 74 (inset)